AMERICAN INDEPENDENTS

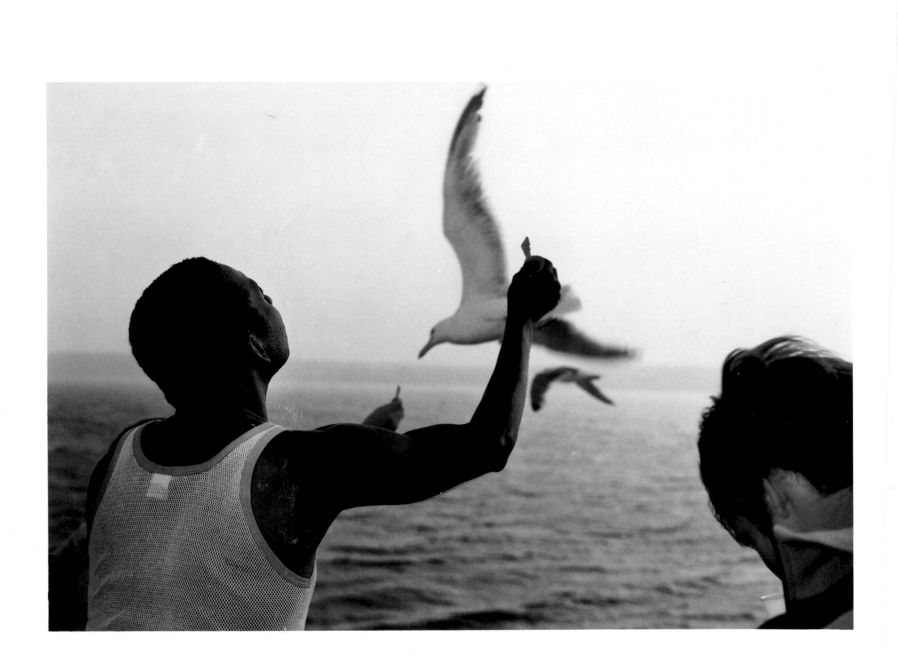

AMERICAN INDEPENDENTS

Eighteen Color Photographers

Sally Eauclaire

Abbeville Press · Publishers · New York

Front cover: Larry Babis. *Untitled, 1974*. See plate 3.
Back cover: Roger Mertin. *Rochester, New York, September 1984*.
 See plate 88.
Frontispiece: Mitch Epstein. *Martha's Vineyard Ferry, 1983*.
 See plate 36.

Editor: Alison Mitchell
Copy Editor: Don Goddard
Designer: Howard Morris
Production Manager: Dana Cole
Production Editor: Robin James

Library of Congress Cataloging-in-Publication Data

Eauclaire, Sally.
 American independents.

 Continues: New color/new work. © 1984.
 Includes bibliographies.
 1. Color photography. 2. Photography, Artistic.
3. United States—Description and travel—Views.
I. Title.
TR510.E28 1987 770'.92'2 86-28789
ISBN 0-89659-666-4

First edition

For Mary

and in memory of Kenneth McGowan, 1940–1986

Contents

Introduction

American Independents honors eighteen contemporary color photographers. The book's title—with its pun on the revolutionary self-determination that gave birth to this country—suggests all-American boosterism as well as rugged individualism. Both are appropriate to the spirit of an art form that emerged in America in the early 1970s and has since been imitated all over the world.

Certain pioneering efforts, produced when color photography was still a new frontier, are published here for the first time. Most of the book, however, displays recent work by established photographers and newcomers to the field, all of whom perceive color as photography's manifest destiny.

For the most part, the "new color" photographers nurture their aspirations and confront their failures alone. In a time when a self-conscious art world hastens to pay homage to those who take theory the inevitable next step, these independents buck fashionable trends to extend the American social landscape tradition that emerged in black-and-white photography a generation ago and earlier. Influenced as well by modern painters, they merge the abstract power of color with photography's unique descriptive capacity. Although they are unavoidably caught up in the battle to attain recognition for color photography as an art form, none of them possess the pedagogical fervor of the avant-gardist.

Knowledgeable and passionate about the history of their medium, they turn for inspiration to photographers who have sought to embody meaning rather than express it. Revering description, irony, and ambiguity, they have studied in depth the individual images and the sequencing of Walker Evans's *American Photographs* of 1938 and Robert Frank's *The Americans* of 1959. Lee Friedlander and Garry Winogrand have also been significant models in shaping form and content. Asked to discuss their own work, many of the photographers quoted passages from Robert

Adams's book of essays *Beauty in Photography*.

The straight photographic aesthetic espoused here embraces respect for the primacy of the object and for the possibility of transcendence in objective experience. In the tradition of nineteenth-century aesthetics, epitomized by Ralph Waldo Emerson's description of the artist as "transparent eyeball," these photographers would rather mirror nature than impinge their egos upon it.

At first glance, many of the photographs in *American Independents* look as if they could have been taken by anyone. They reflect a democratic stance that emphasizes "making" rather than "creating" photographs, and they eschew conspicuous technical wizardry. Appearing to be easily made, their subjects easily found, these works attain art in the selection and framing of things and events in images that become emblematic of American culture.

This collection focuses on the myths and dreams that have shaped America since the nineteenth century. Politically volatile themes are explored—the incursion of technology and tourism on the virgin land, sex roles and racism, the disappearance of vernacular architecture, the Hollywoodization of God—but viewers who expect propaganda or exhortation will be disappointed. These photographs contain no indictments or proposals. But by obliquely drawing attention to some of the conflicts and enigmas of our time, they may help viewers resee and reinterpret some of the many variants of the American dream.

AMERICAN INDEPENDENTS

LARRY BABIS

Got What It Takes till It Breaks

Larry Babis's street photographs propel viewers through random, surreal, funny, and mock apocalyptic adventures.

The title "Got What It Takes till It Breaks" reflects many aspects of America's boom-or-bust mentality: the collapse of the Nixon administration, the hype of the Bicentennial, success-in-excess schools of home decoration, and theories of aerodynamics in which design takes a backseat to force. The last theme—a favorite of Babis—might be summed up in the words of a NASA official who said, "Give us enough thrust and we'll make a barn fly." An alternative title, "Over the River and through the Roof," further describes the absurdist premise of this series.

Just as military test pilots "push the outside of the envelope" ("envelope" referring to the limits of a particular aircraft's performance—how tightly it can turn at a certain speed, for example), Babis probes the possibilities of photographic seeing and pushes at the outer limits of style, taste, and sanity. He concurs with Walt Whitman that "slang, profoundly considered, is the lawless germinal element," and he risks rough edges to transfigure the world kaleidoscopically. Taking advantage of rakish angles caused by a wide-angle lens and the amplifications of a strobe, Babis directs a theater of the absurd in which objects careen and action threatens to burst the proscenium. Whether composing centrifugally (moving outward from the center) or centripetally (moving inward from the edges), he attempts—to borrow a phrase from former astronaut Wally Schirra—to "maintain an even strain."

Idiosyncratic allusions to space travel dominate this series of photographs. Fun houses lure the public with rocketships and astronauts (plate 4), and a television shop exhibits an ashen gray photograph of the moon (plate 8). A barbershop pole shaped like a rocket and painted like an American flag seems to drag clouds, wires, a phone booth, and a person in the wake of its thrust (plate 3). Stretching the point, Babis includes the flight of Santa Claus and his

11

reindeer (plate 5) and a conceptual artist's attempt to "fly by the seat of his pants" with the aid of ropes and pulleys (plate 6).

Babis often revels in spatial games of hide-and-seek. In an image from a St. Patrick's Day parade, near and far spaces are pressed together on the picture plane, creating a mosaic of shiny, flashing, brightly colored segments (plate 7). Eyes peering out from the xylophone, like those gleaming from within a mask of Richard Nixon (plate 2), reveal an undercover spark of genuine life. Adeptly exploiting the fun-house effects of compacted space, Babis depicts a lollygagging pedestrian twirling an astronaut on his finger. This hotdogging occurs in an image that includes the words "play," "playland," and "out of this world" (plate 4).

In presenting absurd connections—and missed connections—Babis rolls with the disjunctures of everyday American life. Self-assertion runs amok when people decorate their halves of a double house but fail to harmonize with their neighbors (plate 5). A pianist tickling the ivories of a zebra-striped piano entertains a taxidermic zoo (plate 9). A character wearing a Richard Nixon mask gladhands inner-city youths in New York's Central Park (plate 2). A humongous and vapid balloon head of George Washington is juxtaposed with an adult wearing a toy fireman's helmet backward (plate 1). A man wearing a scowling countenance and another silly hat bypasses a moon, blind to the imaginative, enigmatic, and mythical force that his rural ancestors revered (plate 8). But then what could televised moon landings sponsored by Tang tell him about his place in the universe anyway?

Clearly, Babis perceives an America in which people are often out of tune with themselves and their neighbors, with nature and the cosmos. Unable to find and present any rational scheme, Babis reacts with ricocheting humor. Subverting our pedestrian sense of reality and causation with cartoonlike people, weird settings, and tricks of composition, Babis expresses his perceptions through repetitions and intensifications, rather than through orderly development.

"Got What It Takes till It Breaks" is eclectic, impure, and rambunctious, the work of a young photographer empowered for the first time. Babis's game is as unpredictable, complex, and absurd as life itself.

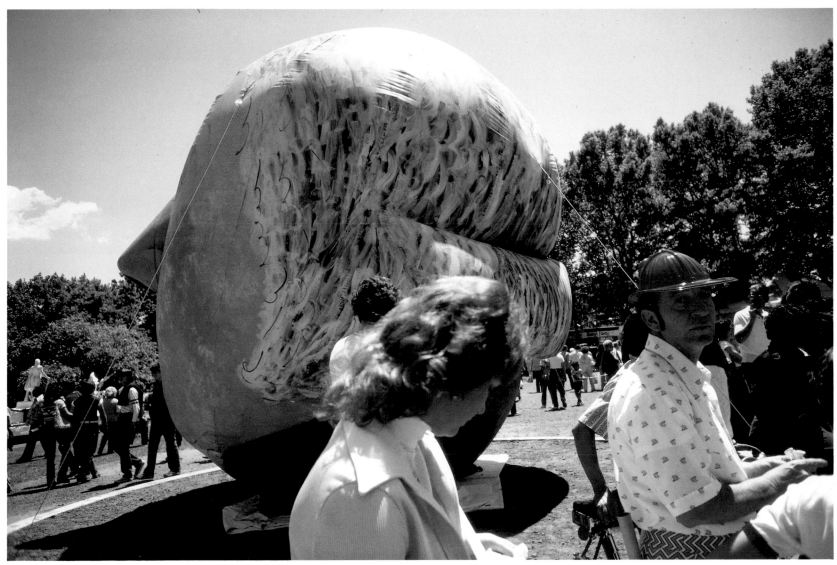

1 Untitled, 1976

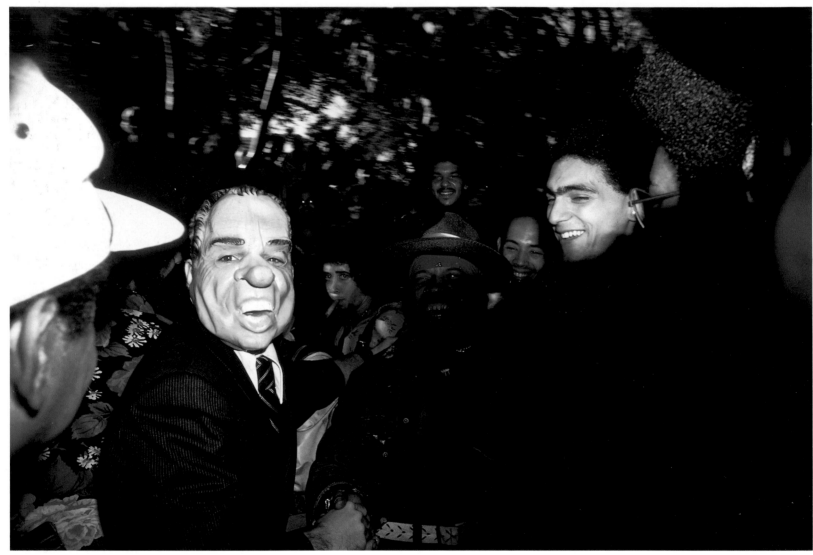

2 Untitled, 1976

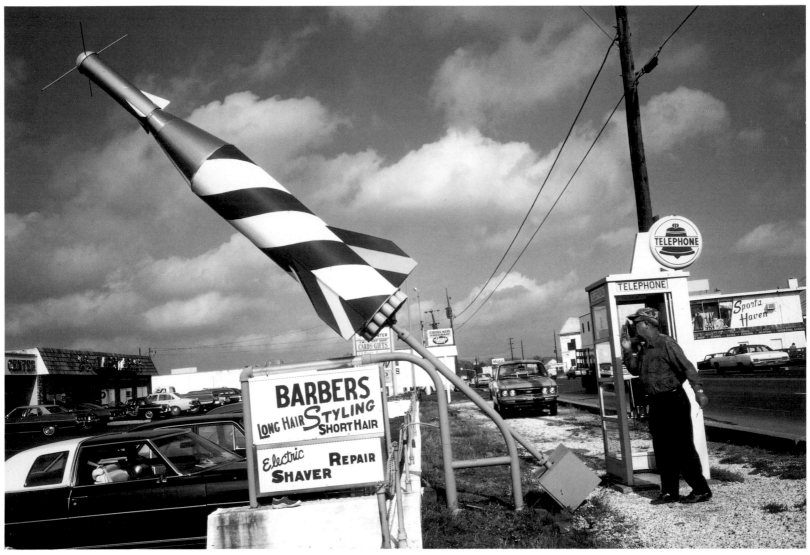

3 Untitled, 1974

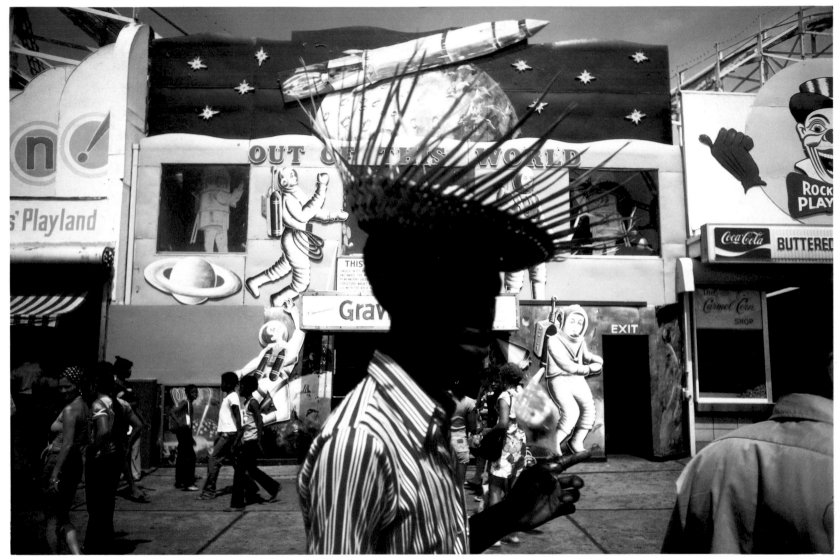

4 Untitled, 1977

16

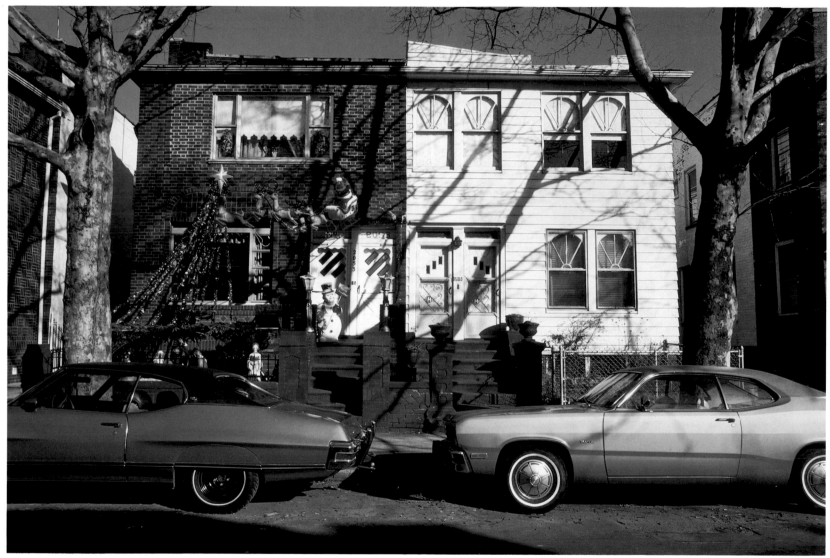

5 Untitled, 1973

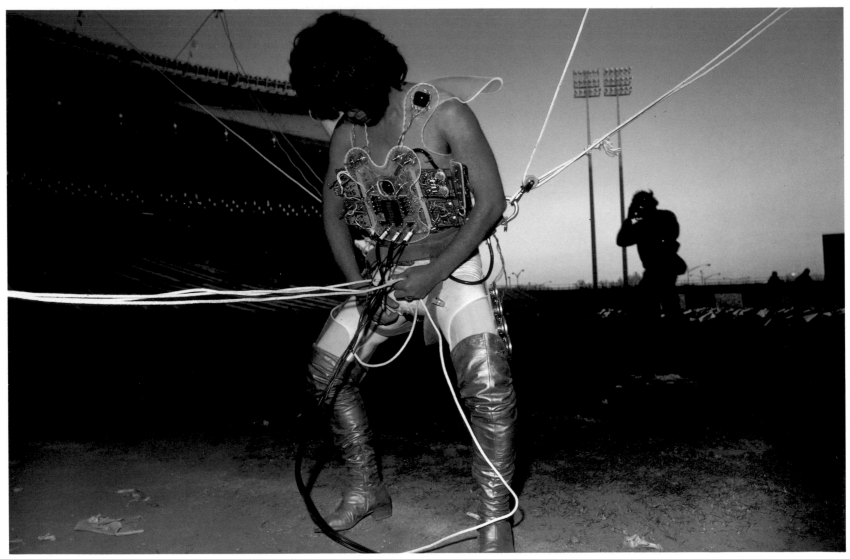

6 Untitled, 1975

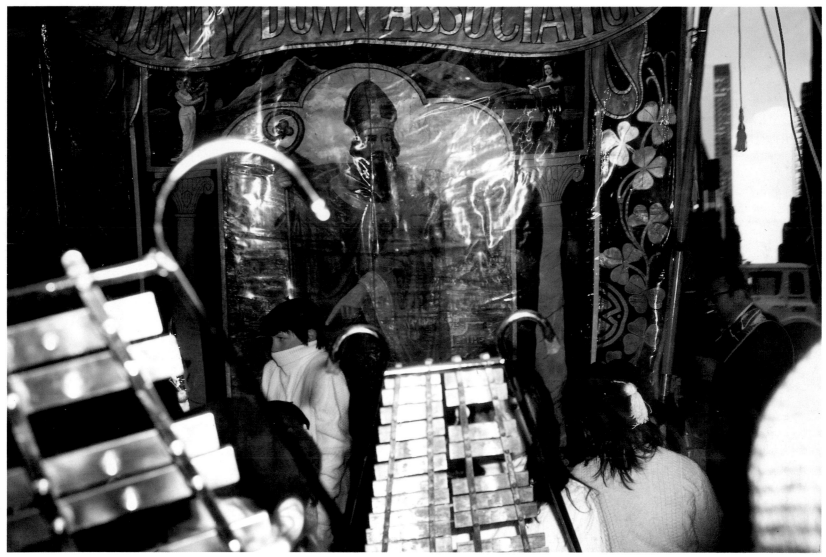

7 Untitled, 1974

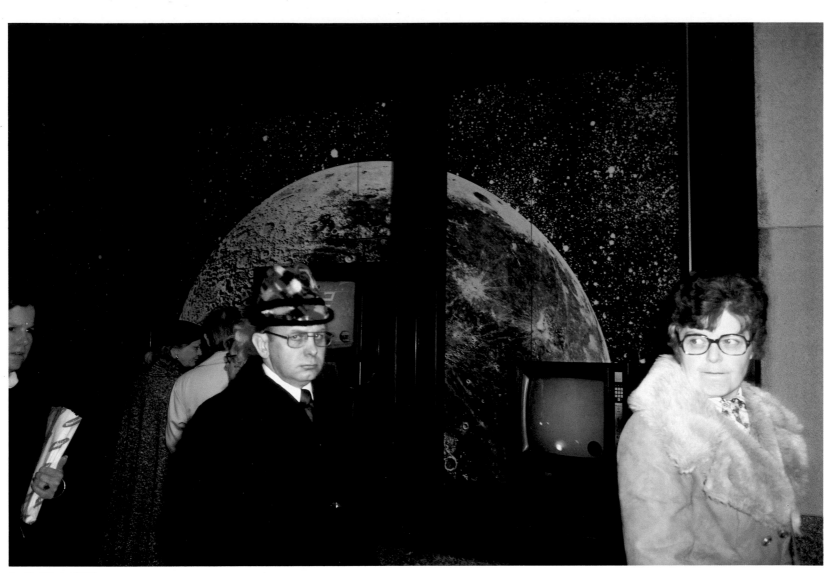

8 Untitled, 1975

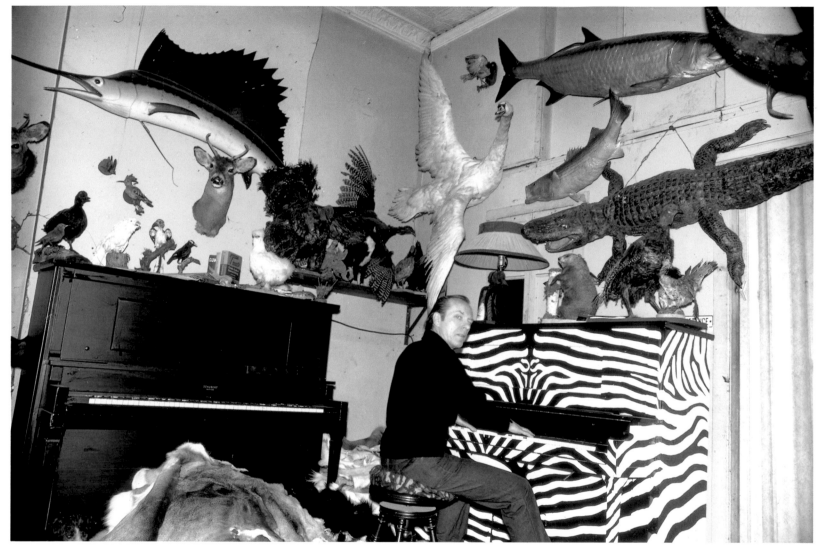

9 Untitled, 1973

JIM DOW

American Vernacular

In search of what is quintessentially American, Jim Dow has found old movie theaters, diners, motels, billboards, barbershops, Masonic lodges, and other vestiges of Americana that have not yet been updated for assimilation into the amorphous middle-American mainstream. His task becomes increasingly difficult each year.

Dow travels along the old highway routes, stopping at sleepy, obsolescent communities that the interstate highways have passed by. Rejecting McDonald's golden arches, Dow looks for its predecessors, the one-of-a-kind, idiosyncratic constructions that reflect local popular taste.

The heydey for such popular architecture was at the end of World War II, when an increase in leisure and holiday travel, faster and more comfortable cars, and growing wealth precipitated the development of the highway strip. In the 1940s and 1950s—the vintage of most of the signs and buildings Dow photographs—travelers were courted by exhibitionistic locals who built architecture that loudly and vividly asserted their regional identity.

Some theorists suggest that the flamboyant façades, bizarre decorations, cheerfully garish color combinations, glaring floodlights, and flashing neon constitute a twentieth-century folk art. Because the motive behind such efforts was to woo the passerby, it was the consumer—not the architect or critic—who passed final judgment. As J. B. Jackson, a writer on the American landscape, has noted, the only possible criterion by which one can judge such "other-directed" architecture is whether or not it is liked.

Dow exploits the theatrical and illusionistic possibilities of such sites, creating quirky photographic transformations. He delights in the overreaction of film to certain colors and light sources. Flaming reds, hot pinks, and chartreuses push against the picture surface (plates 10 and 12); windows, fluorescent tubes, light-struck floors and mirrors

"burn out," becoming lurid presences (plates 16 and 17); and mixtures of natural and artificial light produce spooky colors (plates 18 and 19).

But it is Dow's framelike devices and pictures within pictures that most tease viewers (plates 10, 11, and 12). Colors and objects jut forward in contradiction of their spaces, badgering us for attention, much in the spirit of the sites and signs they record. Illogical spatial relationships are thus coupled with pinpoint detail to create distinctive portraits of each place.

Dow describes himself as a "butterfly collector in search of the perfect specimen." Many examples testify to the American technology of fast food. The lunch counter, invented in America to accommodate the haste of train travel, offers fast service and a built-in discomfort that discourages customers from lingering over their meals. Dow photographed one of the few remaining diners that still serve train travelers (plate 17). The roadside stand, which caters to the automobile as an inseparable part of its owner's identity, is epitomized by Pat's, an establishment that appears to be a quintessential highway diner but is actually a neighborhood haunt (plate 18).

Some of Dow's photographs include objects and buildings that occupy the realm of nostalgic funk: tepees made of piled-up beer cans, store window displays of 1950s-era fantailed sunglasses, and collector's items such as rusting weathervanes. But most of his subjects are perfectly ordinary barbershops, cafeterias, shoeshine parlors, mom-and-pop diners, flagpoles, and burger joints—places and things that Americans have looked at for years but seldom thought twice about.

Not everything in Dow's photographs dates back to the 1940s and 1950s. Of much earlier vintage is the flamingo wallpaper in a deluxe hotel that prospered during the railroad era (plate 14). And more recent, if anachronistic, are such vernacular creations as the jovial primitive painting in a North Dakota bar (plate 12) and a unique chapel built by a Louisiana man for his invalid wife and preserved by him after her death (plate 11). Amid the jumble of iconic treasures on the altar is an earlier photograph by Dow of the same room.

An admirer of mellow old materials, Dow particularly enjoys the accidents of age that transform them. Witness the shoulder-high coating of grease on the walls of a truck stop billiard room in Alabama (plate 16) or the scumbled pink fresco of a tire shop (plate 15). Dow's flashbulbs envelop these seedy scenes with a transcendent luminosity in which scintillating colors emerge from graffiti and smudges.

People are conspicuously absent from Dow's photographs, and only rarely does he show his subject's placement in the landscape. Thus Dow's photographs can seem glossily escapist, the images plucked from the crowding of their actual contexts. Nonetheless, clues to social, economic, and aesthetic woes abound. A duct has been poked by some pragmatic cad into the historically significant wallpaper (plate 14). A tipsy lampshade, piled-up furniture, and missing letter "B" record the decline of a hotel lounge that was probably last renovated in the early 1950s (plate 10). And a fallen cookie-cutter-like Hollywood icon that once flashed neon in a come-hither gesture reflects the deterioration of the Marilyn Motel (plate 19).

Dow regrets the galloping homogenization that is overtaking America. Today's popular architecture, calculatedly designed to please everyone and no one, is making every place look like every other place. The automobile, while providing an easy means of travel, has spawned the sterile and standardized superhighways that destroy the rich and varied experience of travel. Soon, Dow fears, it will be possible to know, encounter, and imagine America only as a deracinated, preprocessed whole. As the March Hare knew: "I like what I get" is not the same as "I get what I like."

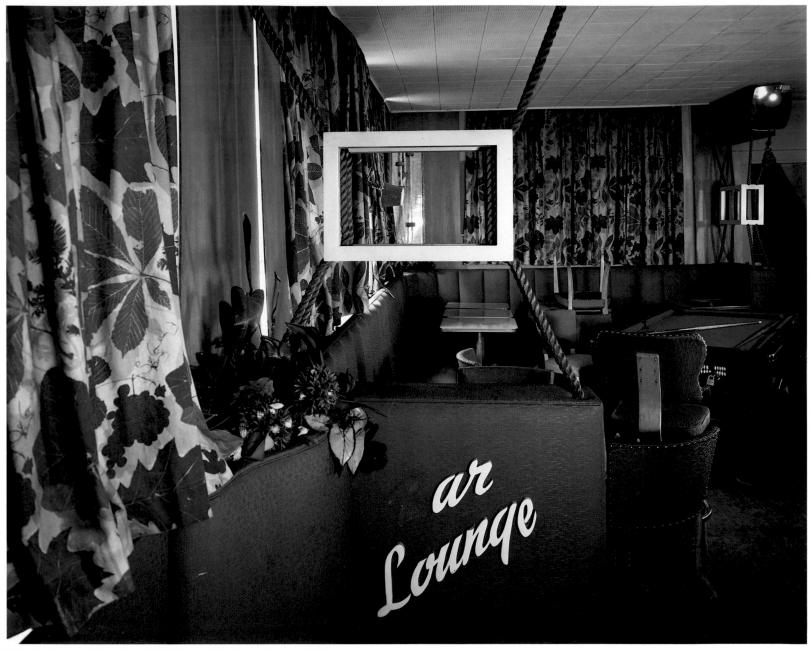

10　Bar/Lounge at the Ship Hotel, Central City, Pennsylvania, 1980

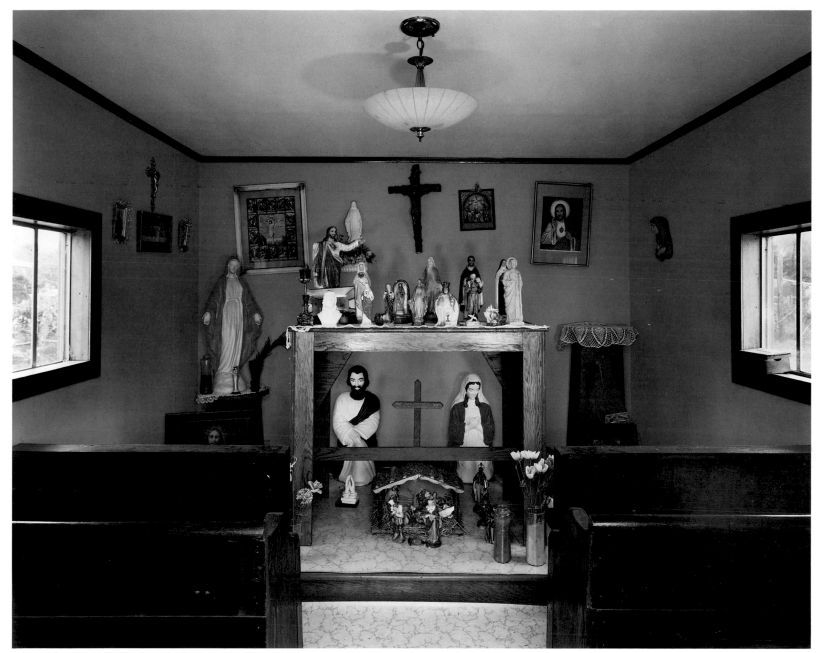

11 Chapel at Mr. Roussell's, Vacherie, Louisiana, 1978

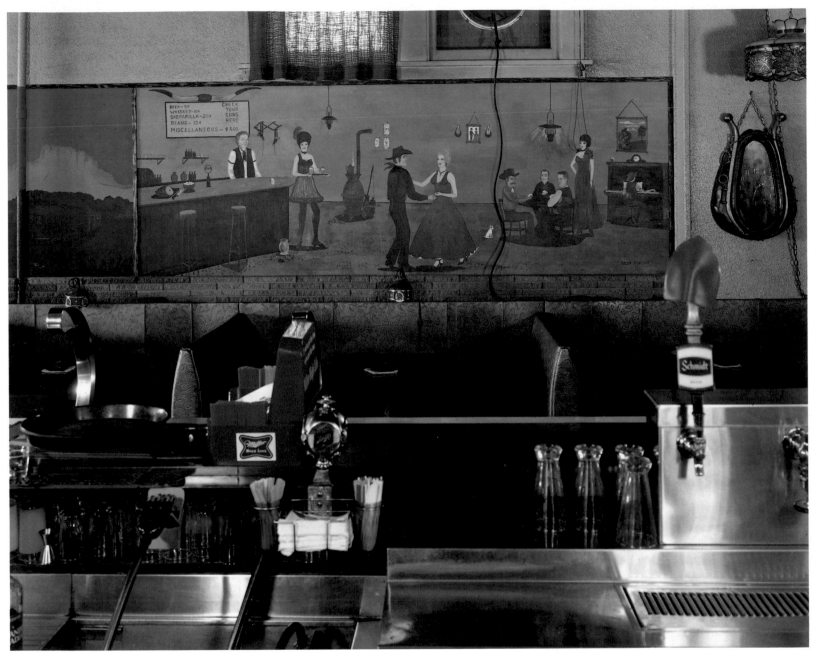

12 Wall Painting, the Terrace Lounge, Carrington, North Dakota, 1981

28

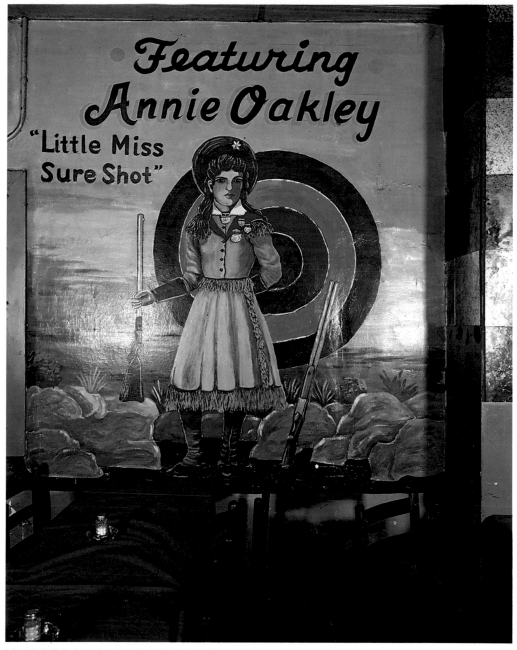

13 Wall Painting, the Longhorn Ballroom, Dallas, Texas, 1981

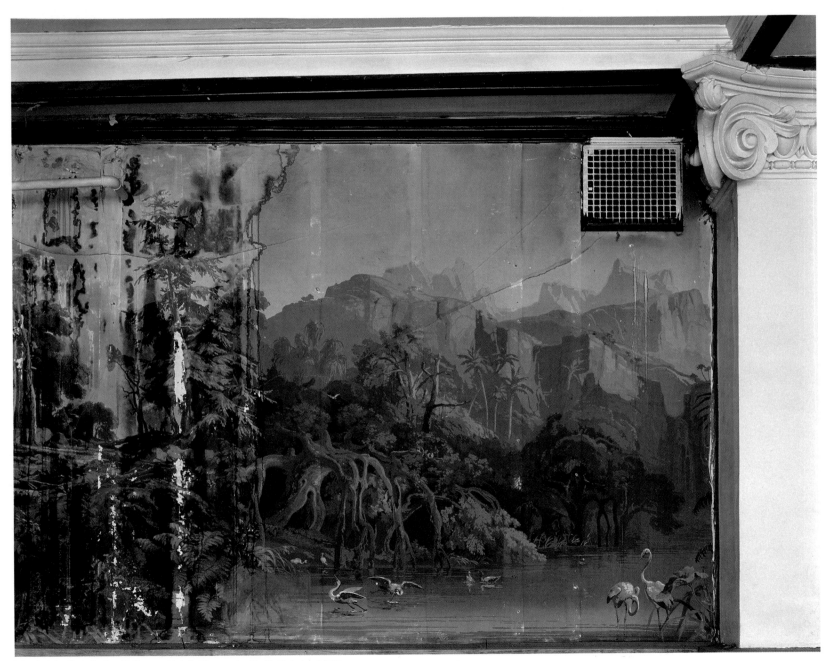

14 Lobby Detail, the Patterson Hotel, Bismarck, North Dakota, 1981

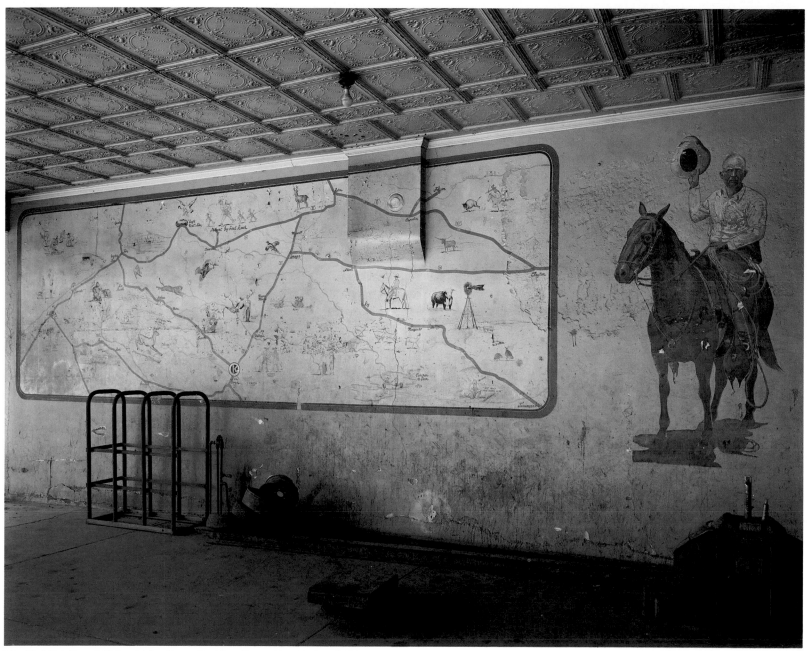

15 Wall Painting at Mohawk Tire Store, East Las Vegas, New Mexico, 1980

31

16 Poolroom at Nora's Midway Truck Stop, Grove Hill, Alabama, 1979

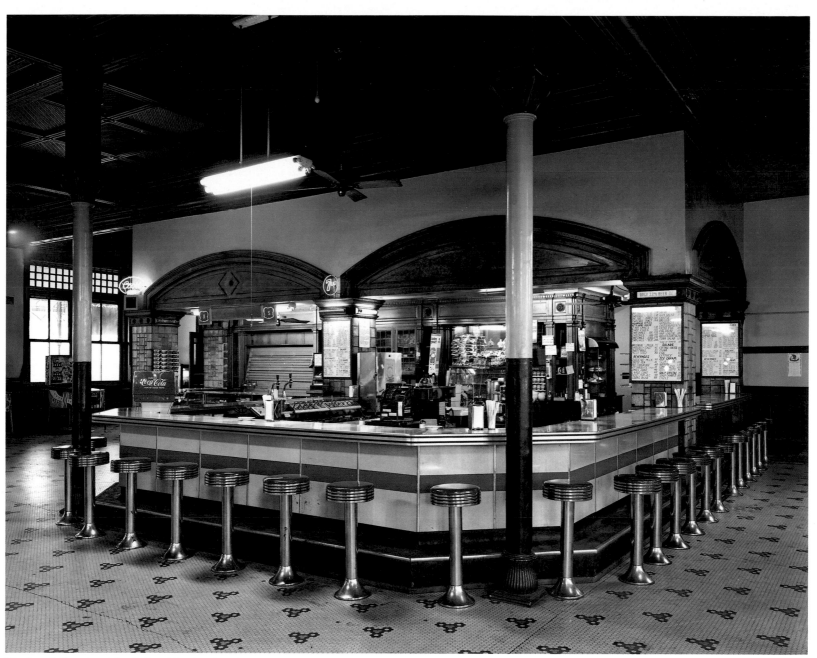

17 Lunch Counter at the Railroad Station, Pueblo, Colorado, 1981

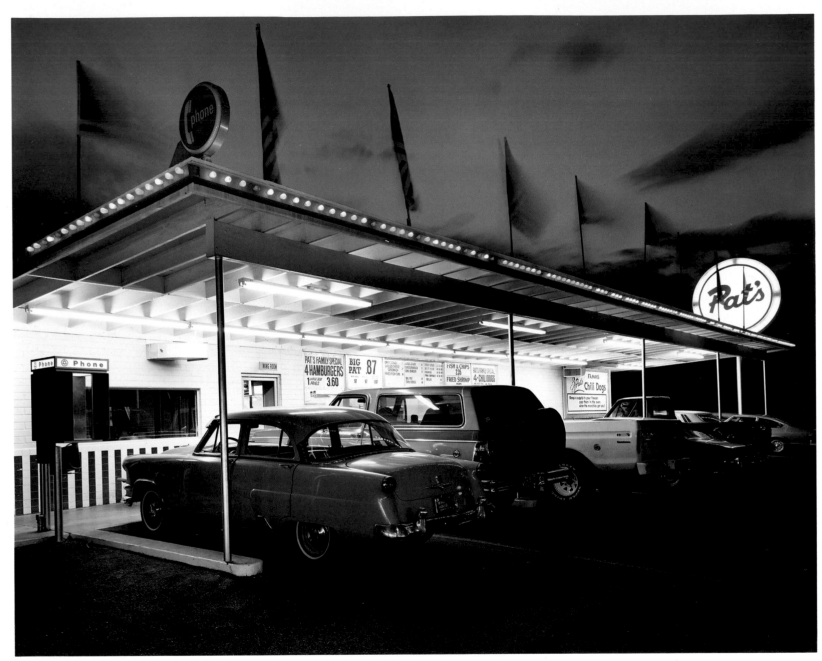

18 Pat's Drive-In, Tucson, Arizona, 1980

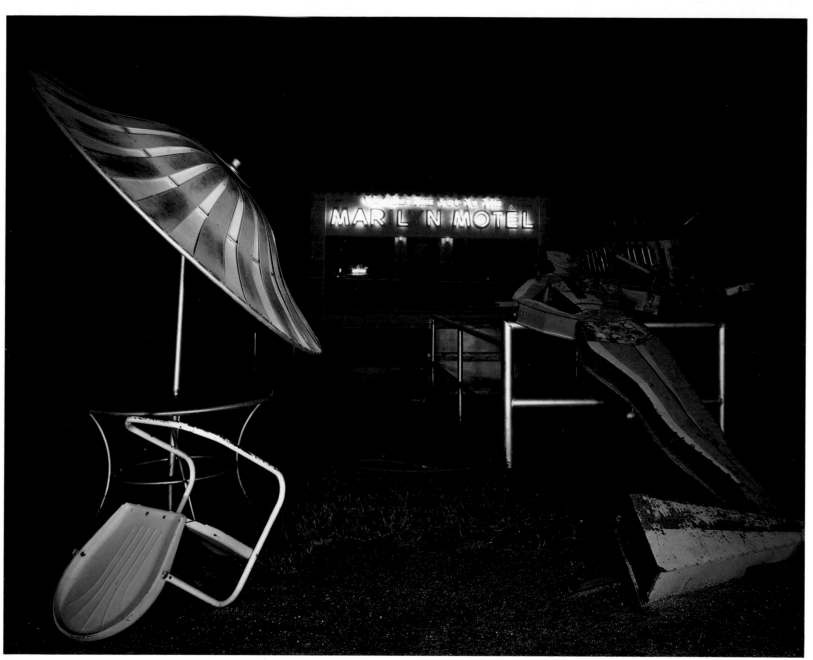

19 The Marilyn Motel, Tucson, Arizona, 1980

WILLIAM EGGLESTON

The Democratic Forest

William Eggleston's "The Democratic Forest"—comprising some 12,000 photographs—depicts America's urban and suburban forest of streetlights, traffic signs, placards, pedestrians, parks, and skyscrapers. Trees grow in decorative pots, travel by truck, and decorate wallpaper, billboards, and advertisements. Stone lions, papier-mâché dogs, plastic alligators, concrete camels (plate 30), and other imitation wildlife live on coffee tables, windowsills, motel lawns, automobile dashboards, formal gardens, and miniature golf courses. Plants sprout up amid herbicide cartons, children wear sweatshirts printed "Loose as a Moose," and Diana the huntress is an art deco figurine stalking her prey in the window of a curio shop (plate 28).

Eggleston himself hunts "democratic" subjects that normally exist beneath our notice: light switches, ceiling fixtures, meters, automobiles, gas stations, litter, and cigarette machines (plate 23). He obsessively circles such seemingly inconsequential subjects as if to call attention to their latent meaning. In the past, Eggleston's compositions included little within the frame. Now he often packs his photographs to the limits, suggesting a consumer society in which more is more, too much is not enough, and only the glitter of a World's Fair supercedes everyday banality (plates 24 and 29).

Despite occasional touches of humor, Eggleston's overriding symbolism is of physical and spiritual sterility. America's once majestic forests have been replaced by heaps of broken images, the flotsam and jetsam of a desiccated culture. Withered growths of kudzu twist downward, photographically cropped from their life source (plate 22). Lifeless animals are cloned in factories (plates 24, 29, and 30), mannequins, dummies, and statues replace human beings (plates 28 and 29), and meters mark the trivial priorities of the measuring, rational mind. Fast-food stores, gas stations, and chain banks (plate 22) establish a world of deracination and alienation where the traditional beliefs,

sanctions, and bonds of family and local community have been severed. The grandeur of the past, of marble urns and classical statuary, no longer sustains us, and the Washington Monument emerges as a tipsy, lurid presence from the unfocused junk heap of the automobile society (plate 20). Peeling paint, torn paper, and rusted metal imply Eggleston's equation of mutability with decay and disease. The shifting cadences of "The Democratic Forest" grind out the discordant music of disillusionment and longing.

Even a cursory glance at the series reveals Eggleston's refusal to photograph the world in "natural" or "normal" ways. Like Robert Frank, he insists on projecting a vision of America that has been radically recomposed through photography—the world not strictly as it is, but as an act of style has made it. Sometimes slyly and sometimes overtly, Eggleston flouts and overcomes reality, achieving a proud independence. He wrenches the photographic language until it says what he wants it to mean.

Eggleston is one of the few new color photographers to successfully use as metaphor the vagueness of out-of-focus zones. Blurs dissolve our familiar and certain environment into an indeterminate realm of shifting perspectives and recessions. Used to similar purpose are recurring burned-out whites that strike the eye with blinding, detail-less glare (plates 21, 23, and 30). Likewise, long narrow bands of black shadow (plates 21, 27, and 31)—most often appearing at the edges of the photographs—further obscure the world. One is reminded of the tension and foreboding in William Faulkner's *The Sound and the Fury* when the idiot Benjy touches a tall, black place on the wall that is like a door but not a door, and where a mirror used to be.

Reflections afford Eggleston the means of indirectly making correspondences, antitheses, parallelisms, and analogues. Deflecting instead of reflecting the photographer's line of vision, these devices create compartments set at different angles. Thus the conventional mirror held up to nature has given way to fun-house mirrors that reflect images directly and also reflect reflections (plates 20, 29, and 31). Forms and ideas remain fluid, unfinished, and unresolvable.

These strategies result in progressive, partial, and delayed disclosure of meaning. Out-of-focus zones, radical foreshortenings, reflections, opaque shadows, burned-out whites, and startling croppings tend to manufacture screens and other obstacles that confound the search for simple clarity. Viewers find themselves variously inside, outside, underneath, above, and catercorner to objects in his photographs.

Eggleston prizes stylistic and conceptual oxymorons. His works often contain sharp contradictions between the bizarre and the reasonable, the illogical and the consistent. These appear most strikingly in such hallucinatory spectacles as the "field of snow" image with palm trees (plate 21). But more often the juxtapositions are understated—shadowy miasma next to crystal clarity (plate 28), flickering light next to deadened mass (plate 23), flat, mural-like surface next to three-dimensional illusion (plate 27). Another frequent device is the alignment of similar forms, one upon another, giving the jarring effect of double or triple vision. Thus structures may nest within other structures (the white cars positioned like Chinese boxes in plate 30) or cluster in herds (plates 25 and 30).

Such restless refashioning of the world denies the easy

satisfactions of neat resolution or rational integration. Extolling flux and discontinuity, flirting with obscurity and chaos, Eggleston leaves meaning in a state of suggestive suspension. But rather than a surrealistic montage in which the artist's consciousness empties itself of discontinuous impressions, Eggleston has constructed a prolific and proliferating essay in which irregular and imprecise allusions echo and reecho with changing voices. The photographer intends that viewers perceive the work as a visual equivalent of a Bach fugue, in which discrete lines interact and interweave, not in strict repetition, but in patterns of augmentation, diminution, inversion, alignment, and overlap. Despite the vastness of the enterprise and the initial impression of incoherence, nothing is casual. It is no accident, for instance, that elk antlers, truck stripes, bromeliads, and rakes correspond (plates 24, 25, and 26). Eggleston has produced hundreds of Wassily Kandinsky-like nonobjective drawings with magic markers and gold paint, in which floating, amorphous shapes of color congest in giddy arrangements that tug and shove at the picture plane. The drawings—which have never been exhibited to the public—formally resemble many of his photographs, particularly plates 24 and 29.

Eggleston's title "The Democratic Forest" reflects his belief that all of the elements in each photograph contribute equally to the total image and that each of the 12,000 photographs in this series participates equally in the realization of his vision. The notion of the single masterwork is anathema to him; he also scorns the idea that superior photographs throw off extended families of dependent photographs. Eggleston would have us believe that the individual photographs in "The Democratic Forest" mutually inform one another. One might interpret Eggleston's failure to edit his own work as evidence of spiritual apathy or paralysis of the will. A likelier conclusion is that the vastness of the series in itself serves to paraphrase the rootlessness, loss of direction, and general confusion of society today.

Ortega y Gasset wrote that all style necessarily deforms reality and involves dehumanization and that an aim of modern poetry is to substitute style for reality. Yet despite Eggleston's clear impatience with rules (photographic and otherwise) and his aggressive rejection of dutiful mimesis, his sense of place remains true; viewers feel dubious about some of his photographs not because he has failed to establish the reality of his world but because he is manipulating style so as to violate that reality. His distended, imaginative approach appears at once grotesque, as though somehow maimed, and proudly expressive of Eggleston's ambition to create a world that is his own.

20 Untitled, circa 1984

21　Untitled, circa 1984

22 Untitled, circa 1984

23 Untitled, circa 1984

24 Untitled, circa 1984

25　Untitled, circa 1984

26 Untitled, circa 1984

27 Untitled, circa 1984

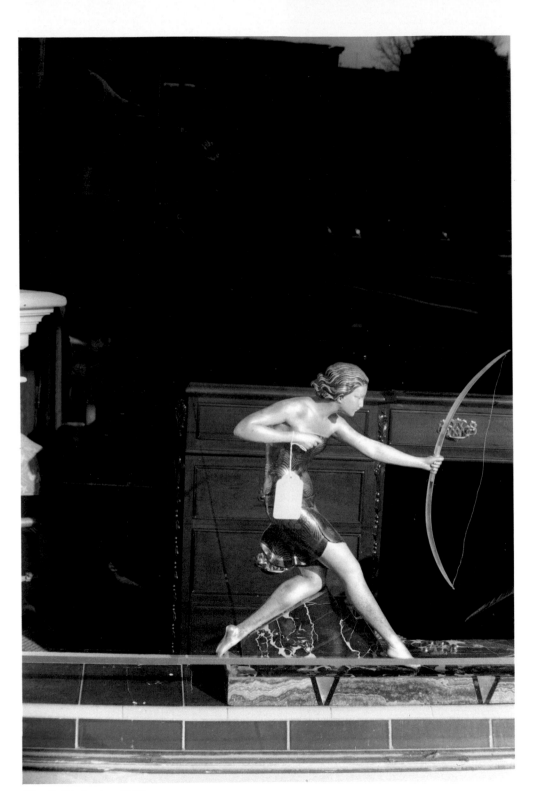

28 Untitled, circa 1984

29 Untitled, circa 1984

30 Untitled, circa 1984

31 Untitled, circa 1984

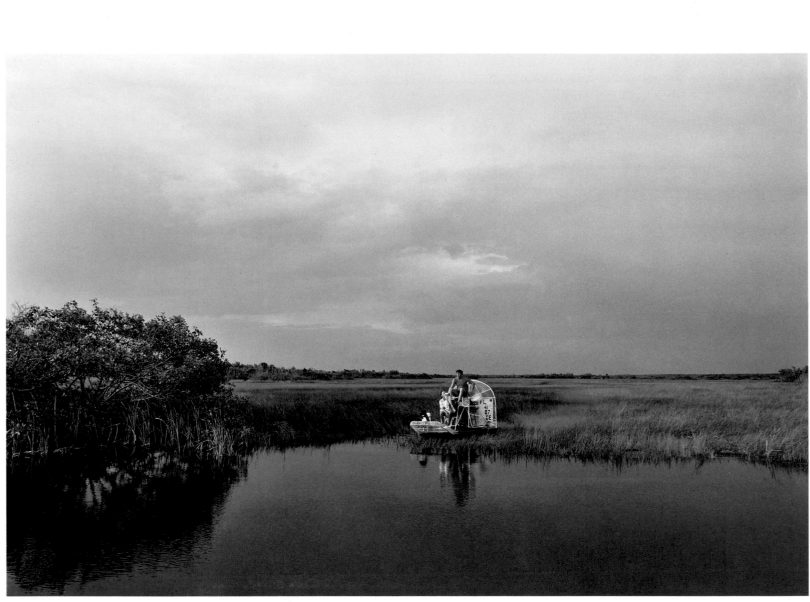

32 Everglades, Florida, 1983

MITCH EPSTEIN

Common Practice

Mitch Epstein trusts in the power of enraptured perception. Navigating the American landscape, he intuits moments that seem blessed, harmonious, and eternal.

Despite their evidence of a plastic-and-polyester society, his photographs of vacation sites such as Martha's Vineyard, the Everglades, and Cape Canaveral recall the revelry, music making, amorous dalliances, and peaceable kingdoms seen in depictions of the Golden Age. A nude couple converses on the beach, a guitar temporarily at rest, while a dalmation sleeps, color-coordinated with the sand (plate 40). A ripe young woman cradles a snake while dappled light and patches of color embroider the scene into a sensuous tapestry (plate 37). Barely clad, prepubescent girls luxuriate on the hood of a car, drenched in the sun's magic, while adults relax inside the car or mount trailers to witness the view (plate 41).

It would seem that Epstein has unselfconsciously reincarnated vignettes from the central panel of Hieronymus Bosch's *The Garden of Earthly Delights*. But whereas Bosch's lusty pairs couple in bubbles, mussel shells, and fruits, frolic in water, or antically ride on assorted four-legged creatures, Epstein's families enjoy cars and trailers or drive air-powered boats through the Everglades (plate 32). At Cape Canaveral they gather to worship rocketships, today's symbols of masculine potency and thrust (plate 41). As in Bosch's prelapsarian world, the races exist in harmony, for a black man and a white man seem ecstatically in tune with each other, the bird kingdom, and by extension, the natural world (plate 36).

Epstein does not reiterate Bosch's warning that lust leads inexorably to hell. But as a citizen of the 1980s, he knows that the "greening of America" in the 1960s has not led to the diminution of social and psychic ills to the extent that Charles Reich envisaged. Epstein's photographs reflect this by being both sophisticated and primitive, sly and innocent, naive and worldly. His Garden of Delights is also

a Garden of Consumer Goodies, in which gluttony competes with lust. And people caught in the summer rush on the Martha's Vineyard ferry know weariness better than joy (plate 35). Moreover, the woman's high-heeled clogs and bleached hair belie the natural look and the natural life.

Clearly, human weakness and stupidity exist in Epstein's ideal world, but he renders them with such delicate irony that folly seems the natural and not entirely undesirable condition of mankind. The source of evil is neither the snake nor the wheel, both of which act as sources of sensuous, ecstatic pleasure in his photographs. The hell to pay is merely the imminent return to the workaday world.

Although arcadian romance envelops these scenes, Epstein never excludes evidence of the industrial age. His photographs are at once dreamlike and vividly real, and there is poetry in their duality. Whatever the symbolic narrative, Epstein consistently provokes our sense of actuality —these events are common practice. We can sense the soft, palpable air of summer evenings, when forms release the light they have been soaking up all day. We can feel the absolute stillness of a summer morning or the tedium of traveling to a destination where relaxation might be possible.

This is not to say that the intensity of these photographs equals the intensity of the experience depicted. Rather, as T. S. Eliot once observed, the effect of the work is "different in kind from any experience not of art" and the "significant emotion" resides in the artwork itself. That Epstein's photographs ring with notions of the ideal cannot be attributed to the duplicative powers often associated with photography. His gift is instead illuminative, the result of recognizing the potential for inexplicable magic in the world's clear facts. Shimmering color passages arise from his meticulous recording of detail. A blonde palette with dashes of rich color paraphrases the smiling aspects of life, and graceful gestures are gathered from everyday chaos, all to evoke carefree ideal states. Yet by grounding his fictions so frankly in common reality, Epstein skirts clichéd romantic formulas and makes it more rewarding for us to enjoy and share in his vision. Rejecting the ponderous effects of intellectual self-consciousness, Epstein blends archetype and visual epiphany to reveal the world with expansive appreciation.

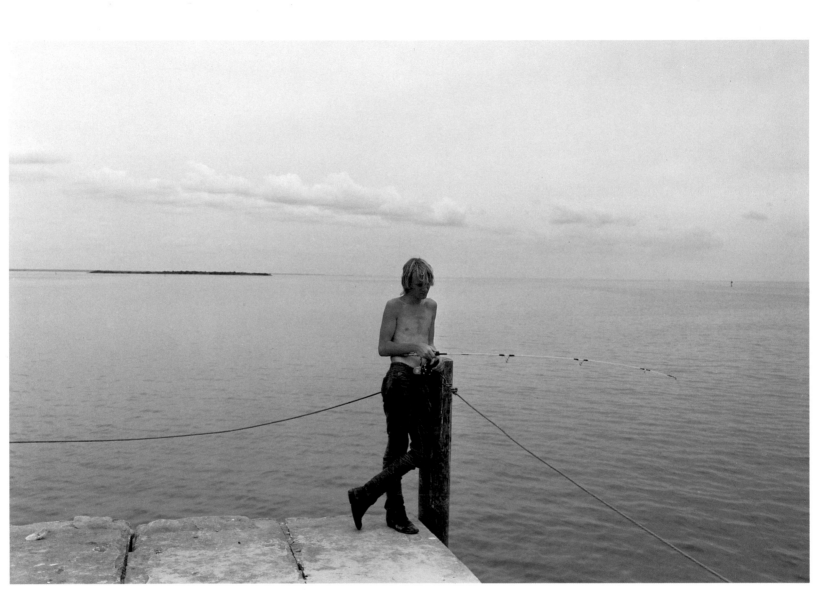

33 Cedar Key, Florida, 1983

34 Menemsha, Martha's Vineyard, 1983

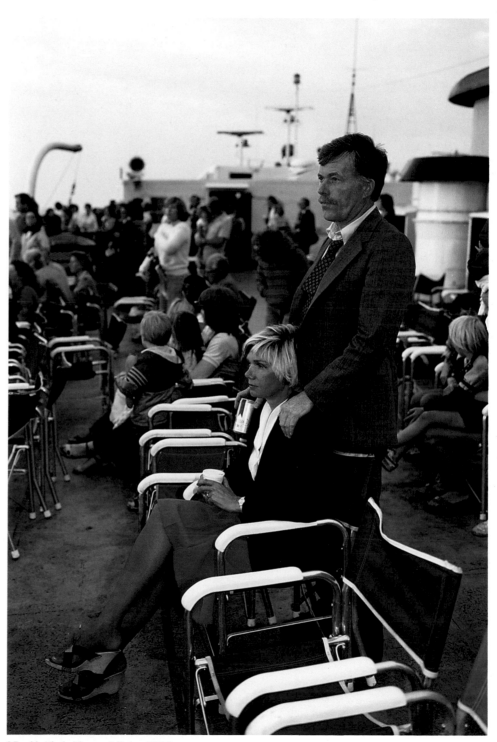

35 Martha's Vineyard Ferry, 1983

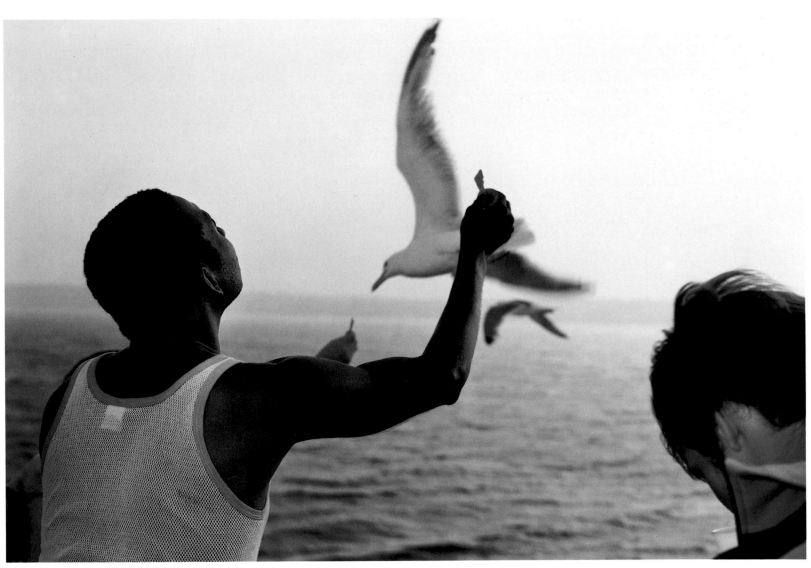

36 Martha's Vineyard Ferry, 1983

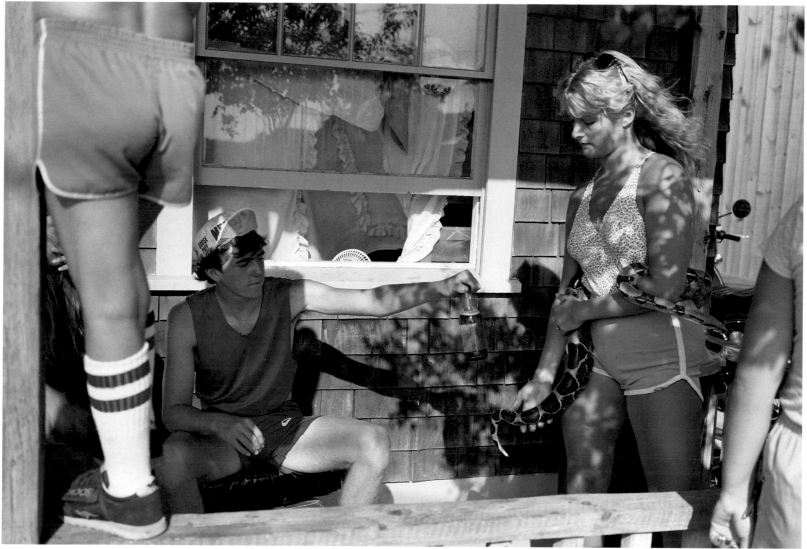

37 Martha's Vineyard, 1983

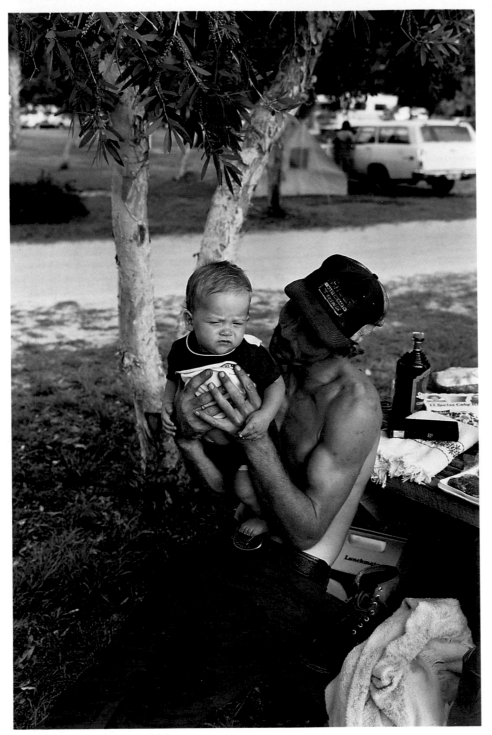

38 Cocoa Beach, Florida, 1983

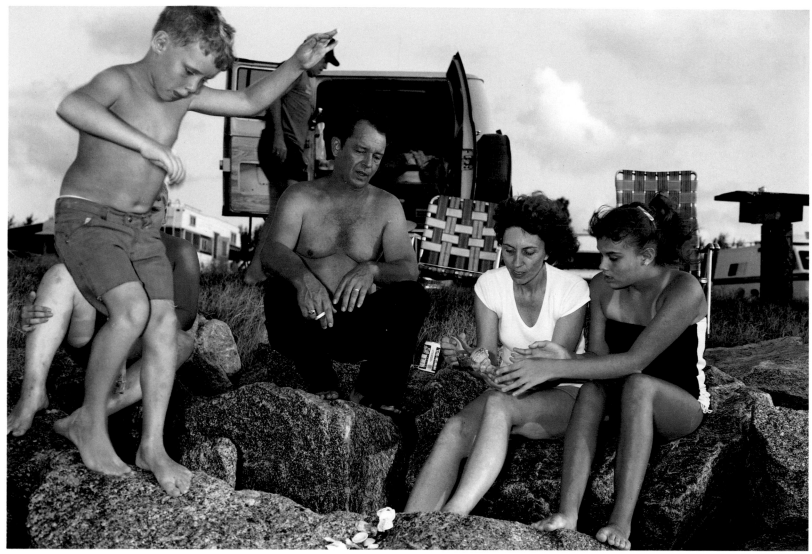

39 Cocoa Beach, Florida, 1981

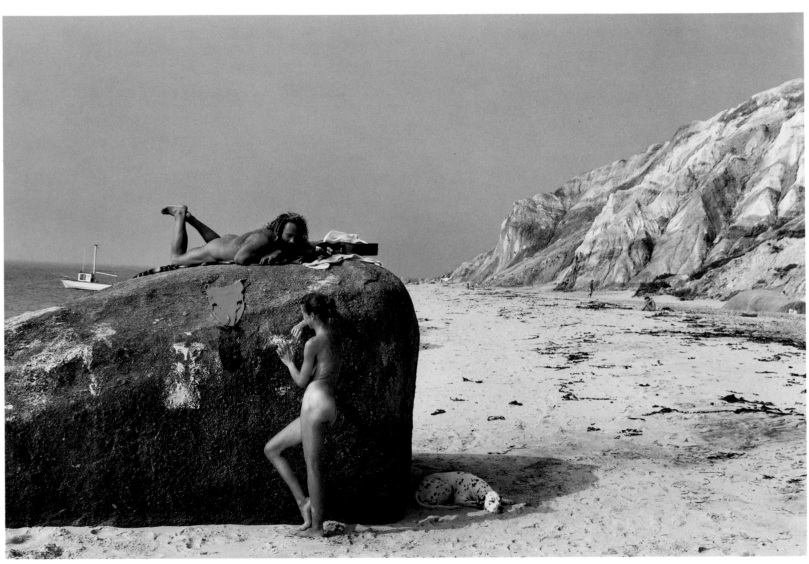

40 Gay Head, Martha's Vineyard, 1983

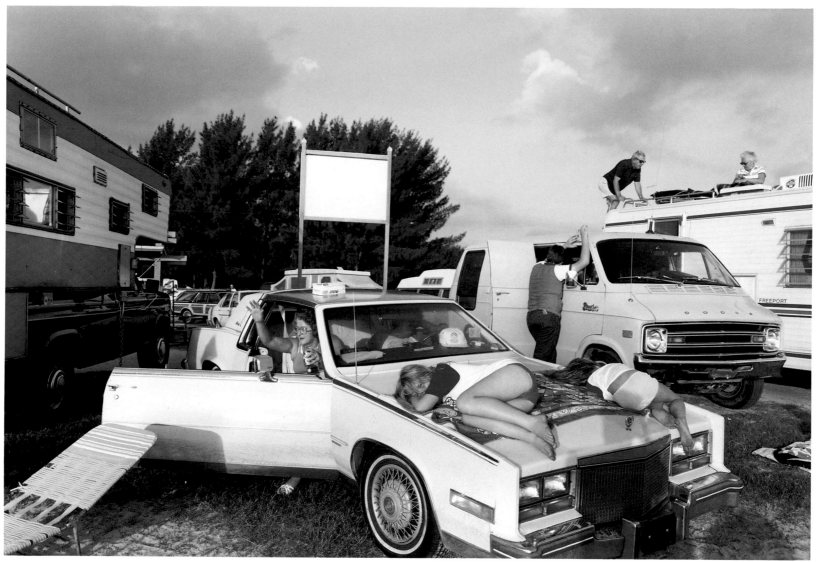

41 Cocoa Beach, Florida, 1981

DAVID T. HANSON

Colstrip, Montana

For David T. Hanson the strip mine and coal-fired generating plant in Colstrip, Montana, serve as both mirror and metaphor for the use, misuse, and abuse of power.

The Colstrip photographs bid us to consider many contemporary issues: ecological awareness, the overconsumption of natural resources, the energy crisis, and environmental reclamation. Yet Hanson aspires to an even larger theme. His photographs chronicle entropy, revealing a society intent upon cannibalizing itself, other cultures, and the land. They are late twentieth-century landscapes, proof of the horrible error of nineteenth-century theoreticians who believed that the factory system that had brought hell to the old world would be redeemed in the new. Instead, the conquest of the virgin wilderness has become the rape of the land.

Colstrip's industry was established in the early 1970s, when oil and gas were no longer plentiful and coal became the mainstay of "Project Independence," a government effort to make the United States self-sufficient in energy production by 1980. Colstrip could not help but be a part; it rests on one of the largest coal deposits in the world. Its 34 billion tons of low-sulfur fuel represent more than one-third of the remaining coal reserves in America that can be blasted, gouged, and scraped from the earth without the expense of shaft mining.

The fifty photographs in Hanson's series document the visible effects of strip mining. After removing the "overburden"—a pejorative reference to the topsoil and rocks that lie between the miner and the coal—and heaping it into "high walls," miners take coal from the open trench. Hanson's photographs show the draglines and scoops with which miners create furrows across the land and the drills used to bore rows of holes for explosives, which when ignited will break up the overburden or the coal itself. The brightly colored square patches and triangles are "effluent holding ponds" in which liquid waste products evaporate until they

are solid enough to be taken away and dumped (plate 49).

Colstrip is unusual in that it possesses one of the largest strip mines in existence that is operated in conjunction with a coal-fired generating plant (plates 42 and 49). The photographs show the plant looming over the town, but, of course, cannot reveal the ever-present noise of loudspeaker announcements and whining, buzzing, and clanking machinery. Like most mining towns experiencing boom-and-bust population growth, Colstrip has gained trailers, tract homes, new highways, and a host of social problems that have otherwise eluded small towns and rural areas.

Although strip mining is safer and cheaper than shaft mining, its effects on the land have proven catastrophic. From Appalachia westward, it has left a trail of scarred mountains, mutilated countryside, polluted air, and streams contaminated by acids and choked with silt. Its assault upon the land is total, uprooting and destroying plants, driving out animals, birds, and insects, and withering whole ecosystems. Ten years ago, America's 200 million destroyed acres were the equivalent of a mile-wide slash from New York to San Francisco. Today the swath would be far wider.

Hanson's photographs suggest that nothing short of a miracle could restore the former ranchland at Colstrip to its original grazing capacity. The churned-up earth, hideous pits, opaque and contaminated ponds suggest an inhospitable world of little vegetation and no wildlife. Although restoration of mined land is theoretically possible, it is considered exceptionally difficult in arid areas. Furthermore, the Surface Mining Act of 1977, which made failure to restore the land to its "approximate original contour" a crime, has rarely been enforced under the Reagan adminis-

tration. The photographs suggest that Colstrip could be classified officially as a "national sacrifice area."

Environmentalists contend that at most American mining sites, including Colstrip, companies limit reclamation to areas within sight of the roadways, areas that will have maximum public-relations impact. In many cases, coal companies avoid reclamation altogether by claiming that the stripped land is part of the industrial site and therefore not subject to regulations. Another means of turning the financial drain of reclamation into positive cash flow is to build workers' housing on gouged land that has been flattened with bulldozers. This solution can result in the startling contrast of rows of brightly painted, newly built tract homes adjoining wasteland and belching smokestacks (plate 42).

If the lands could be fully reclaimed, strip mining might represent merely an interruption in traditional usage for farming, grazing, wildlife management, forestry, or recreation. But as a lawyer representing the coal companies has said, "We know the land can be restored. We just don't know how to do it yet." In any case, environmental problems associated with mining, particularly water pollution, do not cease when the operation shuts down; problems of contamination may be undetectable for decades and irreversible. In 1975, *Scientific American* magazine reported that "the ground water at Colstrip, Montana, is only now being found to have been contaminated by mining operations of 50 years ago."

For Hanson, Colstrip stands for the "cruelest part of the American genius." The photographer writes, "What we are practicing, finally, is masochism (schism), the fragmentation of our original wholeness. Certainly the contemporary

Colstrip landscape stands in diametrical opposition to the attitude of the American Indians who lived on this very land and who felt so attached to and united with Mother Nature that they could not bring themselves to farm for fear of *cutting into* the Mother."

In mythical terms the issue at Colstrip is masculine–feminine, a dialectic manifest in Colstrip's archetypal forms of smokestacks and crevices. Here the sexual metaphor of the farmer gently plowing furrows is replaced by that of the industrialist's brutal drilling; the earth is a victim, not a participant, and violent domination has usurped love and creation. Competition, too, is involved, for industries like coal mining, asbestos mining, and nuclear power destroy and depreciate one person's business for another's speculation and profit. In sum, Colstrip epitomizes the evils that occur when patriarchal power and aggression supersede matriarchal fertility and continuation. Mind and matter, mind and body, and mind and feeling have been split. Like the military officer who deemed it necessary to destroy a Vietnamese village in order to save it, the absentee energy corporations seem intent on razing these areas to make them prosper.

Hanson's focus on Colstrip's pits and infected ponds connotes the surfacing of the subterranean, the hellish, and the repressed. Here the photographer's debt to Frederick Sommer and other makers of "visionary landscapes" that embody symbols of the unconscious is clear. As many psychologists have noted, dominators are ineluctably linked to the dominated. They face the never-ending task of keeping their oppressed subdued with controls, silencing mechanisms, and extinguishers of motivation. Dominators are

never free from uneasy awareness of the dark, murmuring masses they control.

Hanson's photographs seem to corroborate doom. Some of the most powerful were taken in the winter, season of death and discontent. But in any season, they are unremittingly bleak, constructed primarily of whites, grays, and blacks, flaring only occasionally with putrid or garish high-tech colors. Contrasts are blunted and compositions nonhierarchical so that nothing receives special emphasis and everything appears equally miasmic. Spatial ambiguities further skew these images of a world in which colorful, contaminated ponds are visual and metaphorical counterparts to man-made rooftops and machines (plates 42 and 49). Scale, too, is a key issue; huge machines are tiny by contrast with the monumental destruction they effect. A child's swing set (its form resembling rigs seen in the background) ironically represents the pastoral ideal under technological encroachment (plate 43). However small a part such details play in some of Hanson's formal schemes, their significance looms large.

Death is suggested by wan colors, ghostly presences, and veiled scenes. The photographs are eerie, unsettling elegies for a lost landscape. As Walter Benjamin wrote of Eugène Atget's photographs, they have the stillness of a place after the scene of a crime. Perhaps when Hanson rendered Colstrip's eyesores almost evanescent by photographing them in snow or polluted mist (plates 44 and 47) he expressed a subconscious hope that the ugliness would fade. But in one such scene, the eternal, mystic pyramid becomes an opaque black cone of death (plate 48).

Ultimately, the chill of Hanson's pictures is part of their

riveting fascination. Their formal aplomb recalls the idea of Jean Genet, the French playwright and former criminal, that evil and ugliness, when intensely heightened, become beautiful. Hanson says that by finding formal order in this "garden of ashes," he has "attempted to reaffirm my own need for beauty and order, to celebrate my love for the land, and to reengage the world, the feminine, and the natural." The Greek word for truth, *aletheia,* means "that which is not forgotten." Hanson's formal and metaphorical power assures our memory.

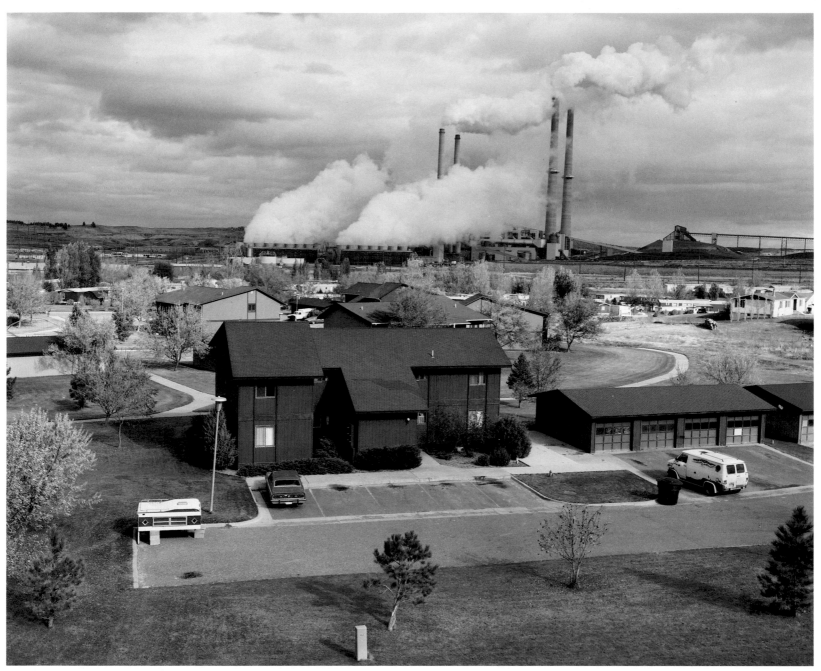

42 Cherry Street, Company Houses, and Power Plant, October 1984

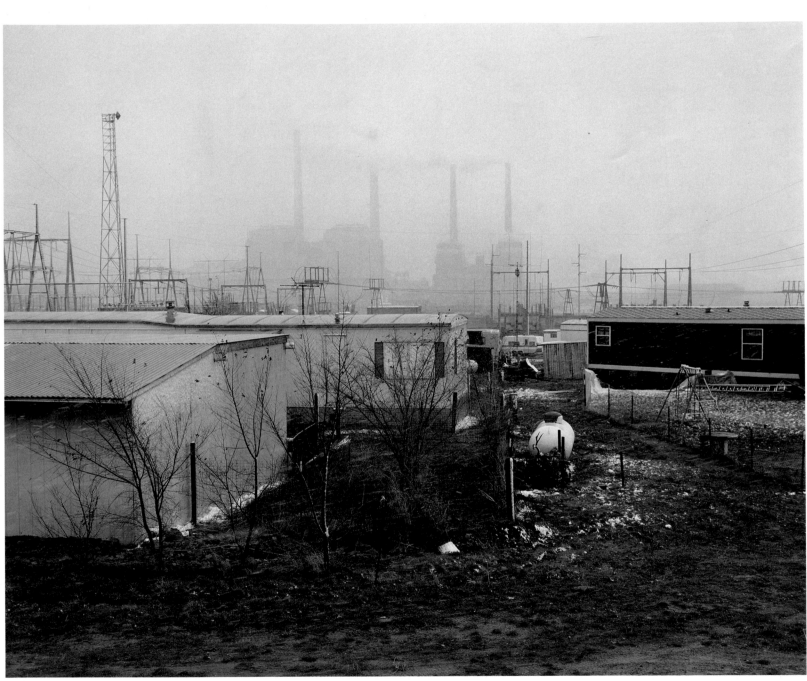

43 Burtco R.V. Court and Power Plant, April 1984

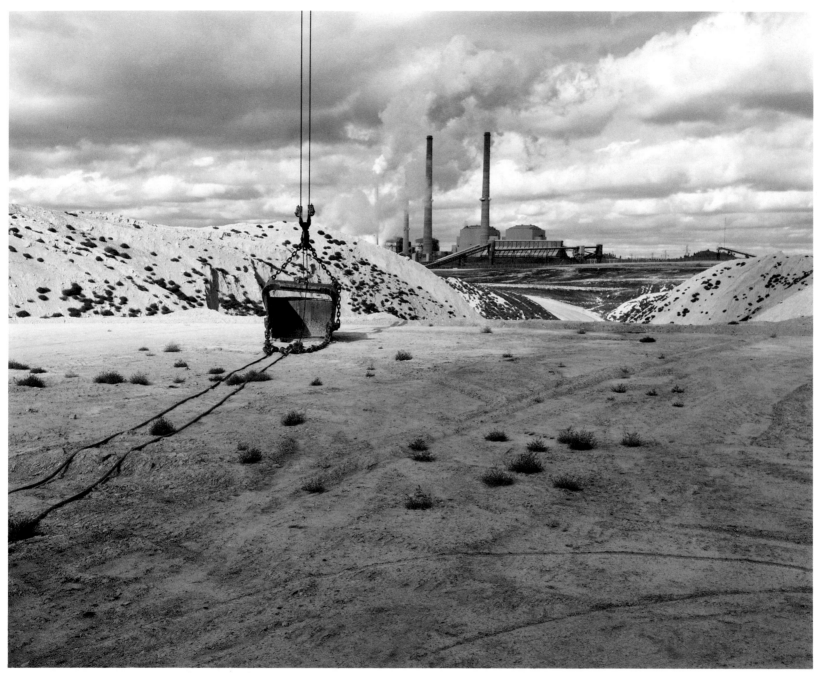

44 Dragline, Mine Spoil Piles, and Power Plant, October 1984

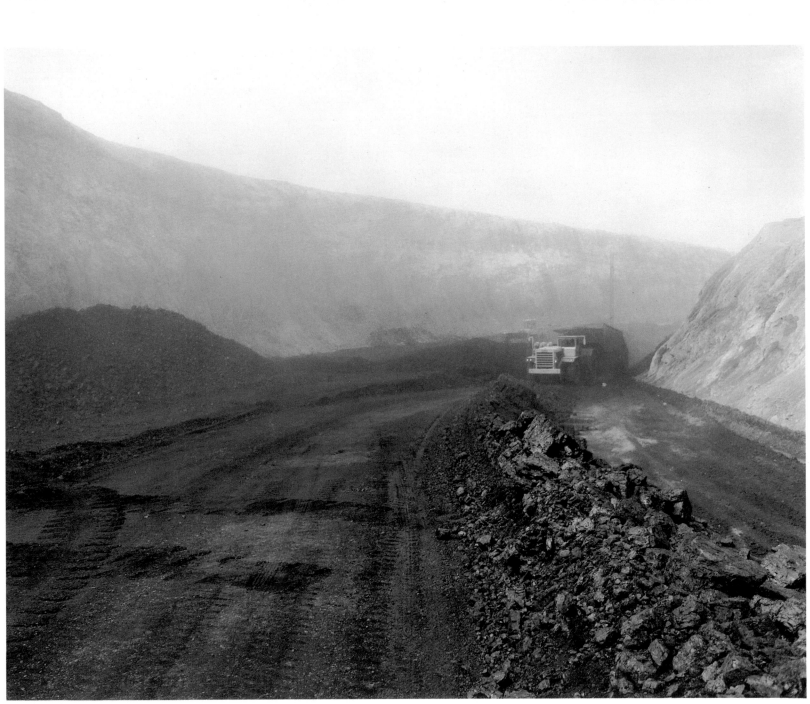

45 After a Coal Blast, in the Pit, July 1982

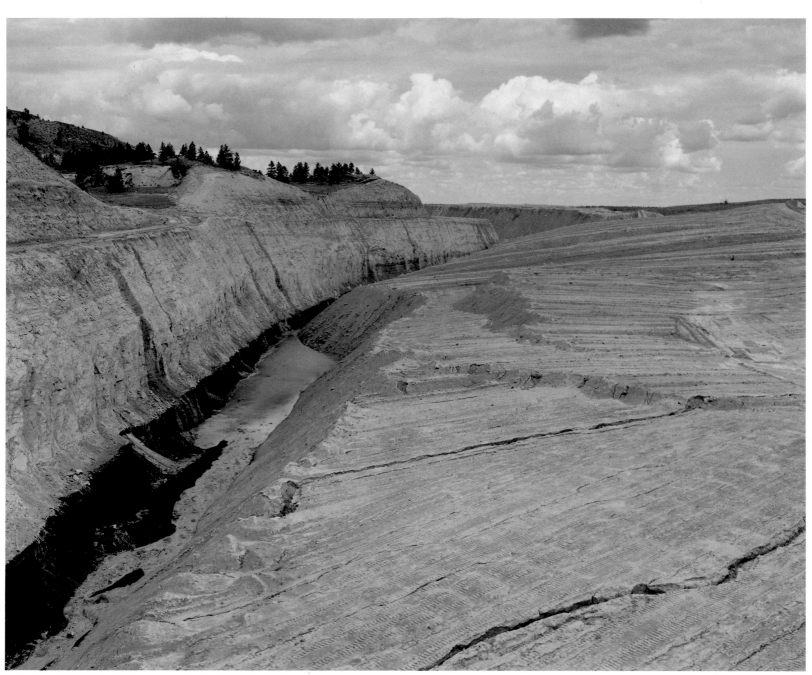

46 Abandoned Strip Mine and Unreclaimed Mine Land, June 1982

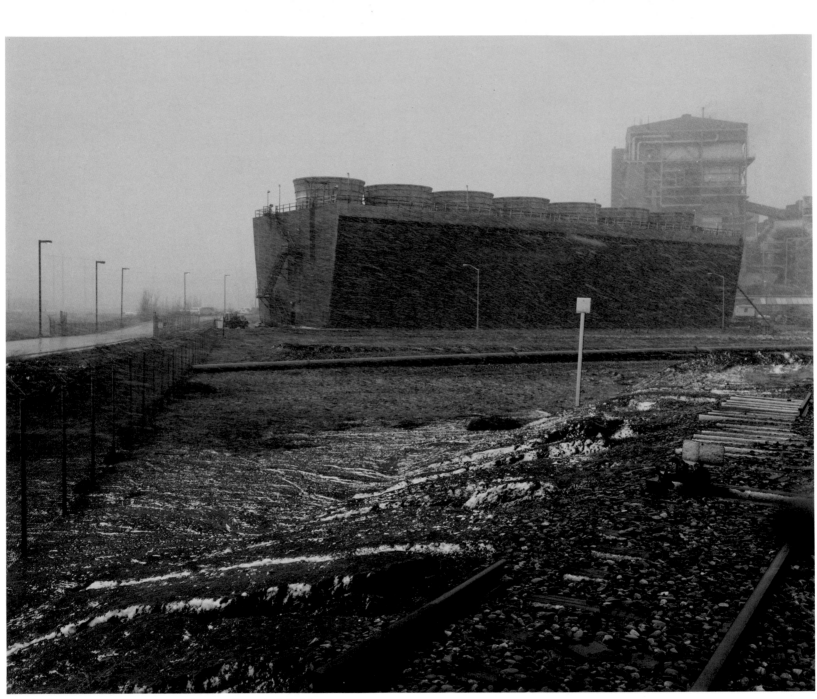

47 Cooling Towers, Power Plant, and Railroad Spur, April 1984

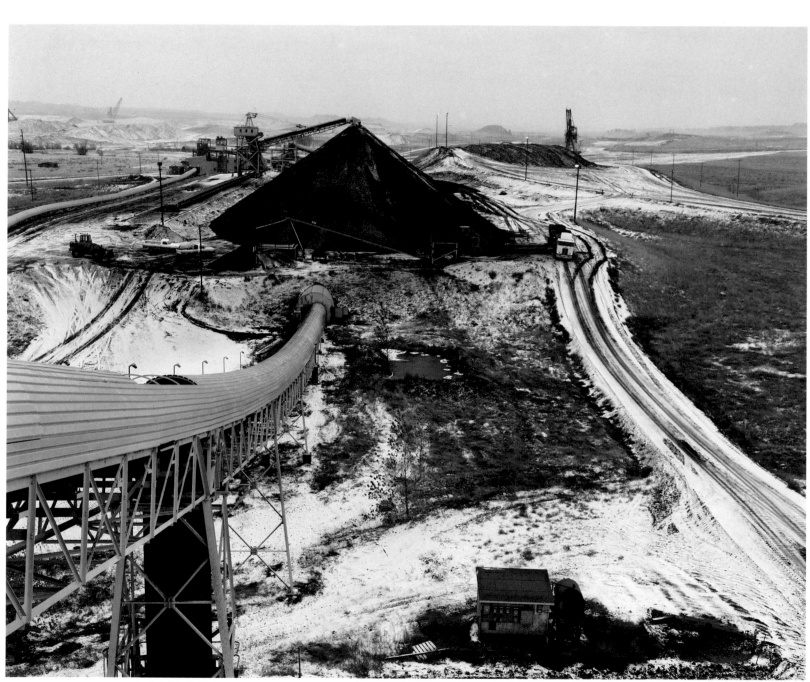

48 Coal Storage Area and Railroad Tipple, October 1984

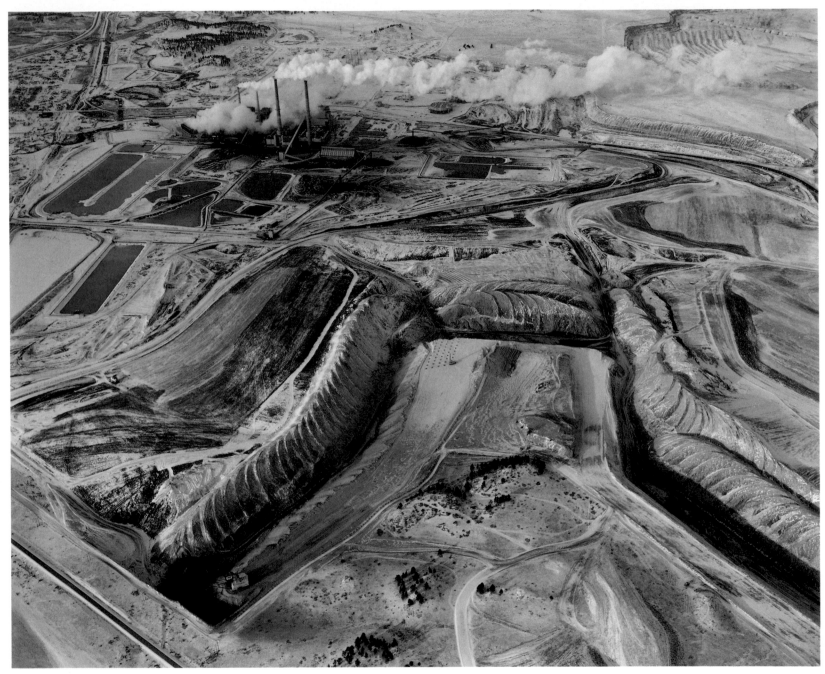

49 Coal Strip Mine, Power Plant, and Waste Ponds, January 1984

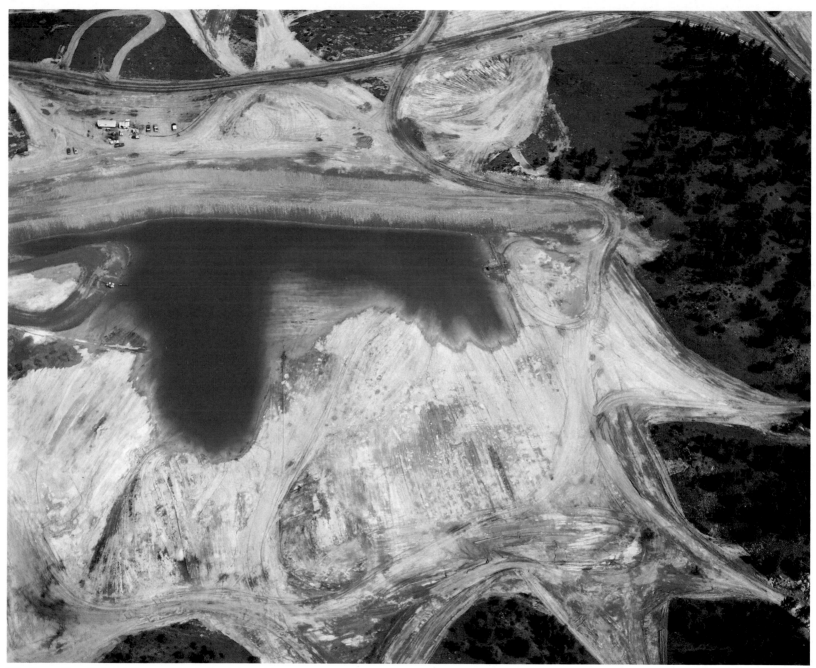

50 Excavation, Deforestation, and Waste Pond, June 1984

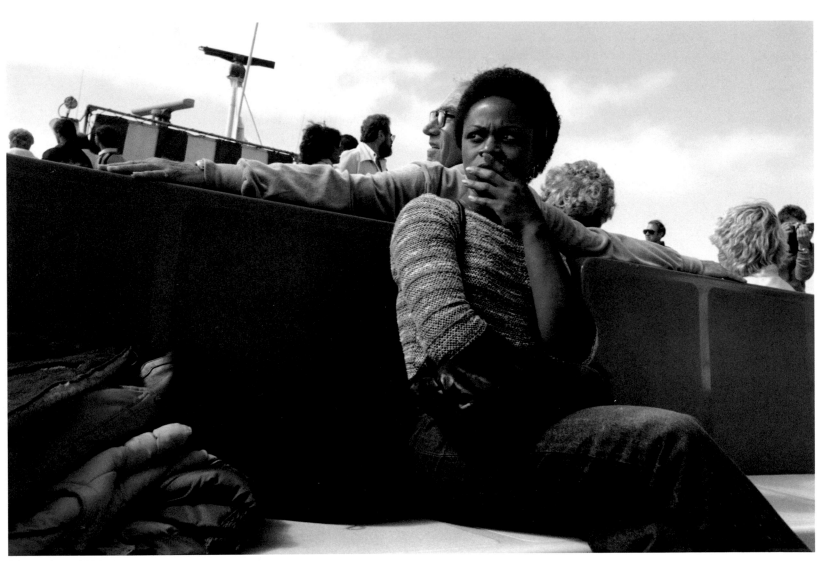

51　Untitled, 1983–84

JOHN HARDING

Perfect Strangers

John Harding strives for photographically perfect chance encounters with perfect strangers. His punning title expresses the street photographer's goal—to transcend photojournalistic documentation by exercising imagination and imposing form.

Harding gravitates to county fairs and to busy sites in San Francisco and other cities where lively street life affords many opportunities to record coincidences that, normally, barely impinge on our everyday consciousness. He adroitly exploits the camera's ability to freeze gestures between one deliberate action and the next, eliciting new meaning much as a writer would from out-of-context quotes.

Garry Winogrand was motivated "to see what something looks like when photographed," and this desire is echoed in Harding's work. The statement reflects a dual ambition: to combine photographically created content with peculiarly photographic form. Although grounded in visual reality, such objectives derive poetic fancy from prosaic fact.

Harding's photographs operate on many levels. Their kaleidoscopically shifting shapes and colors reveal much about the jostle of humanity as well as trends in fashion and social and sexual mores. They indicate people's preference not for solitude but for congregation. As Jane Jacobs has noted, lively streets always have both their users and their watchers, and the more crowded, animated, and hectic a street is the better. John Harding clearly concurs.

Viewers with a more symbolic bent might see in Harding's urban delirium a bacchanalia in which wild men with strong libidos and women with loosened tresses seem almost demoniacally possessed (plate 52). Fur coats project an air of animal-like sexuality (plates 56, 57, and 58). Fire and lust, metaphorically suggested by recurrent golds, reds, and oranges, are countered by evocations of Christ in crucifixion forms (plates 51 and 55) or by a policeman, whose presence implies transgression (plate 52).

At his best, Harding pushes realism into the realm of

surrealism, recording the bustle of the American city in images whose splashy forms and unexpected juxtapositions suggest the imaginative exuberance of surrealist theater.

In noting the surrealist nature of photography, André Bazin described photographs as hallucinations that are also facts. Frozen motion, focused peripheral vision, figure-ground reversals, double and divided experiences, disconnected images, and encapsulated irrational episodes characterize Harding's connection with this notion. As a street photographer, of course, he depends upon his intuitive sense of place and moment for creating the photographic "found object."

By photographing frames within frames, Harding lends importance to characters and events isolated within individual enclosures. This staging heightens the sense of street theater and offers layered metaphors for seeing. His lens includes people who watch the same people he watches, and whom we, in turn, are shown.

Reflective glass functions as a monitor, as an attentive, mysterious, creative force. In plate 55, a head and a building with windows merge into a watchful automaton. In plate 51, the extreme flattening of space and the back-to-back people imply a mirror where none actually exists. Paying homage to Lee Friedlander, Harding includes his own reflection in an image that literally points out his role as an observer (plate 57).

Harding's play with reflections inevitably reminds us that virtually all photographs function as windows on the world, but he rarely offers an uninterrupted view. Indeed, Harding often seems intent on fusing and confusing experiences by recording them as ghostly layers and traces, using reflections and "stop-time" techniques to capture blurred motion and eerie, haloed effects of light.

Harding's complex interplays of space and surface confound perception. With an overload of rippling facts and patterns, helterskelter highlighting, and hedonistic jostlings of color, Harding achieves the kind of pictorial vibrancy that is produced by animated brushwork and rich color in Abstract Expressionist painting. Like the painter Gregory Gillespie, who has used the term "Rorschaching" to describe the abstract passages in his largely representational paintings, Harding exploits abstract passages as triggering devices to prod meaning from broken, disjunctive narrative.

Like most surrealists, Harding enjoys paradox. By photographing reflective surfaces, he conjures depth from flatness. By dissolving boundaries, he makes ambiguous such concepts as distance, space, and identity. The blurring of distinctions in its extreme manifestation is Dionysian, a madness and ecstasy classically associated with drink. Harding, however, only flirts with this extreme as he merges discrete events and personalities. Indeed, his "still" photographs fix and preserve chaotic and elusive experiences, making them finite and tangible in a form that offers the illusion of control. These frozen movements and tableau-like vignettes counter insubstantiality, inexpressibility, and the flux of experience by declaring quite the opposite: solidity, permanence, and the possibility of definition. They express Harding's fervent need to order and communicate his myriad perceptions of perfect strangers.

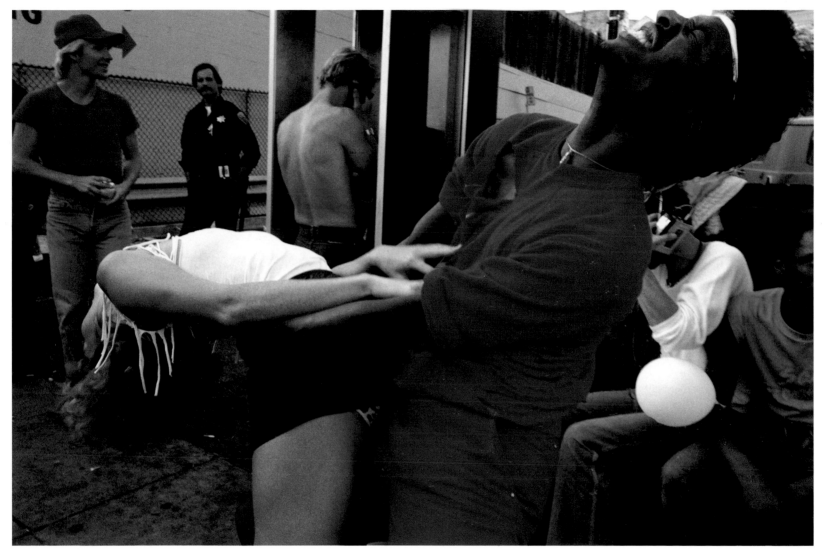

52 Untitled, 1983–84

53 Untitled, 1983–84

54 Untitled, 1983–84

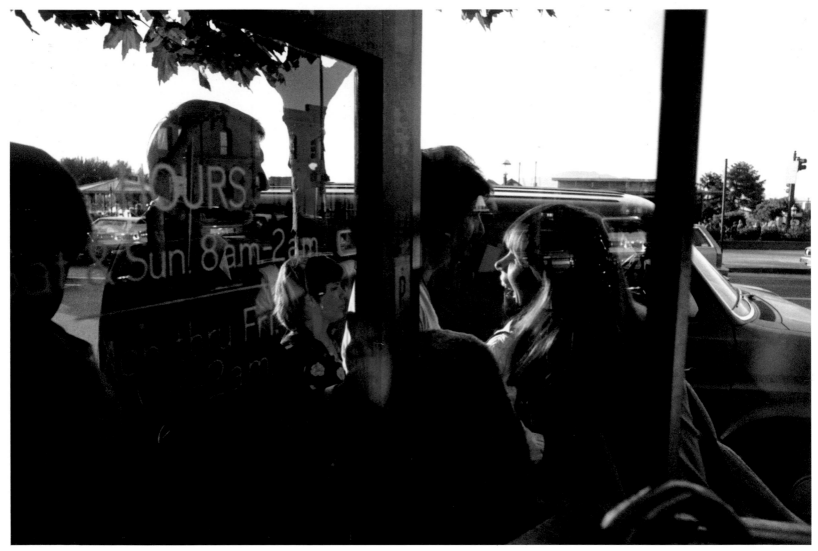

55 Untitled, 1983–84

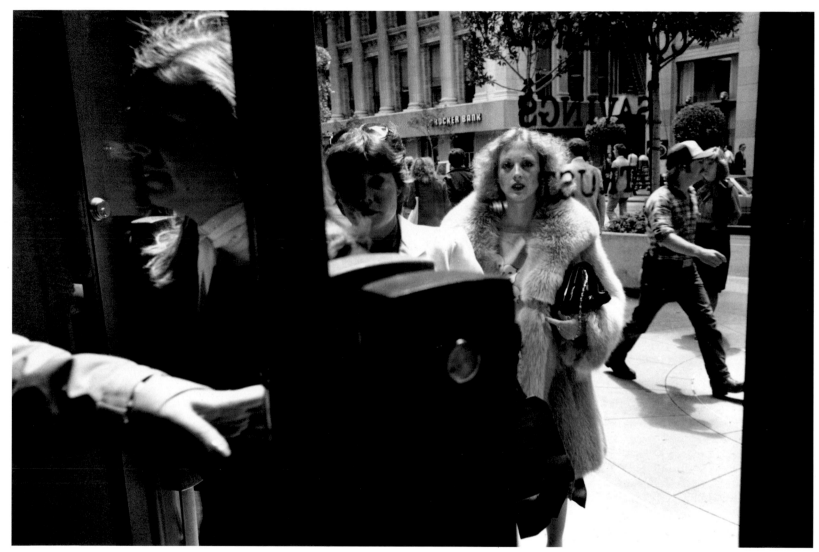

56 Untitled, 1983–84

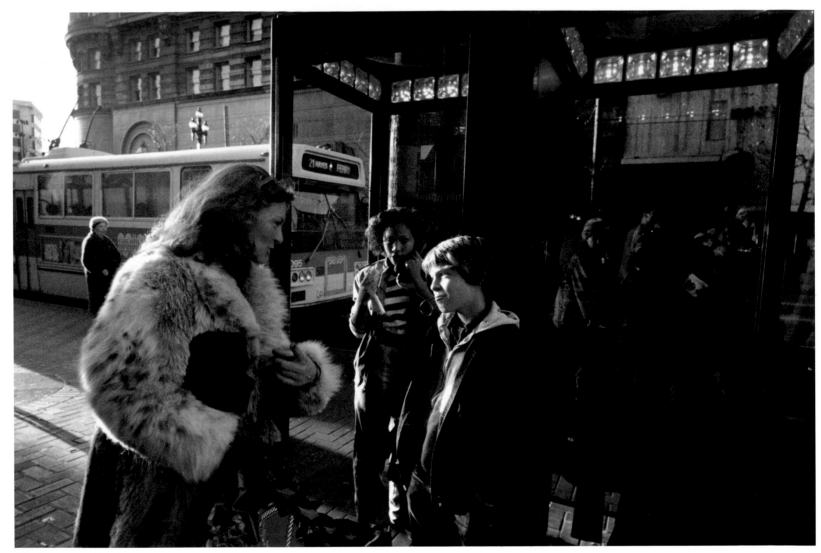

57 Untitled, 1983–84

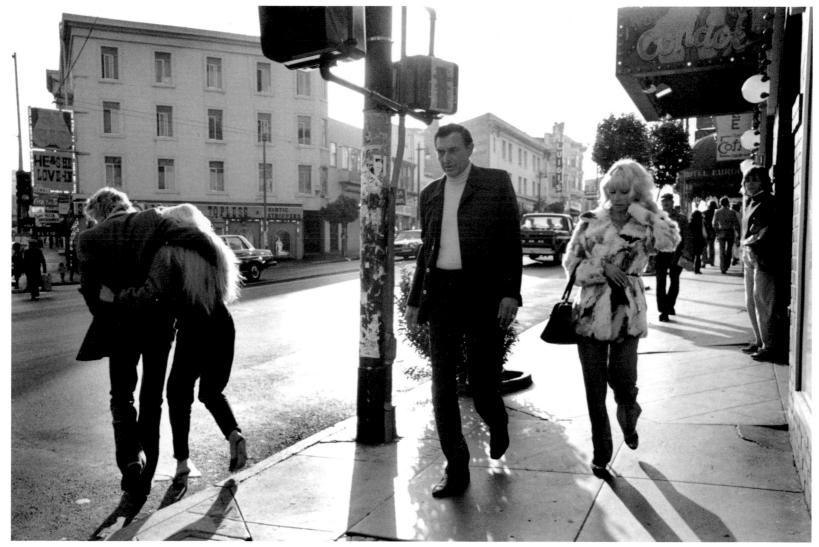

58　Untitled, 1983–84

LEN JENSHEL

Industrial Tourism

In 1968 Edward Abbey coined the term "industrial tourism" to describe the exploitation of our national parks by American consumers. Abbey would like to see nature treated with the same deference accorded cathedrals, concert halls, and art museums and would close the parks to the automobiles and other comforts of the industrial age that American vacationers demand. His goal is to maintain the wildness of the wilderness, its freedom, danger, integrity, and exclusivity.

While their title borrows Abbey's phrase, Jenshel's photographs, dating from 1978 to 1985, differ in tenor. Shunning two-fisted polemics, Jenshel approaches the subject with gentle wit, irony, and a wry acceptance of his own contribution to the problem.

Asphalt roads, service stations, and other modern encroachments in Jenshel's photographs evince industrial tourism. Protective fences, telescopes, and binoculars keep the public at a safe distance. Wildlife and wild places have been tamed. A Polaroid photograph and a picturesque mural (plates 63 and 67) recall Abbey's fear that our parks will eventually be paved over to build visitors' centers where nature can be conveniently and comfortably experienced secondhand through photographs, dioramas, and other mock-ups.

But the power of nature is also represented in this series. At the seashore, a protective wall encases a maplike ruin (plate 68). The barrier and grid imposed by man have fallen prey to the ocean, symbol of eternity, destruction, creation, mystery, and life. Other age-old symbols are broken twigs and barren trees as death, and light as spiritual radiance. In a Utah winter scene, a denuded tree seems to reach toward an evergreen as if anthropomorphically reenacting the medieval "Death and the Maiden" scene (plate 61).

Jenshel's view can also be tongue-in-cheek. On a wood-paneled service station, a landscape mural depicts a sus-

pension bridge, but the light bulb is turned off, the word "service" cropped, and the door closed (plate 67). In a real landscape, the arms of two tourists connect with lines formed by a road below, while the position and posture of a nearby bird suggest its role as a pet—or as yet another tourist (plate 63). And on the porch of a mountain cabin, a photographer shoots the scenery while a surfboard, a Christmas tree, and a ski area beyond represent the domestication of nature for recreation and ritual. Cloud cover forms a "roof" over the mountains, as if the clouds themselves were joining with modern industrial forces to encase the last vestiges of the wilderness (plate 62).

Throughout this series, references to sightseeing prevail. The woman on the observation deck of the World Trade Center becomes the emblematic tourist, standing in as surrogate for the viewer (plate 59). A visual pun may also be intended, for though she blocks the panorama, her head is as glorious in its luminous, coiled, and striated monumentality as the weathered sandstone of the butte in plate 69. Another woman appears to be chained and caged as she sights with her telescope, her viewpoint both fettered and artificially enhanced (plate 64).

Although many of the pictures convey symbolic meaning, Jenshel is, at heart, a visualist, seduced by the pleasures of seeing. Photographing at dusk, when the strident contrasts of midday light dissolve into soft, subtly nuanced hues, he can savor delicate, unexpected color shifts and the gradual unfolding of forms. He relishes rich surfaces, quivering light, and details that evoke synesthesia, suggesting the soft touch of a breeze, the twitter of birds, or other sensations. He sometimes plays with the spatial characteristics of color, as in plate 60, where a bright piece of blue sky protrudes from a golden rock.

Jenshel's intuitive picture making is a holistic art that defies the dissection of reality by abstract intelligence. Considering the evidence of industrial grit in his work, it would seem that Jenshel is not opposed to the industrial world per se but rather to the machine mentality, which lacks respect for natural rhythms and living organisms. As a photographer—and as an industrial tourist, despite himself—Jenshel tames and enjoys mysteries that he cannot fully understand. His photographs take the sting out of the modern world, providing oases of serenity for our assaulted, overstimulated senses.

But for his photographs to be meaningful and true, Jenshel knows he must find such beauty where it is not rare and isolated and where it emerges from surrounding dissonance and incongruity. Overweight tourists, vacation condominiums, phone booths, and cars offer rich formal possibilities, but they also provide a means to bridge the gap between America's nineteenth-century pastoral fantasy and the modern industrial age.

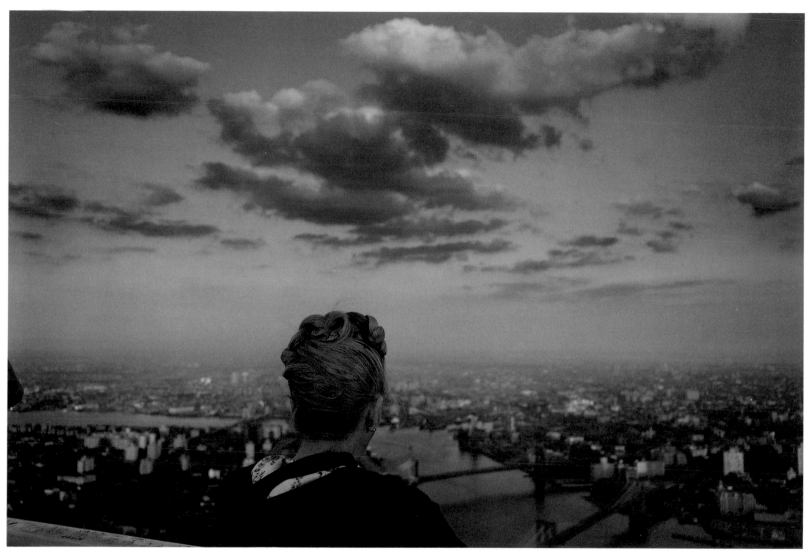

59 World Trade Center, New York City, 1979

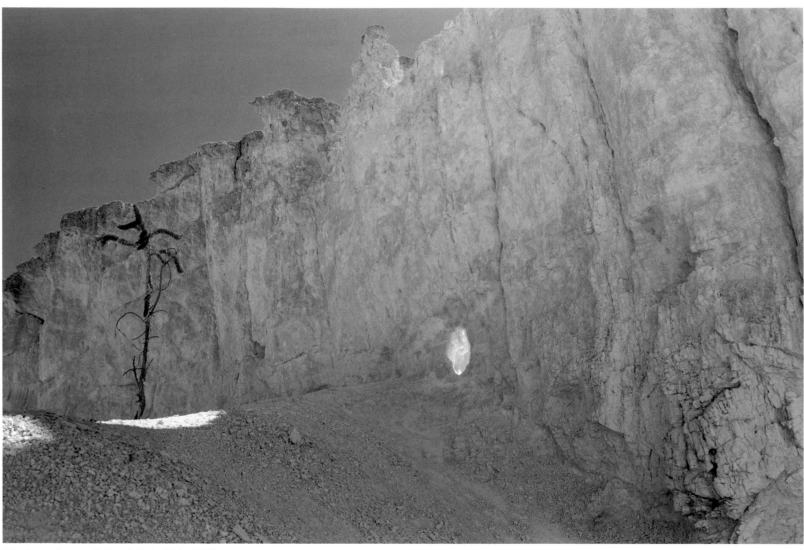

60 Bryce Canyon National Park, Utah, 1980

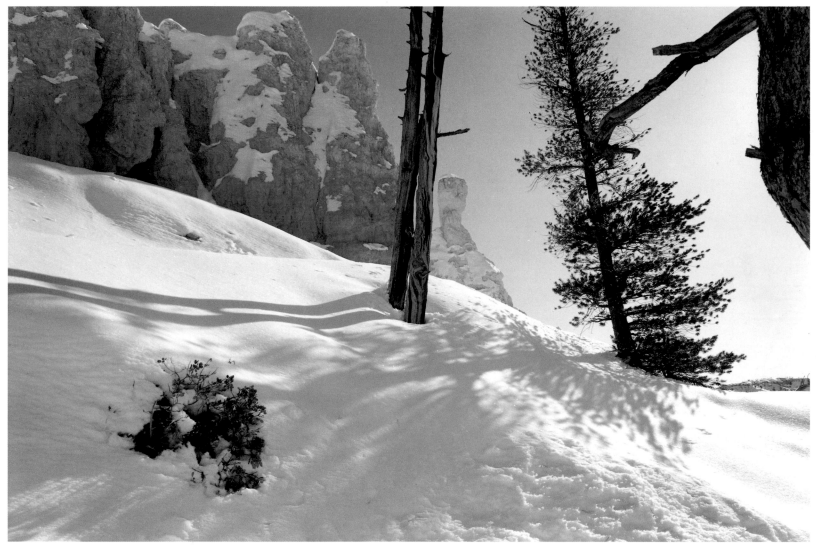

61 Bryce Canyon National Park, Utah, 1985

62 Winter Park, Colorado, 1985

63 Rocky Mountain National Park, Colorado, 1980

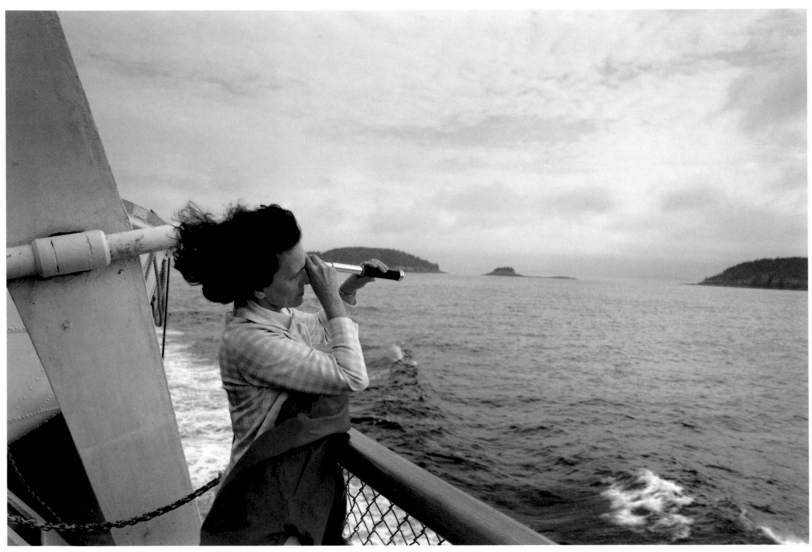

64 Bluenose Ferry from Bar Harbor, Maine, to Yarmouth, Nova Scotia, 1981

65 Nantucket, Massachusetts, 1984

66 Arches National Park, Utah, 1985

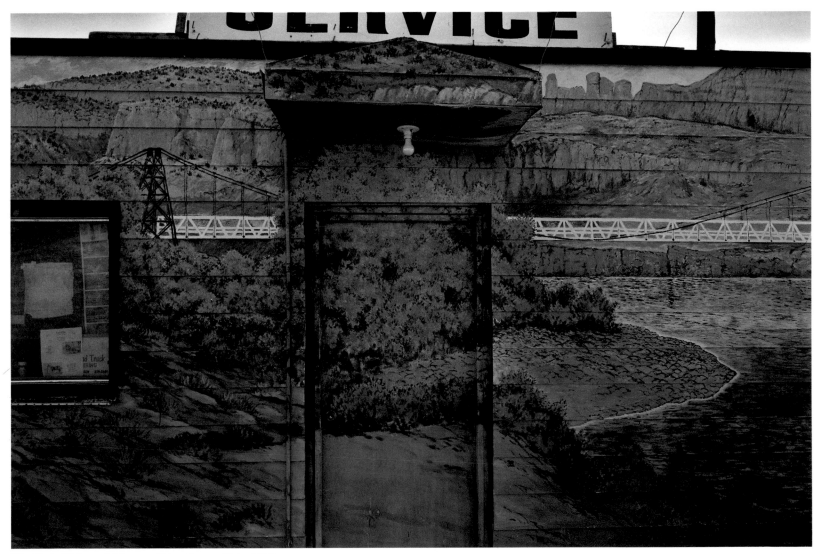

67 State Highway 128, near Fisher Tower, Utah, 1985

68　Golden Gate Park, San Francisco, 1978

69 Arches National Park, Utah, 1985

70 Easton, Autumn 1983

NANCY LLOYD

Keeping Place

Nancy Lloyd photographs domesticated nature at its most lambent and evanescent. She is awed by moments when trees, fences, stones, and grass seem charged with mystic energy. Gesturing wildly or glowing with a pearly sheen, nature is caught in a state of magical flux.

Lloyd's desire to preserve such visual epiphanies led to her "keeping of places" through photography. "Landmarks" was the title of one of her earlier photographic portfolios, and the word continues to have meaning in "Keeping Place." Bewitched by the ways that light and atmosphere momentarily change the physical and emotional timbres of places, she records "personal landmarks" that would otherwise disappear into memory. Although Lloyd only rarely photographs historical or architectural signposts, she often includes such markings on the land as fences, roads, and other boundaries. Finally, these photographs were taken in the area of Easton, Pennsylvania, near sites that Walker Evans made photographic landmarks in 1935. Lloyd has lived in Easton since 1983.

Wendell Berry's *A Place On Earth*, a long, slow, and memorable novel that asserts the value of living close to nature and finding one's own place on earth, inspired Lloyd. In the book, personal identity and meaning are denied to those who forsake a sacred relationship with the land for an artificial, secular relationship with society. Perceiving the arrogance and futility of the grasping and manipulative behavior that so many people employ to assert control over their world, Berry advocates recognizing the preciousness and transience of each moment, of giving one's self up to the world's flow. This seeming passivity paradoxically leads to personal power and responsibility, as well as to freedom, wisdom, and a noble consciousness of one's place on earth.

Landscape photography deepens Lloyd's sense of the sanctity and mystery of the human predicament and increases her tolerance for what might otherwise seem anarchic and threatening. Photographing the ever-changing, ever-renewing face of the world, she preserves visions of its revelation and creates her own place on earth.

103

In Easton and Bethlehem, Pennsylvania, Lloyd photographed the yards of small-town Americans, whose lives generally revolve around family and tradition. It is a world of boundaries, stabilized by well-established rules that promote alikeness, togetherness, and agreement. In this setting, Lloyd responds most vividly to moments when nature seems to gently challenge civilization for control. Where time and weather, growth and decay conspire to return the domesticated landscape to the wild, Lloyd finds nature advancing with strangely human gestures. Branches fan out expansively, encompass protectively, beckon us to enter, warn us away, and swing in circular motions to mark special clearings. Wind and light contribute to the aura of animistic flux.

In her compositions, Lloyd arranges visual enclosures, contrasting envelopes of stillness with oscillating forms and crackling conjunctions of complementary colors. Light-struck clearings project against dark areas to confound perspective, background sometimes piling onto foreground. Euphoriant colors and undulating vegetation express abundance and energy; in more somber works, luminous tones emerge resonantly from shadows. These perceptual confusions and shimmering color interactions cause nature's forms to emerge, retreat, and dissolve in an almost mystical fashion. In plate 72, an orange glow crowns a stone stairway that is guarded by clawing branches.

Before moving to Easton, Lloyd photographed Niagara Falls and many of the sites in the Hudson Valley that were favored by nineteenth-century American painters. While sharing their respect for light, detail, and atmospheric effects, she incorporates man-made elements that those painters would have considered uncouth or discordant. Also, Lloyd's structural use of color causes forms to vibrate between fact and sheer abstraction and signals her conversance with modern painting and photography.

Unlike traditional nature painters and photographers, who exclude subjects that are not inherently beautiful, Lloyd believes true affection for life necessitates embracing the world as it is. She cites the novelist and poet Lawrence Durrell, who said that the "troubles American artists talk about are not due to industrialization or technocracy but something rather simpler—people not attending to what the land is saying, not conforming to the hidden magnetic fields which landscape is trying to communicate to the personality."

71 Easton, Autumn 1983

72 Easton, Autumn 1984

73 Bethlehem, Spring 1985

74 Bethlehem, Spring 1985

75 Bethlehem, Spring 1985

76 Easton, Autumn 1983

77 Easton, Spring 1985

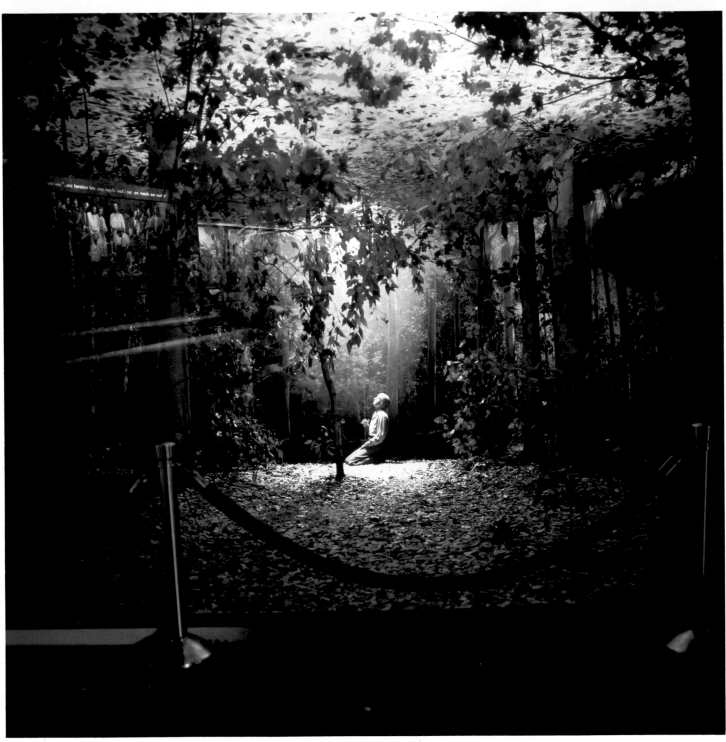

78 A Vision, 1981

KENNETH McGOWAN

The God Pictures

"Give me any couple of pages of the Bible and I'll give you a picture," boasted director Cecil B. De Mille, the master purveyor of campy sin-and-retribution cinema. Similarly, American evangelists from Billy Sunday to Billy Graham have turned religion as spectacle into long-running road shows. Throughout the country both the well-intentioned and the crassly commercial manufacture images of gods and secular saints based on sweet illusions, fulsome flattery, and vulgar sham.

McGowan's "The God Pictures" proposes that anything God can do, Hollywood can do better. A wax museum's Crucifixion shows Christ and the two thieves as they appeared in *Ben Hur* (plate 84). The Mormon Visitors' Center in Salt Lake City, Utah, illuminates young Joseph Smith's vision with shafts of sunlight and a Technicolor hologram of Christ and the disciples (plate 78).

The world of advertising also traffics in miraculous conversions. The Man from Glad, the White Knight, the White Tornado, Brawny, and other assorted deities possess the power to save damsels in distress from noxious odors, spotted crystal, and other real-life crises. Celebrities endorse products, bestowing their divinity on the masses via consumable goods. McGowan shows a crude plaster copy of Michelangelo's *David* in a room with Comet cleanser and Ivory detergent (plate 81), implying that a handsome hero crafty, bright, and brutal enough to slay Goliath would be just the man to hawk products today.

The democratic, multimillion-dollar kitsch industry makes gods of every pantheon available in icon form. A window display pays obeisance to Hollywood stars and sex goddesses as well as the Rev. Martin Luther King, Jr. (plate 82), a hallowed figure (with John F. and Robert Kennedy) in a triumvirate of American martyrs. In the 1940s a factory commissioned an arcadian relief for its exterior, an irony compounded by the later application of unparadisiacal, oleaginous paint (plate 83).

Paying homage to the twin gods of youth and beauty, McGowan notes a man's glittery metamorphosis into a "Silver Being" (plate 79). Bizarrely divine, he is all facade and illusion, a reincarnated *fin-de-siècle* worshiper of satanism, dandyism, eroticism, exoticism—everything the bourgeois American might regard as decadent. A totemic baby head, its nose and mouth chipped, projects both force and vulnerability (plate 80), and a movie theater biting the blacktop is an apocalyptic vision of destruction (plate 85).

These deceptively simple pictures suggest the ordinary but achieve rich comic and dramatic effects by isolating and monumentalizing objects. Colors are mildly dissonant, their brooding harmonies initially attractive but ultimately unsettling. The pictures are alien and a bit ridiculous, as though black humor were the only appropriate response to our absurd make-believe world.

Above all, McGowan's photographs are steeped in pathos. Rather than brittle sarcasm, McGowan projects great sadness at finding such inadequate gods. The cut-rate version of Michelangelo's *David* reduces the sculptor's *terribilitá* to adolescent petulance (plate 81). The power of the six-foot monolithic baby head is undercut by its farina-like interior (plate 80). Worst of all, divine machinery is often exposed; the wires and spotlights of the lurid wax museum Crucifixion are the blatant props of a trumped-up spirituality (plate 84). Nothing is permanent, everything is something else, and the mock falls pathetically short of the real.

Preoccupied with voyeurism, McGowan presents images of images, revelations of the hoaxes routinely perpetrated on the unwary. Nowhere is this more apparent than in *A Vision* (plate 78), in which a retainer rail isolates the reverie of Joseph Smith, who himself sees a picture within his picture. Even this Mormon saint on earth is shown transported by a photographic pseudopresence.

Ironically, McGowan's attempts to redeem surrogate reality put it at one more remove. By lifting events from their original contexts, altering scale, and otherwise refashioning significance, he comments on the ways that façade and illusion are purveyed. The heroes, prophets, and Jehovahs of America seem only a profusion of tawdry, manipulative images served up by moviemakers, advertisers, and other contemporary mythmakers to give ersatz philosophical meaning to ordinary life.

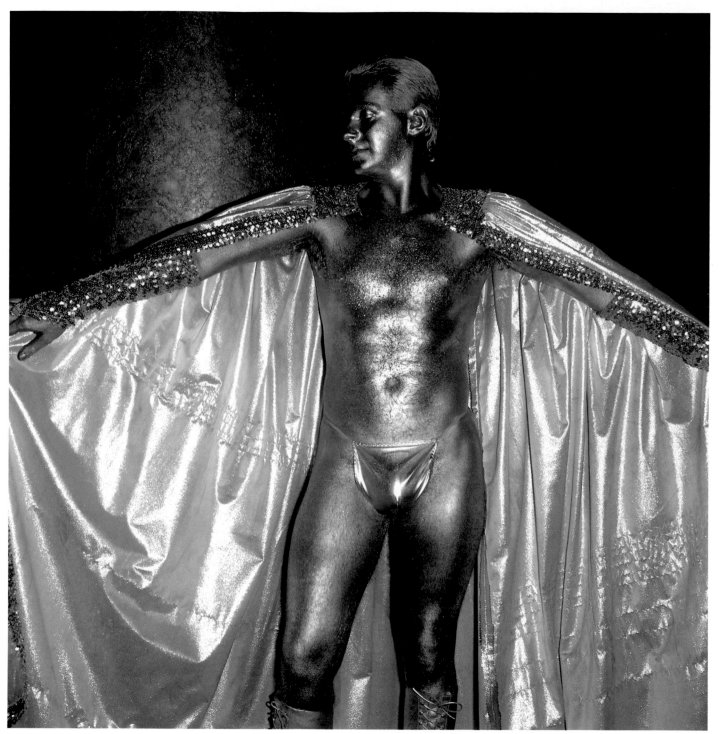

79 Silver Being, 1977

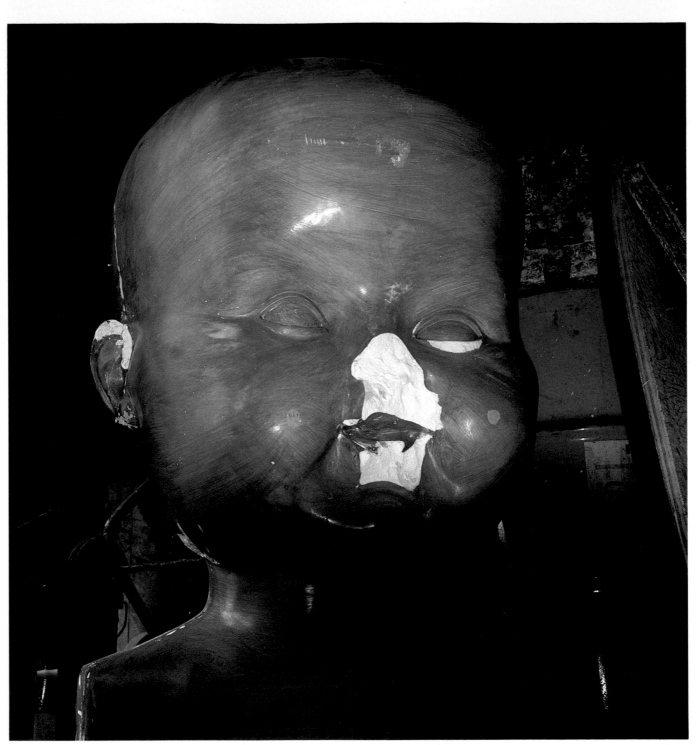

80 Huge Doll, 1979

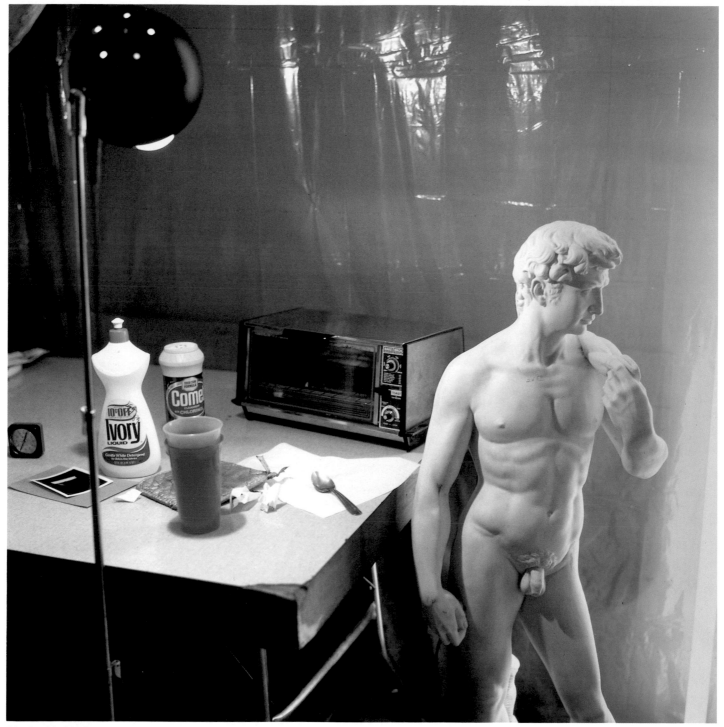

81 David, 1978

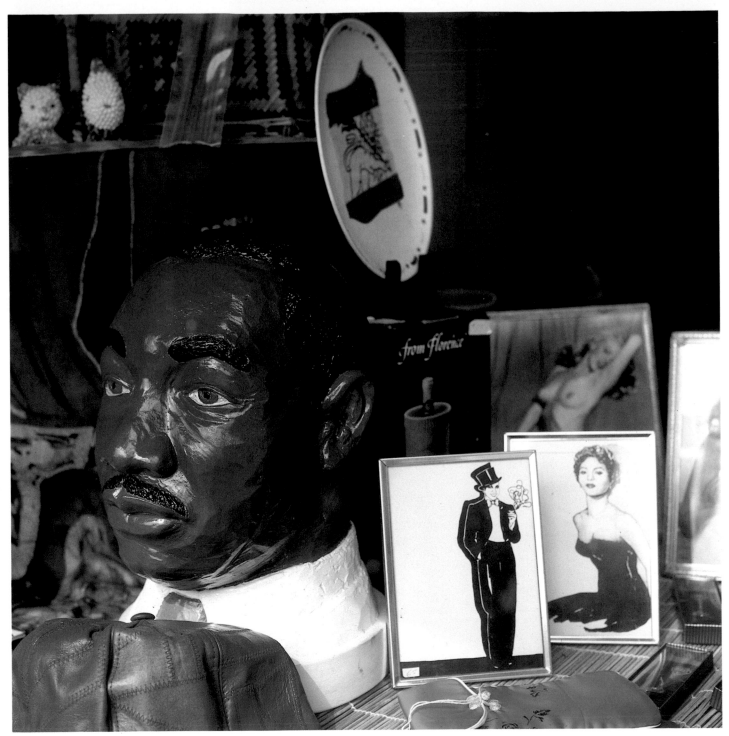

82 Martin Luther King, Jr., 1985

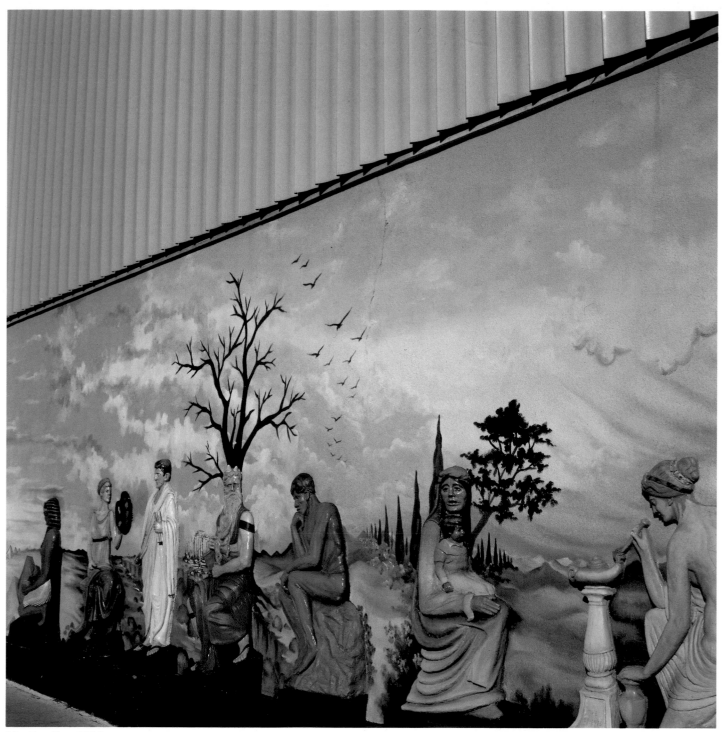

83 Paradise, 1983

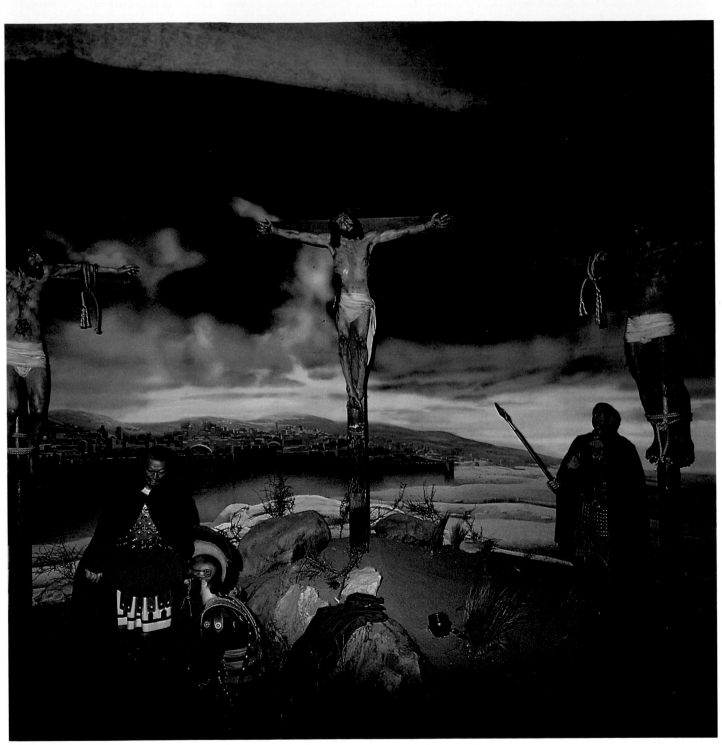

84 Crucifixion, 1984

85 Destruction, 1984

ROGER MERTIN

The Rochester Sesquicentennial

In 1984 Roger Mertin received a grant to document the transformation of the city of Rochester, New York, during its year-long sesquicentennial celebration.

Naturally, Mertin photographed the Great Canal Caper, the Tall Ships, Rediscover the River Day, and other big-ticket items of the $1.2 billion extravaganza. But he gravitated as well to schools, church halls, department-store windows, and other venues altered by celebratory decor. In his photographs, T-shirts, flower arrangements, postcards, cakes, and ornamental gardens all represent the myriad ways in which people and places were packaged to make history come alive.

Cardboard replicas of mills recall Rochester's past as the "Flour City" (plate 91), and T-shirts illustrated by local artist Robert Conge celebrate its current status as the "Flower City" (plate 89). The considerable twentieth-century role of Rochester's Eastman Kodak Company is reflected in the prevalence of "Kodak yellow" (plates 87 and 91) and in a special sesquicentennial panoramic photograph taken by Kodak photographer Norman Kerr (plate 90).

Mertin's still lifes of festive decorations and commercial tributes reveal his fascination with artifice and simulation. Painted façades float by on river barges (plate 86), model ships sail a classroom floor (plate 91), and people impersonate historical characters (plate 94). Postcards and the panoramic photograph also show the city once removed (plates 88 and 90). Everyone and everything are dressed to the hilt, on good behavior, and "picture perfect," as one sign says (plate 93), playing their part, however ersatz, in the effort to revive Rochester's waterfront and spur tourism.

Rarely does Mertin deliver the expected view. Rather than the Tall Ships on Lake Ontario, or the 110,000 people who came to see them, Mertin focused on a floor model in which the ships are proportionally so prodigious that they rival Rochester's mills and skyscrapers (plate 91). In

this way he preserved the glory of celebrational anticipation; inflated expectations caused many Rochesterians to suffer from what a newspaper writer dubbed "TSD (Tall Ships Disillusionment)." Models to the contrary, Rochester's Tall Ships were, in fact, short; only the shortest of the international fleet could slip under the power lines that cross the St. Lawrence River.

For the Great Canal Caper, barges from as far away as Lockport and Seneca Falls traveled down the New York State Barge Canal to join the celebration at Genesee Valley Park. The vessels were bedecked with symbols of local pride—models of a cobblestone house, a lighthouse, a trolley, and other historic displays. The Village of Pittsford's float—which boasted models of the landmark Federal-style architecture that was built when neighboring Rochester was still a squatters' town—gave Mertin the opportunity to apply photographic illusion to the trompe l'oeil miniatures (plate 86). The resulting visual non sequitur plays havoc with our perceptions and exemplifies the essential quandary in all the sesquicentennial events—these surrogate models were constructed to represent a history that (despite our historians' best efforts) is itself largely illusion.

During the festivities, many people dressed as characters from bygone days. "The Fox sisters," reflected on the slick surface of a marble monument to the Spiritualist Movement in America, appropriately appear as angelic ghosts; the image is also a pun on the sesquicentennial's motto, "Our Spirit Shows" (plate 94). A circle, above the inscription "There is no death/There are no dead," can be read as a halo, and the buildings behind, as institutional angel wings. Another reading might hold that the govern-

ment complex, with its punched computer-card look, represents a red-tape deadening of the spirit.

Amiably jaded wit marks other photographs as well. Fabrics printed with Jackson Pollock–style drips and dribbles are draped above the legs of store mannequins and reflect the city's confused exuberance (plate 93). The division of the word "cropped" comments not only on the unexpected amputations to be found in this and other photographs by Mertin, but also on the sesquicentennial's truncated, collapsed version of history. A black paper chain of human silhouettes lines a hallway bathed in a ghoulish green mixture of natural and artificial light (plate 95). Measuring tapes mark the growth of students during a year in which the entire city measured its progress (plate 87).

As a black-and-white photographer in the late 1960s, Mertin was one of the first to forge the "snapshot aesthetic," using "incorrect" exposures, "improper" flash lighting, unexpected croppings, shadows and reflections, and other typically amateur "mistakes" in the service of form and content. A major series of his recent color work is titled "The Blues" (see New Color/New Work), partly because of the blue glow he achieved by shooting daylit interiors with indoor film. Many outdoor scenes in "The Blues" are resplendent with "Kodak-blue" postcard skies.

Not surprisingly, Mertin frequently employs such effects in his sesquicentennial series. Blue, of course, is featured because blue and yellow were the punchy theme colors of the celebration. But Mertin intensified the blue in his patriotic red, white, and blue windowsill still life, again by using indoor film (plate 88). He burned out the rippling stripes of reflection above a row of flags to complement the gar-

lands of cake decoration and table bunting and to complete a grid pattern established by the horizontals of the table and its base and the vertical seams of the metallic wall (plate 92).

Color film's technological limitations become special effects in such jazzy commercial icons as Norman Kerr's panorama of Rochester's skyline at night (plate 90). With its sparkling lights and psychedelic magenta-and-navy skies, this work was highly popular throughout the sesquicentennial year and was chosen for the April 1984 "Colorama" in New York City's Grand Central Terminal. Mertin slyly crucifies the image by placing it on an altar; behind it a large wooden pole and distant fluorescent lights have been photographically fused. Or perhaps—as the hearts suggest—Mertin intended a tongue-in-cheek valentine to Kerr's vision of the city.

Mertin's snapshot techniques suit the sesquicentennial theme. His exaggerations of color recall the razzle-dazzle and booster language that mark such occasions. With their haphazard balance, cropped edges, and intruding shadows and reflections, Mertin's photographs uniquely depict a vague realm between fact and hope, between history, conjecture, and wishful illusion. It is a realm of extravagant rhetoric bred by hazy knowledge, in which Mertin could indulge his gift for lethal description, tantalizing ambiguity, graphic audacity, and brittle wit.

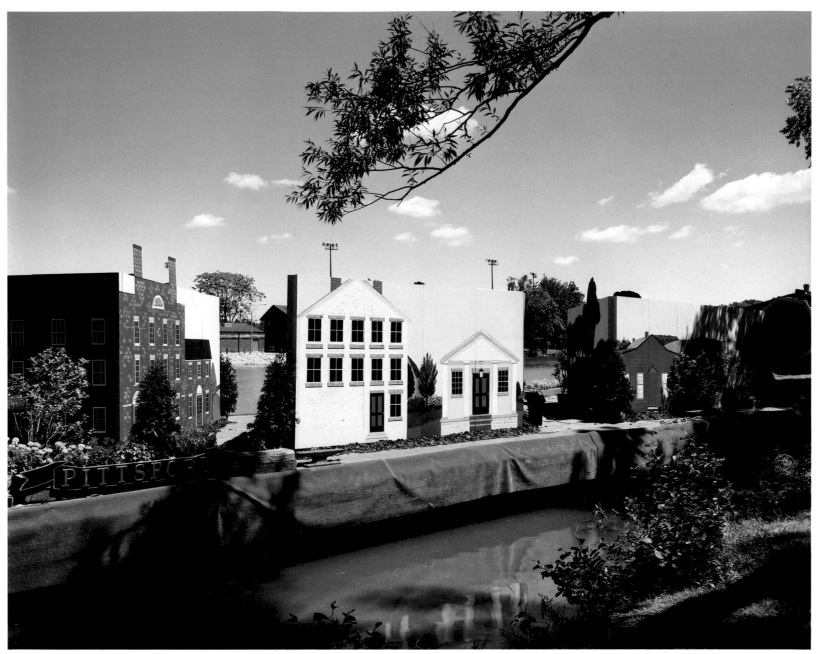

86 Great Canal Caper, Genesee Valley Park, Rochester, New York, July 8, 1984

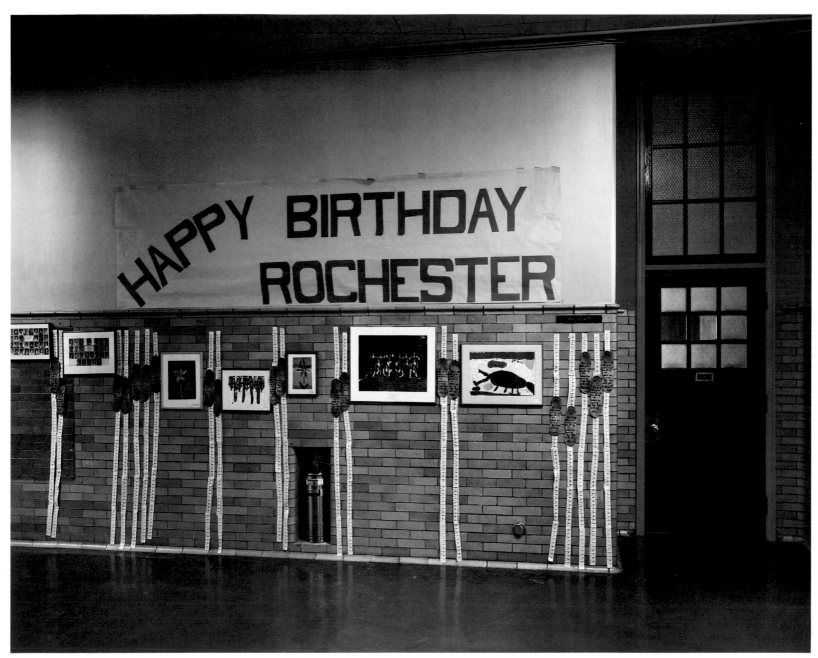

87 School #34, Rochester, New York, October 1984

88 Rochester, New York, September 1984

89 Rochester, New York, 1983

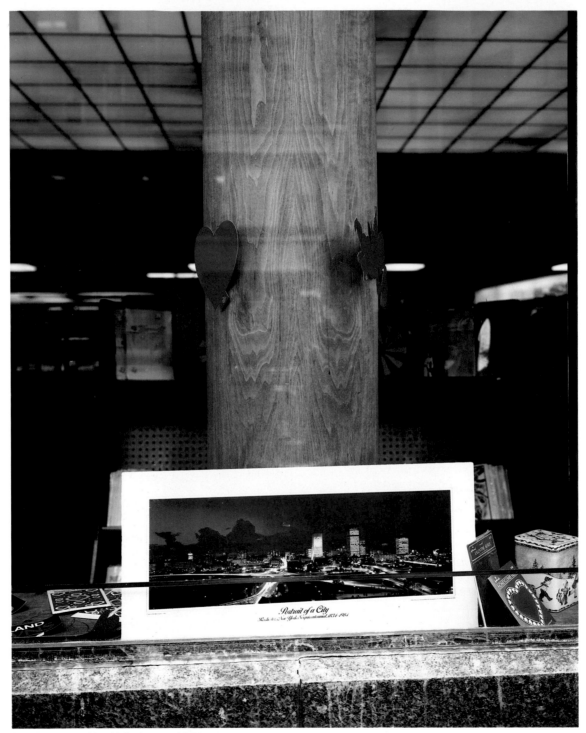

90 Rochester, New York, January 1984

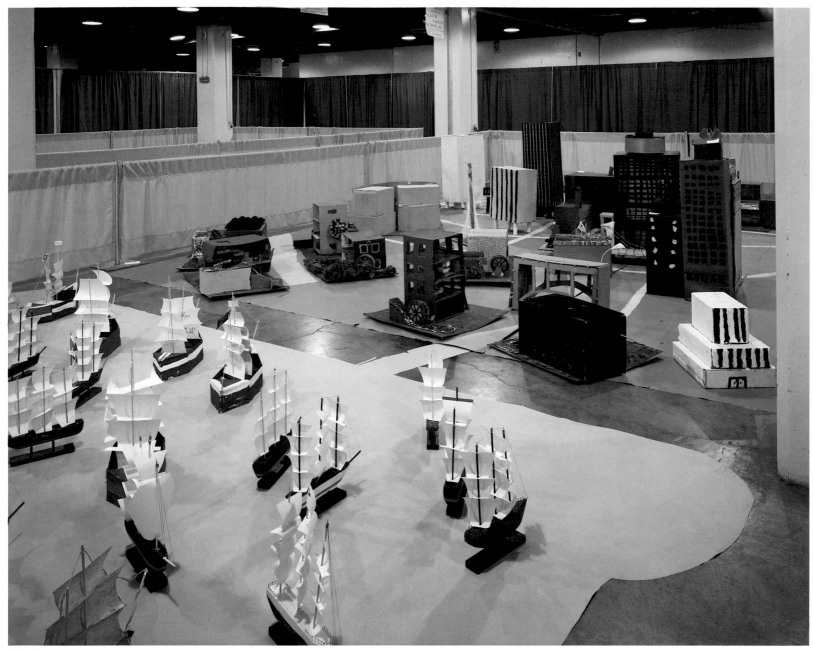

91 School #23, Celebrate the Lake—Tall Ship Extravaganza, Rochester, New York, April 1984

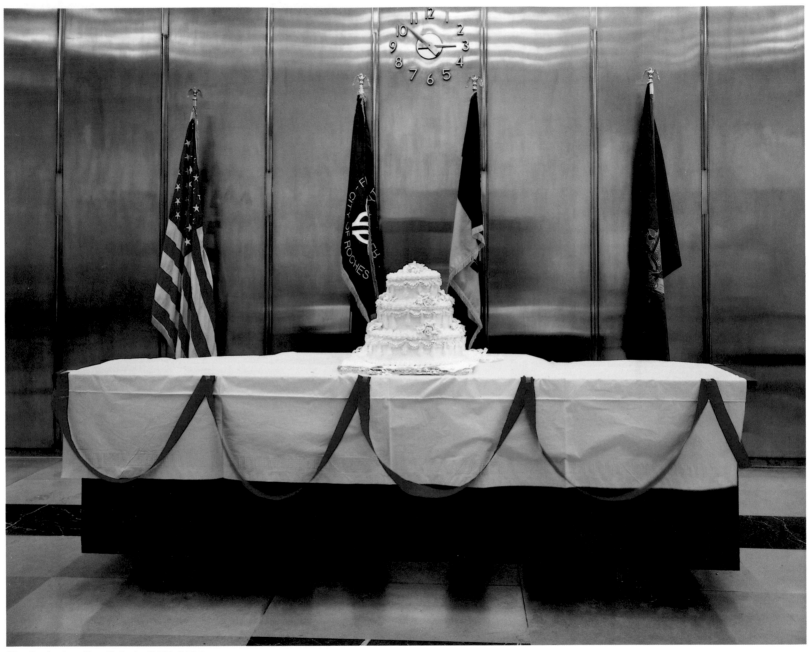

92 Rochester, New York, April 28, 1984

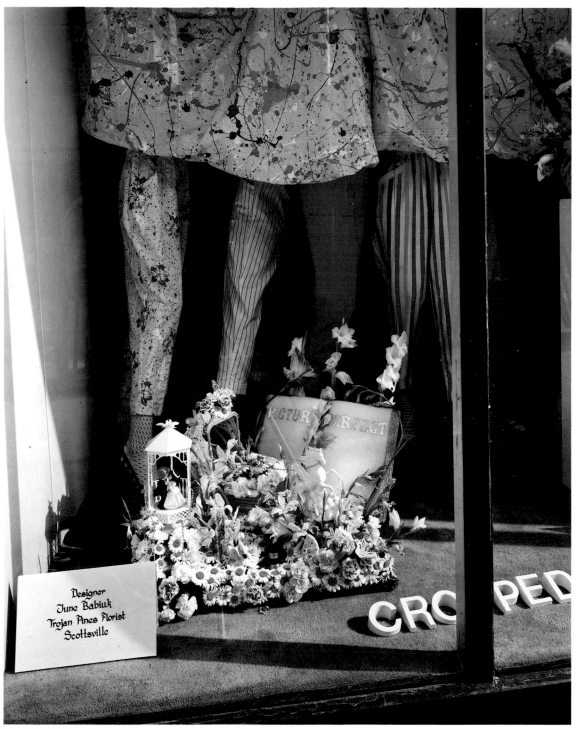

93 City Jubilee, Rochester, New York, June 10, 1984

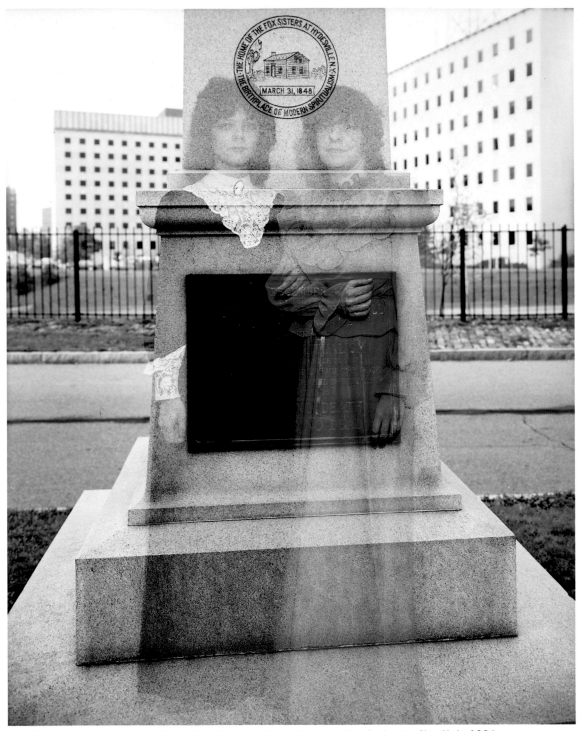

94 Historical Personae, Gail Sallome/Kate Fox, Carol Manes/Margaret Fox, Rochester, New York, 1984

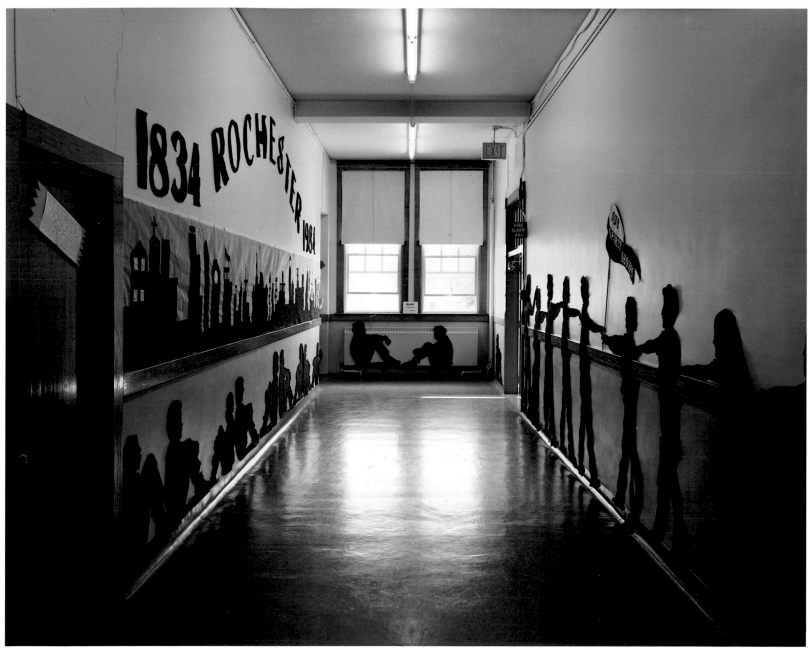

95 School #39, Rochester, New York, June 1984

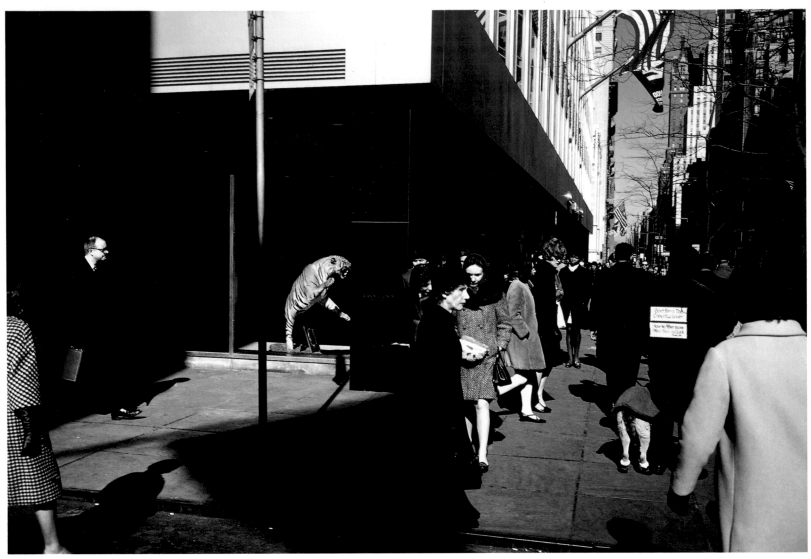

96 Fifth Avenue, 1968

JOEL MEYEROWITZ

Out to Lunch

Unlike Garry Winogrand, Lee Friedlander, Tod Papageorge, and other photographers who came of age in the turbulent 1960s, Joel Meyerowitz forged his street aesthetic primarily in color, guaranteeing that his pioneering work would remain "invisible" for years. Because he could not afford to make dye-transfer prints from his Kodachrome slides, he could not exhibit those images. To compensate, he supplemented his color shooting with black and white, and by the late 1960s he achieved a substantial reputation in that medium. Within another decade, his view-camera color photography was popularly and critically acclaimed.

But it was not until 1983, in his book *Wild Flowers*, that Meyerowitz presented to the public his early color street photographs. These tough and funny photographs, dating from as early as 1964, differed radically from the sensuous, explicitly nuanced images of his celebrated book *Cape Light* of 1978. The leitmotif of flowers—real, plastic, paper, or pictured—accompanied a sense of wildness in the photographs themselves. Unruly, odd, spontaneous, uninhibited, and erratic, these photographic "wild flowers" were brought to bloom by Meyerowitz's trust in his own intuition. Willing to risk forming the world anew by photographic means, he used density, cropping, and juxtaposition to conceive new possibilities of beauty and vitality. It mattered little that not all the photographs would succeed; *Wild Flowers* contained the seeds for future growth.

The similarly wacky series "Out to Lunch" dates from the same period as *Wild Flowers*. Here, too, Meyerowitz concerns himself with the overall distribution of energy, the dynamic potential of off-center balance, and timely improvisation with encountered situations. He understands that alertness to accident can be the mother of invention; the street photographer's development is not a tidy movement forward but a rush of hunches and impulses, producing styles that crossbreed constantly, occasionally begetting hybrids that evade categories. Editing and reflection must

come afterward. As the playwright Eugene Ionesco once explained, "if lucidity is required a priori, it is as though one shut the floodgates. We must first let the torrent rush in and only then comes control, grasp, comprehension."

In their search for visual form, energy, and symbolic potential, street photographers generally forgo emotional involvement with the subjects they photograph. But unlike many 35mm photographers, Meyerowitz works so inconspicuously that his subjects rarely perceive his interest in them, let alone make his acquaintance. He prefers not to "bruise the situation."

The impersonality of his method, however, belies the humanity of his motivation. Meyerowitz wishes "to feel the thrilling human pressure" of the crowd, to sense the vibrations of its spirit and flesh. Accepting people as they are, he acts as neither a minister of salvation nor a cynical observer. Rather, he allows himself to move with the sway of the street experience.

In this way, Meyerowitz amplifies the rhythms of the subjects he records. Working in the "blasting, edgy, and cutting" sunlight that splashes New York lunchtime crowds, Meyerowitz produces striking confluences of color, form, and gesture. Reds, blues, and yellows aggressively jostle against the picture surface, capturing the rowdiness, gaudiness, and bustle of the city's garment district (plate 99). A brilliantly light-struck column shimmers with the magic of New York's "Golden Corridor," Fifth Avenue (plate 100). Dappled sunlight blesses a modern-day *fête galante* in the park (plate 103).

The photographs provide information about New York's tensions and tempos, its patterns, its system of tenuous yet complex social relationships, its breathless, sometimes stultifying atmosphere, its daily routines and mechanized monotony, and its impact upon the mind, imagination, and spirit. Meyerowitz considered titling a group of photographs in this series "Mean Business," referring both to the cutthroat competition of American business and to its acceptance as average, typical, and democratic.

Although the people in "Out to Lunch" occasionally betray bemusement, weariness, or irascibility, Meyerowitz does not stress what Ezra Pound called the "accelerated grimace of the age." A sybarite and an urbanite, Meyerowitz revels in the city's energy and its abundant, often unexpected happenings. Like Federico Fellini, he seeks people who are beautiful, deformed, sinister, endearing, ridiculous, cunning, and fatuous—as complex and manifold as humankind itself. He relishes the bizarre and grotesque juxtapositions of urban life, such as the startling convergence of a sharply angled prosthetic leg and a woman whose flamboyant sunglasses sport a gleaming string of beads (plate 104). His street-level perspective highlights the swaggering, schmoozing, and self-important airs of people dwarfed by their towering glass, stone, and concrete environment. In one image, an outstretched arm directs fluorescent lights (plate 102).

Meyerowitz's vision both confirms and satirizes Middle America's notion of New York as the big, bad city, center of falseness and trickery, where only the ruthless survive. The urban jungle is depicted with wit; witness a man-eating tiger in a window display (plate 96), a Great Dane licking its "victim" (plate 97), and a woman in fur cornered by a male "hunter" (plate 98). The world of commerce seems a

place of mock demonic, hostile, and unpredictable forces, where steam rises from a yawning abyss. Minority laborers and an elderly man are caged by a rack from the garment trade (plate 99). Businessmen march in regimentation, as if modern-day soldiers of fortune, while industrial-age spools may symbolize the wheels of progress, mass circulation, or the treadmills of meaningless lives (plate 101).

Disconnected image fragments suggest rapid movement and the segmentation of relationships in city life. Strangers react to only a part of each other's personalities—to the *sales* in *sales*person, not the *person*—and this contact is often incidental, superficial, and transitory. Yet, however much urban society trims and stamps people into approved patterns and dehumanizes interaction, Meyerowitz shows people who are remarkably individual, a choice that accords with both his democratic belief in the common people and his exultant, golden vision of the city.

On the whole, "Out to Lunch" is arch and spirited. Meyerowitz has clearly enjoyed reinventing the city through photography, stopping and starting action according to his own spontaneous, often irrational whims. Conjuring ironies of coincidence, he fashions meaning from the moment amid the rootlessness, instability, and impermanence of the city. His message? As was said in the sixties, "Be here now."

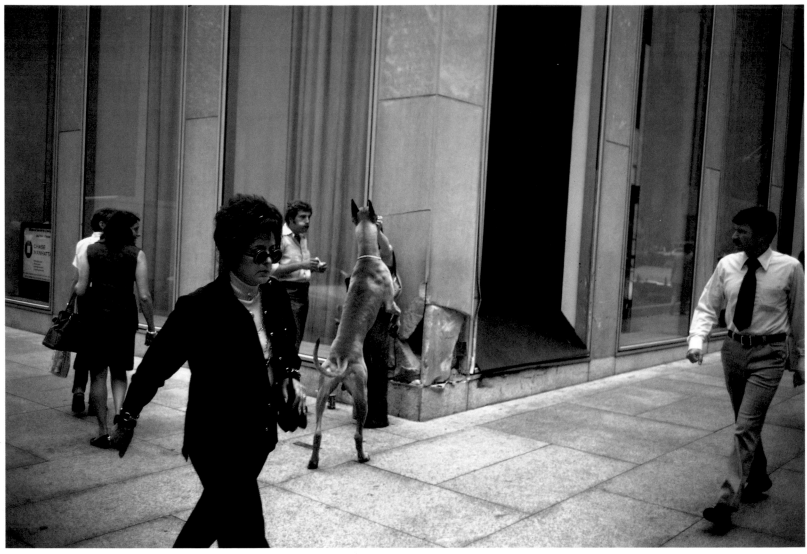

97 Sixth Avenue, 1975

140

98 Fifth Avenue, 1974

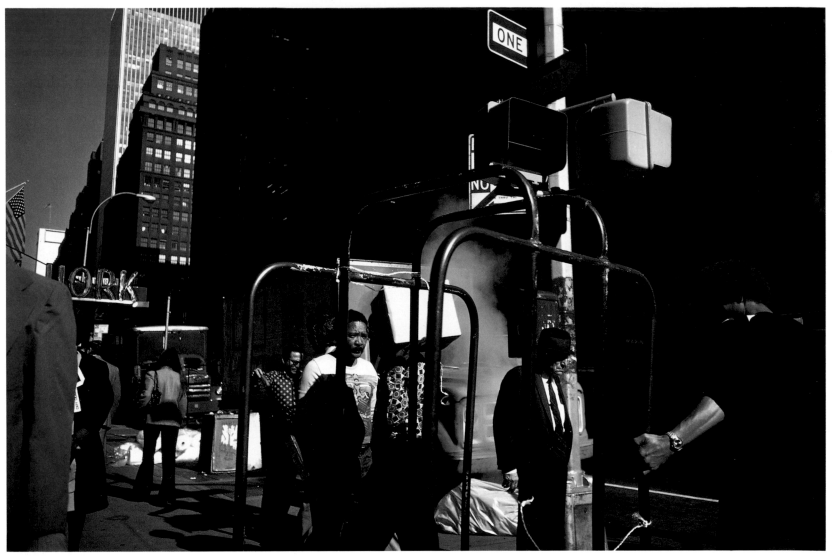

99 Seventh Avenue, 1976

142

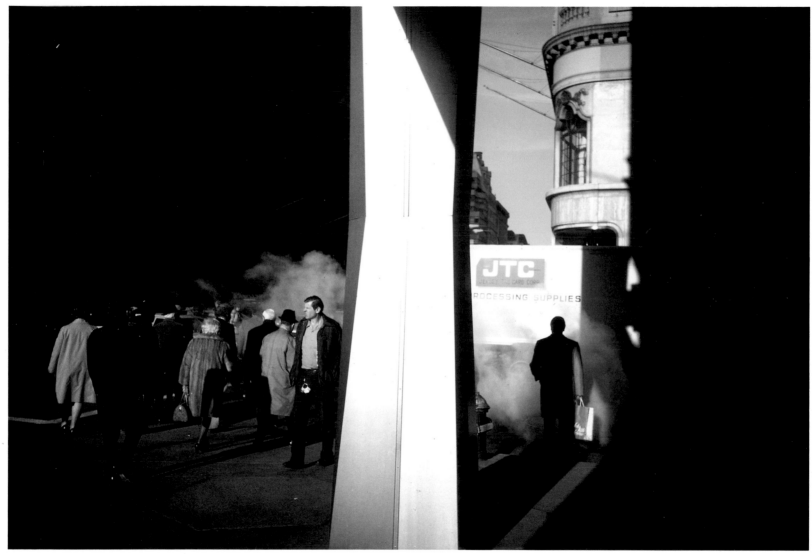

100 Fifth Avenue, 1975

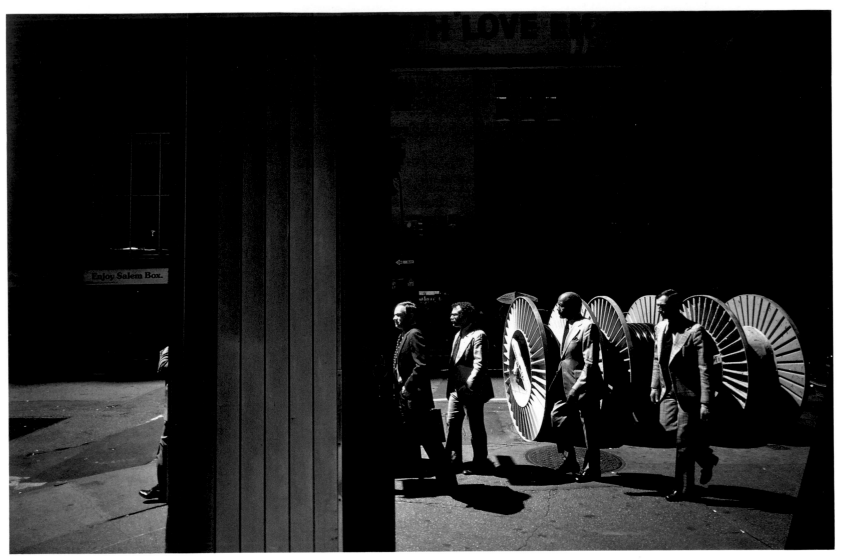

101 Lexington Avenue, 1976

144

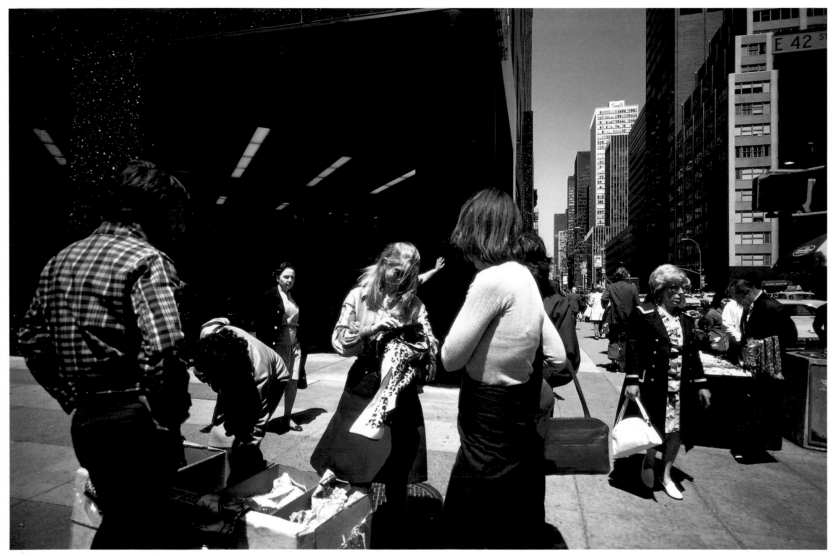

102 Forty-second Street, 1976

103 Riverside Drive, 1973

146

104　Fifth Avenue, 1976

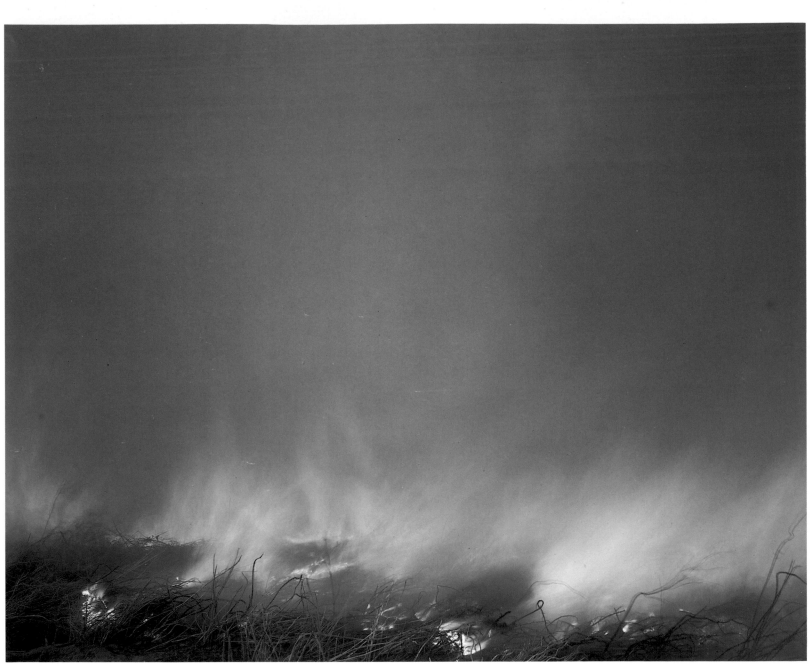

105 Desert Fire #187, 1984

RICHARD MISRACH

Return to Wasteland

During the past six years, Richard Misrach has ventured repeatedly into the desert near Coachella, California, producing a monumental photographic essay composed of ten cantos. The final section, "Return to Wasteland," depicts a phenomenon peculiar to the American West—runaway desert fires.

The photographer intends that the ten cantos—titled "Highway," "Terrain," "Space," "Scale," "Light and Color," "Inhabitants," "Visitors," "Survival," "Human Artifact," and "Return to Wasteland"—progress from description to metaphorical resolution. Considerable overlap exists, however, from one canto to the next. Highways and human artifacts appear in many of the photographs, and scale, light, and color are Misrach's priorities throughout.

On a primary level, "Return to Wasteland" documents desert fires, but the essay also demonstrates that Misrach is entranced with the light effects and riotous explosions of color caused by smoke and flames. Twisting streaks of fire,

veils of smoke, and flickering embers energize minimal compositions that feature few colors or ombré variations of a single hue. Often only a zip of orange rescues a composition from monochromatism.

Misrach's work is tenaciously photographic, the flickering nuances of light and color meticulously rendered with an 8 x 10 inch view camera. Though the photographs recall canvases by Joseph Mallord William Turner, Mark Rothko, and various color-field painters, Misrach's clearly readable foregrounds orient viewers to the landscape and prevent the plunge into pure abstraction. These are not tricky transformations with arty special effects but attentive evidence of the world's own metamorphoses.

Unlike most of color photography's luminists—particularly Joel Meyerowitz, photographing the bay and sky of Cape Cod—Misrach is only rarely drawn to the lustrous colors of resilient, infinite space. Instead, he records views that are wispily infused or overwhelmingly choked with

smoke, combining airiness with constraint. Dark and glowing, muted and intense, his photographs are enveloping, not expansive.

Given the overridingly horizontal subject matter of the desert, stylistic similarities were perhaps inevitable between Misrach and Meyerowitz and, to a lesser extent, Len Jenshel. But Misrach lacks those photographers' supreme visual sensitivity and his work is far more polemical. There are also obvious similarities between Misrach's photographs of Edwards Air Force Base and Joel Sternfeld's earlier views of the space shuttle, but Misrach's content is more direct and less multilayered than Sternfeld's subtle web of irony and historical and literary allusion. Misrach's many debts have led some viewers to question his originality. But like Ezra Pound in his *Cantos*, Misrach clearly felt free to lift, transpose, and adjust as he thought fit from the literature of other times, other people, and other languages.

Little in Misrach's earlier photography presages these photographs. Whereas the photographer now seeks the subjective possibilities of objective things, he once actively reached out and manipulated his landscapes into states of significance. To create his well-known selenium-toned black-and-white photographs of the mid-1970s, Misrach worked at night, using a strobe to feature iconically centered cactus, Grecian ruins, and other subjects that the flash lighting made eerily romantic and otherworldly. Switching to color in 1978, Misrach blasted away with a strobe in jungles so dark that he could not, by his own admission, see ninety percent of what he was shooting. Ceding to his camera the right to select, edit, compose, and frame, Misrach discovered, in his darkroom, jumbles of artificial colors resembling psychedelia.

In 1980, Misrach entered the desert, recording its myriad ways with sobriety, intelligence, and visual grace. Unlike colorists who emphasize trivial distractions, Misrach endows these images of destruction with a striking beauty that contributes to their repellent fascination. In their feel and their content the photographs are poignant and tragic. Misrach's fascination with fire and flirtation with danger may be an extension of his need to confront the trauma of losing thousands of prints and negatives when his studio burned in 1982.

"Return to Wasteland" documents man's intrusion on, yet helplessness against, nature. Roads, telephone poles, fences, and other proofs of human development appear as transient minutiae in the vast and timeless expanse of desert. So easily, nature reclaims its territory with flames.

Whereas Misrach's other desert landscapes show extremes of peace and quietude, the desert fire series depicts nature's elemental terror, primeval energy, and simmering unrest. Tremors and eruptions, blackened soil, sooty sky, and charred vegetation connote the apocalypse. But fire —symbol of passion, purification, and justice—also marks the phoenix in rebirth.

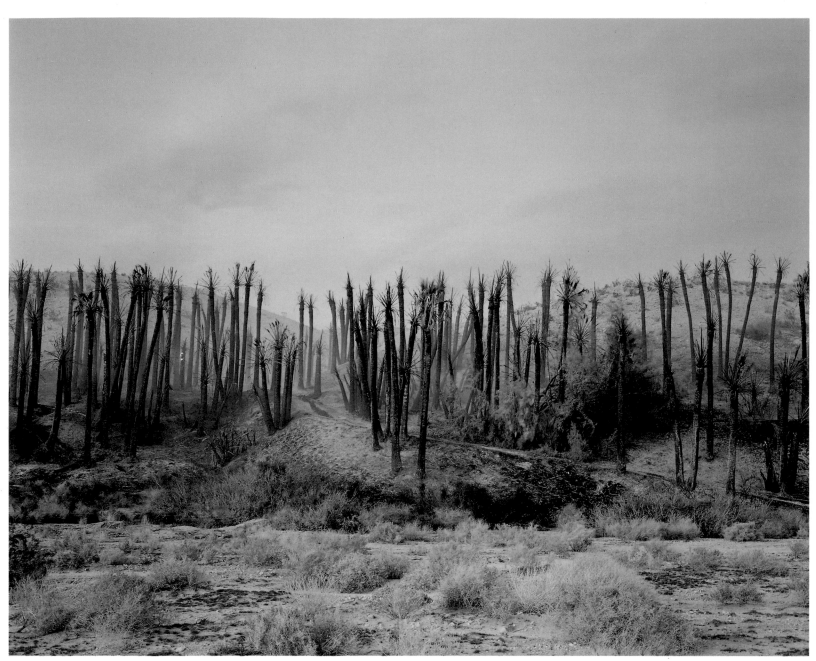

106 Desert Fire #2, 1983

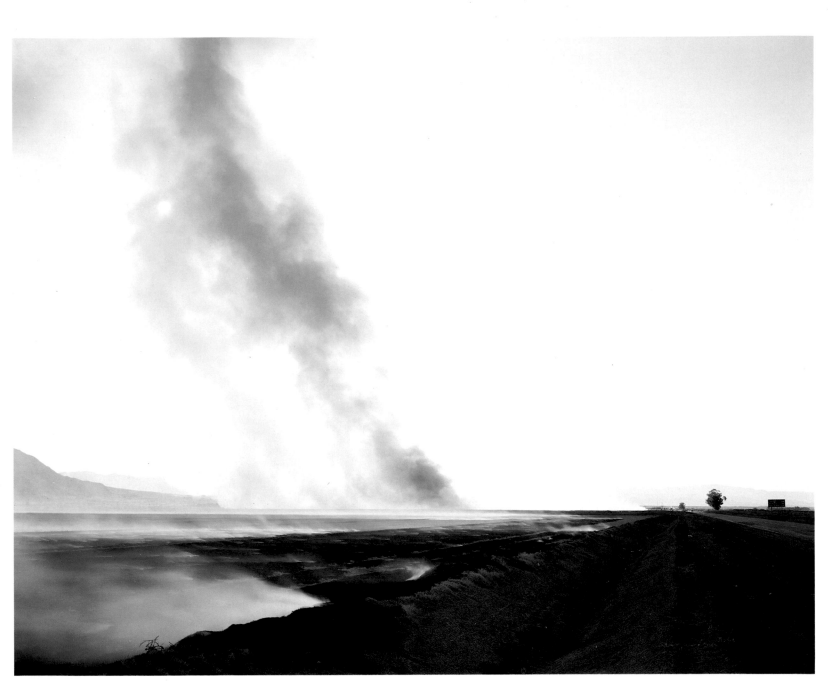

107 Desert Fire #253, 1985

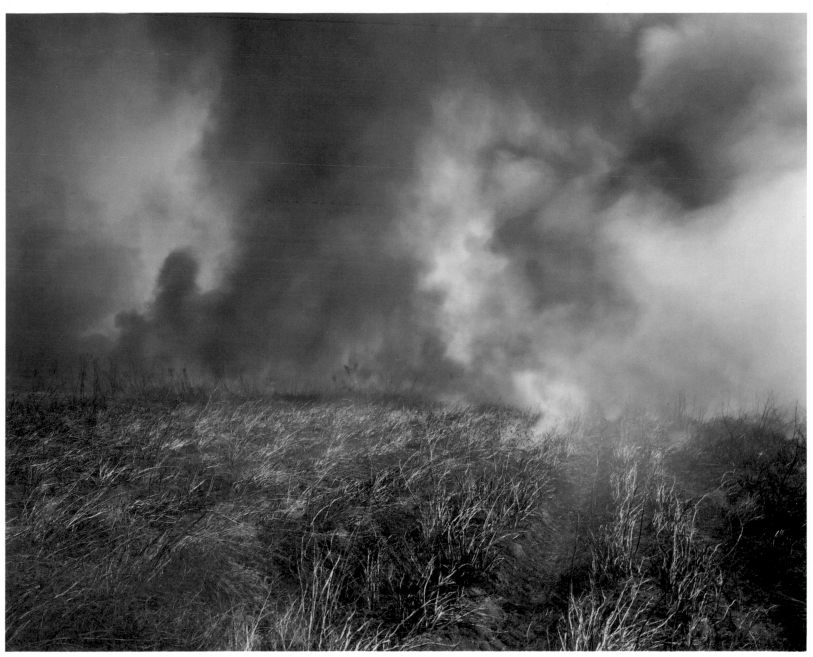

108 Desert Fire #134, 1984

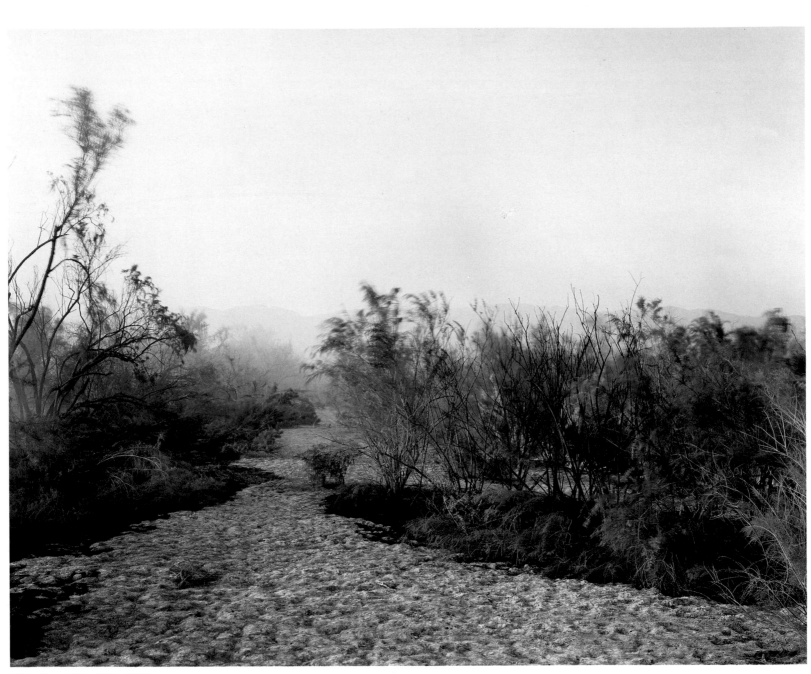

109 Desert Fire #16, 1983

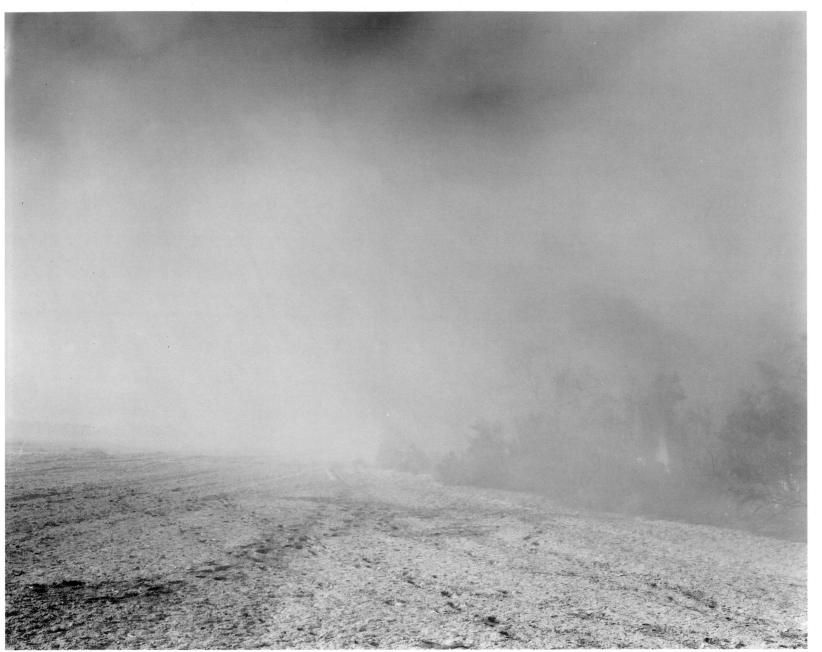

110 Desert Fire #19, 1983

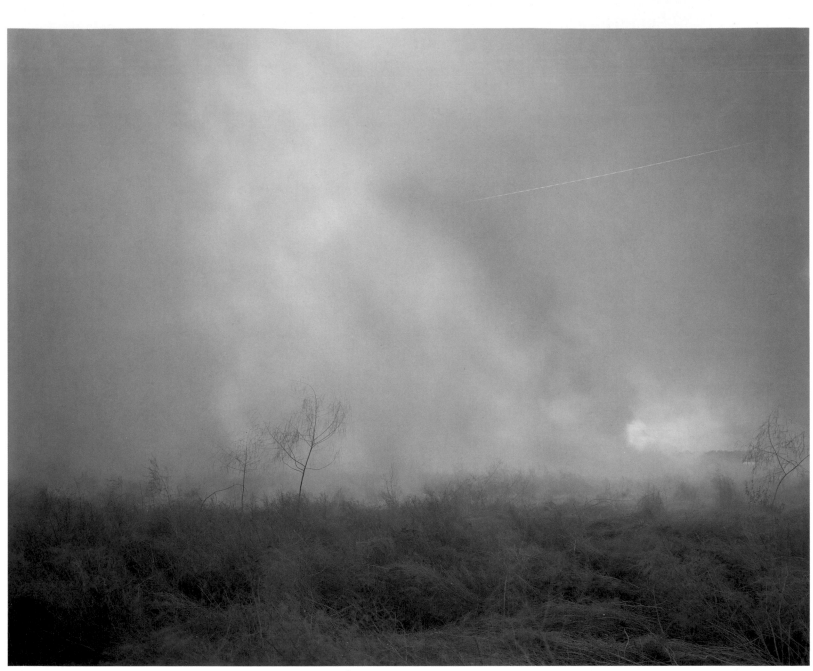

111 Desert Fire #154, 1984

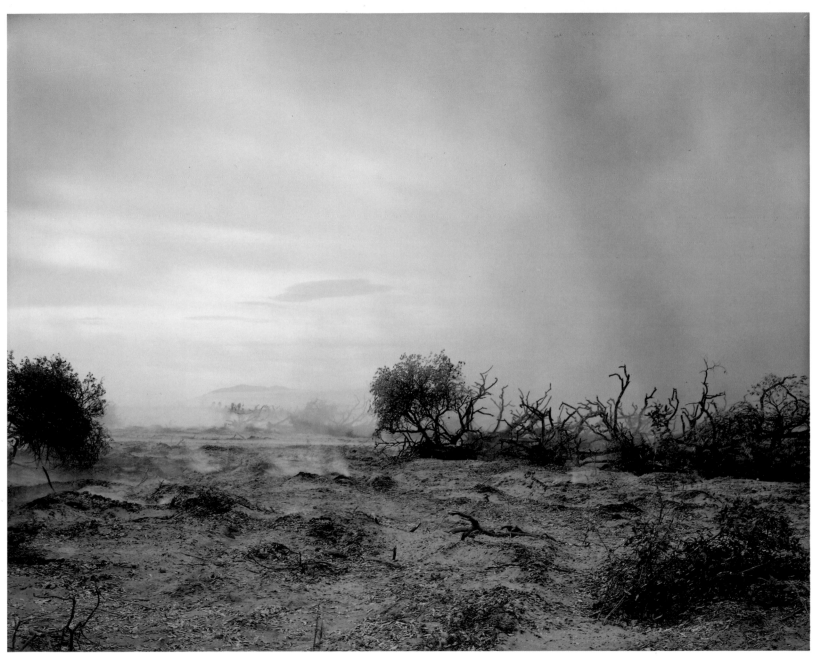

112 Desert Fire #83, 1984

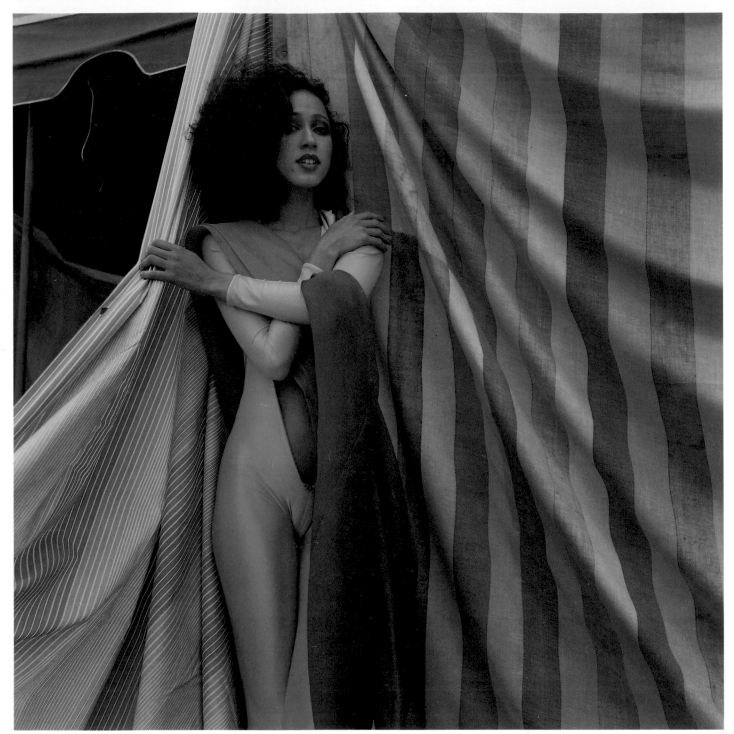

113 The Fire Island Pines Fashion Show, 1982

JOANNE MULBERG

Cupid's Net

The Miss Fire Island competition, held each September in Cedar Grove, New York, parodies the feminine ideals espoused by the Miss America, Miss Universe, and other beauty pageants. Frou-froued in feathers, netting, lamé, lace, and glitter, the male contestants can be read as symbols of aberration and frivolity or of a rowdy and cheerful rebelliousness that challenges cultural taboos. Either way, their mockery reveals the differences in how men and women in our society are programmed.

American attitudes hold that "real" men do not trick themselves out to entice a mate because they have more substantial means to prove their worth. As Susan Brownmiller pointed out in *Femininity*, men of action and power are generally colorless by choice. Only those more likely to be ignored or discounted—blacks, gays, and short men, for example—or those whose livings depend on their image —entertainers—are demonstrably more fashion conscious.

In contrast, American women since the nineteenth century have been maniacally obsessed with their appearance.

Despite protests by many that fashion is a "tyrant" and "fickle goddess" and that its most loyal followers are "slaves," dress, quite simply, has provided one of the few opportunities for women to strive for success without defying their culturally assigned roles. Fashion can leave women economically, psychologically, and even physically debilitated, but it remains an accepted and even applauded means for women to serve the capitalist imperatives of individualism, competition, and materialism.

In Joanne Mulberg's photographs of Fire Island, of course, the "women" so eager to be whistled at and admired, and so ludicrously enslaved by beauty standards are, with few exceptions, men. In person, broad shoulders, sinewy calves, flat buttocks, Adam's apples, and five o'clock shadows may give the game away, but Mulberg chooses vantage points that play on sexual ambiguity.

Theatrical poses, coyly flirtatious glances, heavily made-up faces, curly wigs, and sexy gowns are cues of seduction borrowed from the heroines of Hollywood, Las Vegas, and

Madison Avenue. Exaggerated makeup (plate 119) parodies the stylized cosmetic mask that many women wear to hide a host of feared deficiencies and imagined flaws. Protruding scarlet fingernails (plate 116) transform the simplest gesture into something contrived, self-conscious, or downright impossible. The "dumb blonde," who has more fun and whom gentlemen prefer, is a prototype of preference (plates 114 and 118).

Mulberg's photographs remind us that in clothed cultures we depend heavily on artificial clues to sexual identity. But the excessive trappings seen here may be unnecessary. As the British transsexual Jan Morris discovered, "only the smallest display of overt femininity, a touch of makeup, a couple of bracelets, was enough to tip me over the social line and establish me as female."

To Mulberg's credit she has underplayed the inherent shock value of her subjects to depict them as tenderly, beautifully, and individually as possible. As a woman and an artist she has no need to soft-pedal sensitivity and emotion and can freely indulge her love for line, tone, shape, color, and texture. Colors from the luscious palette and romantic vocabulary of women's fashion—aubergine, heliotrope, mauve, cerise, and peach—are present in abundance.

Veils and nets, evocative of intrigue, mystery, and illicit liaisons, also tend to soften features and create shimmering color interactions. Just as chain-link, tarpaulin, and picket fences intricately screen Mulberg's landscape photographs (see "Threaded Light" in New Color/New Work), veils simultaneously hide, reveal, and transform the subjects here.

Mulberg also loves the living, breathing quality of fabrics, the way they carry light as they bunch, stretch, hang, and flutter. However fascinated by the more startling aspects of her portrait subjects, she is ever alert to radiant light effects and reverberative color harmonies. Nonetheless, she rejects fussy contrivance, declining to obsessively match motifs and colors in the way that women once paired purses and shoes.

Mulberg's equal treatment of men and women, no matter what their degree of "normality," contributes to the extended meanings of her photographs. For the trivial pursuit of beauty at all costs is not limited to women and gay men—whose liberations could free them from this unending distraction. Increasingly, obsessions about personal appearance are shared by politicians, executives, and ordinary citizens—anyone influenced by the media's disproportionate focus on the young and the extraordinarily good-looking.

By gently teasing us with gender games, Mulberg issues a humanist challenge to the domain of fashion and the tyranny of sex-role stereotyping. Rather than calling us to arms, her photographs encourage us to consider a number of issues: why does our culture demand the strict polarization and unambiguous definitions of "masculine" and "feminine" categories? Why is sexualized clothing for men—such as the leopard-skin jockstraps of another Fire Island competition, "The Hottest Man Contest"—thought undignified and foppish, whereas the skimpy swimsuits and décolleté gowns worn by female beauty contestants (plate 113) are considered appropriate and attractive?

Finally, the Miss Fire Island contest becomes a metaphor for our cultural masquerade and the artificial disguises in which many Americans are trapped. Mulberg reminds us that we are all impersonators to some degree.

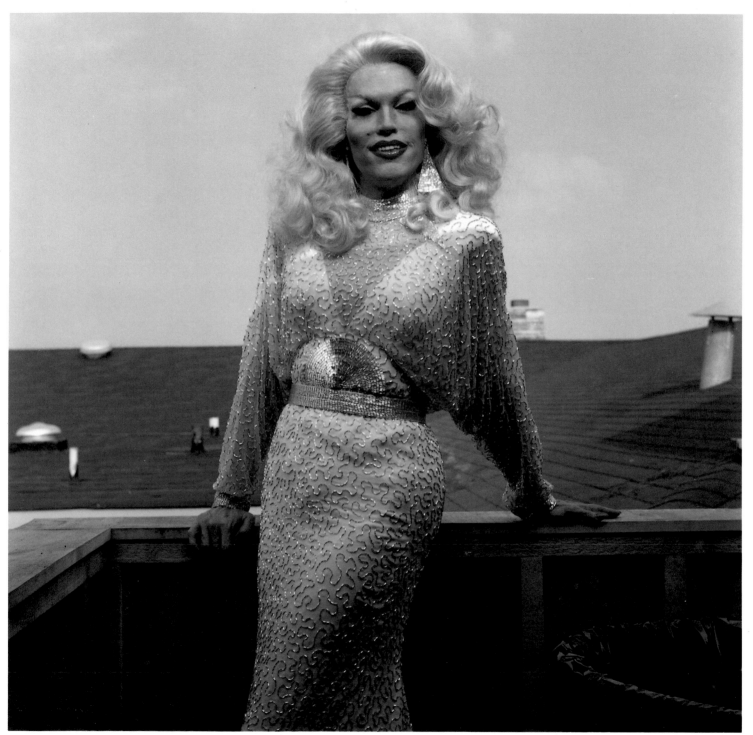

114　Miss Fire Island Contest, 1983

115 Miss Fire Island Contest, 1985

116 Miss Fire Island Contest, 1984

117 Miss Fire Island Contest, 1983

118 The Hottest Man Contest, 1984

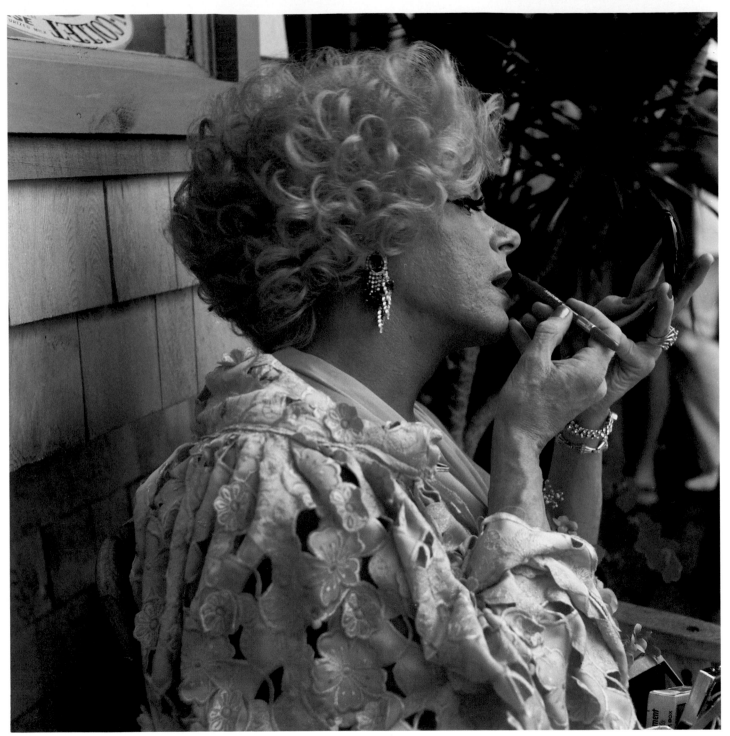

119 Miss Fire Island Contest, 1984

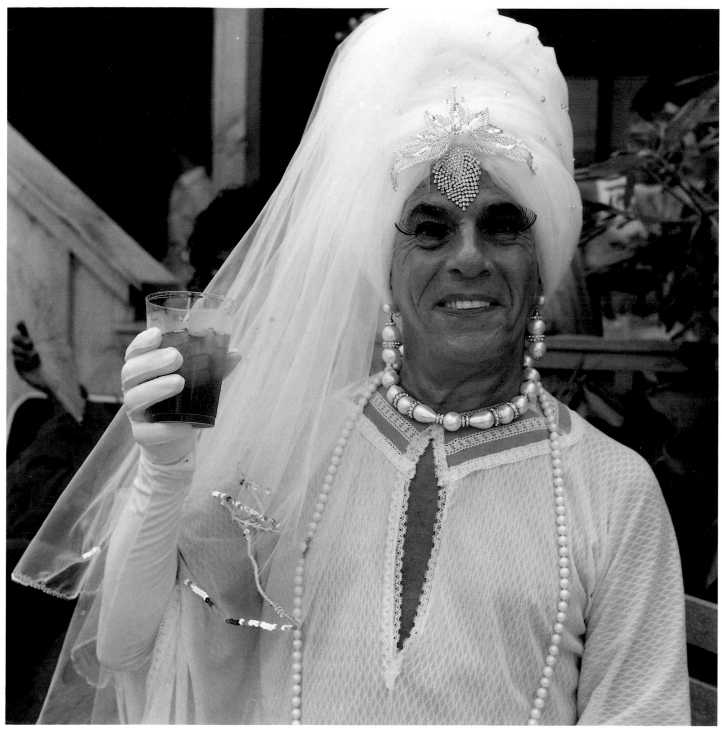

120 Miss Fire Island Contest, 1983

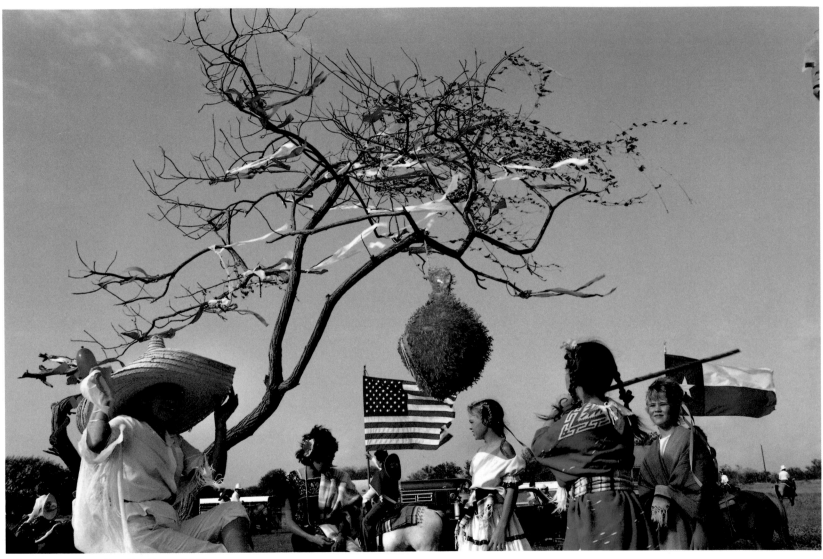

121 Western Days, Beeville, Texas, 1984

STEPHEN SCHEER

Texas Tourney

Perhaps more than any other state, Texas has preserved American individualism and its economic counterpart, entrepreneurship, in their most undiluted forms. Low taxes and minimal government regulation lure immigrants at all levels of society, and the self-made winner commands maximum respect. In every part of their lives—in their vocations and avocations—people put themselves to the test. Rodeos, beauty pageants, and other contests establish a winner–loser dialectic that reflects the fundamental competition of American life.

Stephen Scheer's "Texas Tourney" shows the various guises of the tournament mentality. No J. R. Ewings, H. L. Hunts, or other millionaires inhabit Scheer's photographs. The common man stars, though in uncommon roles. Most typically, Scheer is drawn to the push and hustle of self-starters— "American" types whose raw ambition ignores tradition.

Represented are the great democratic virtues—energy, industry, mobility, and practicality—often carried to extremes. A canvassing salesperson has stuck books and record albums to his car, the title of one volume, *The Bermuda Triangle*, reflecting his own high-risk business (plate 130). A sign painter hoists the lid of his trunk in the most expedient way (plate 123). A family—"making a go of it" by traveling to sell alfalfa—improvises a picnic in the shade beneath their truck (plate 126). And a mother and child have simply passed out, amid day-trip paraphernalia, from the strains and pleasures of their visit to an amusement park (plate 127).

Most Texans believe that the phenomenal economic growth rate that Texas has experienced until recently hinged on the state's refusal to provide a safety net. In 1980 Texas ranked eighteenth in per-capita income, but its per-person government expenditure ranked only forty-fourth. Compared with the rest of the nation, Texas spends little on hospitals, health care, education, and public welfare.

The sign painter of plate 123—whose position on a bowed plank seems precarious—writes "Your Protection Is Our Business," hardly the motto for the Lone Star State. In one photograph a helpless tot waits unprotected in an unlocked Ford LTD, whose worn paint and protruding insulation reflect its own neglect (plate 124). Likewise, the frontier spirit demands that criminals not be coddled; although the prison system is one of the nation's largest, expenditures per inmate are less than one-third of the national average.

Photographing a rodeo held at the high-security prison at Huntsville, Scheer notes the macho blend of cowboy and criminal, of men, behind bars and wearing bars, willing to give all because they have nothing to lose (plates 125 and 128). A cross around one cowboy's neck suggests he may be trying to do the Lord's work, but his squinting, faraway gaze is that of an evangelist gone haywire (plate 125). Such criminals may be frontiersmen born too late, men who have bent laws to suit their own conditions but are today considered lawless rather than pragmatic.

Scheer implies that people are often performing or at least on display, as those standing on a platform (plate 121). A beauty contestant, looking like a wedding cake figurine, patiently awaits her chance for the success with which America rewards feminine innocence, beauty, and charm (plate 130).

Scheer photographed this series when Texas was on the verge of commemorating its sesquicentennial and therefore putting a ceremonial handle on everything from pea-shelling contests to gala balls. But celebrations typify everyday Texas life. In the town of Beeville, Scheer photographed festivities for "Western Days"; the Texas state and American flags and a Mexican piñata and sombrero represent the state's melting-pot heritage (plate 121). Braggadocio is also a kind of Texan celebration, even for animal crackers—"Mega Animal Crackers"—and soft drinks—"Thirst Busters" (plate 126).

Scheer divides many of his photographs into vignettes and often employs manipulative juxtapositions of scale. The curve of a tree trunk separates the jubilant image of a man holding a child in the air from that of a woman who appears childless and morose (plate 122). The beauty contestant is miniaturized by apposition with nearby American flags (plate 130). A motorscooter and its rider become an improbable ornament on a decrepit behemoth of a car (plate 124). And elephants become playthings for oversized people, though one young girl's expression indicates a fear of animals unusual in a land of ranching and rodeos (plate 129).

Depicting Texas, where aggressive striving is considered proper behavior, Scheer packs his pictures with competing focal points and fragments that crowd in from outside the frame. His bold colors joust for supremacy within each photographic tournament; only failure (plate 124) is flat, grinding, and gray. With irony and ambiguity, Scheer plays both the satirist and the spokesman for this state.

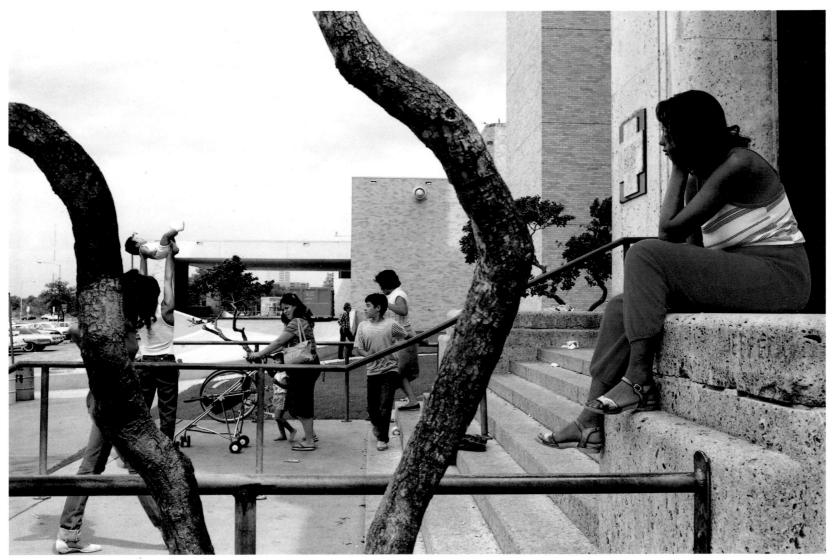

122 Maternity Ward Steps, Houston, Texas, 1984

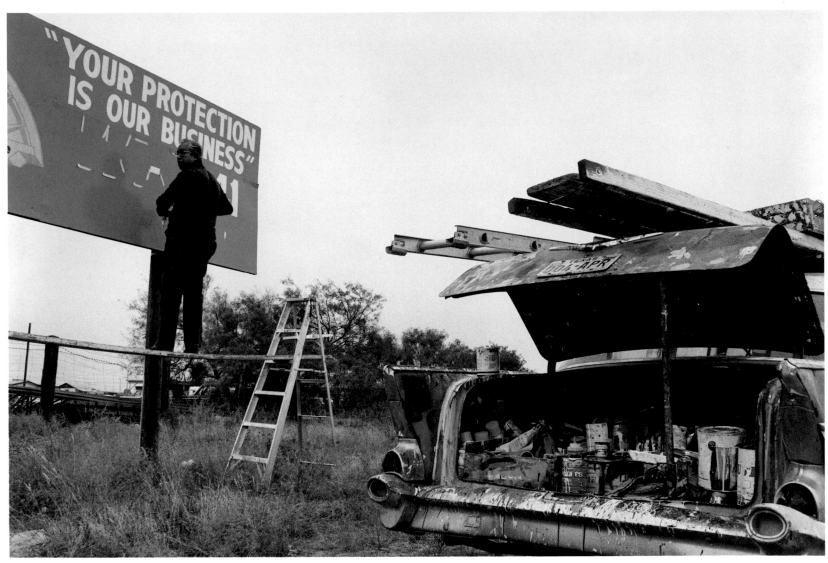

123 Signboard Painter, Del Rio, Texas, 1984

124 Lone Baby in Open Car, Dallas, Texas, 1985

125 Bull Rider, Huntsville, Texas, 1984

126 Portrait of a Family, Austin, Texas, 1985

127 Sleeping Mother and Child, Irving, Texas, 1985

128 Prison Rodeo Dugout, Huntsville, Texas, 1984

129 Traveling Circus, Del Rio, Texas, 1984

130 Supermarket Parking Lot, Beeville, Texas, 1984

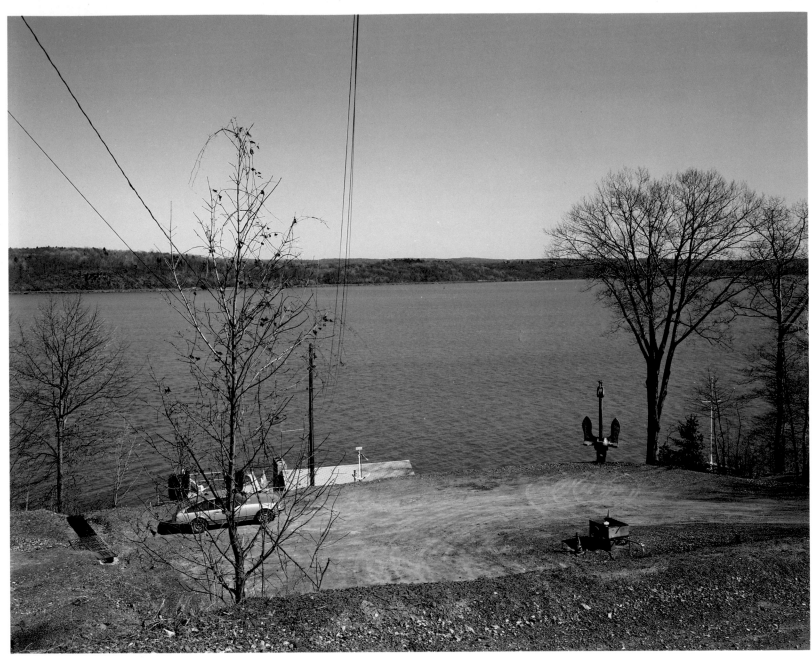

131 Ulster County, 1984

STEPHEN SHORE

The Hudson Valley

The composer Igor Stravinsky once said, "I never return, I only continue." So it is with photographer Stephen Shore. By the late 1970s he had achieved work so assured that it was obvious he knew what he wanted and how to attain it. But Shore came to fear that continuing in his signature style would lead him to produce facile, undistinguished work, so he retired from the photographic arena in order to reinterpret and transform his aesthetic.

In his struggle to create a new photographic language, Shore has produced few photographs that he stands by. These rare and unanticipated images have generated considerable controversy. Though his "Montana Suite" of 1982–83 (reproduced in *New Color/New Work*) was decried as nihilistically reductive, redeemed only by touches of whimsy, it was in fact a complex effort that used symmetry, abrupt changes, apparent incompatibilities, and unique and varied timbres in ways that visually parallel Béla Bartók's third, fourth, and fifth string quartets.

Shore's ongoing series "The Hudson Valley," begun in 1985 with a grant from *Reader's Digest* cofounder Lila Acheson Wallace, will surely continue the controversy in new, even more perplexing terms. Obdurate, gritty, and even more sparing in their offerings of aesthetic grace, elegance, and simplicity, the photographs defy easy analysis.

Perhaps reactions would be milder if the pictures were not of the Hudson Valley, a favorite haunt of nineteenth-century painters and a subject resonant with notions of the picturesque and God's immanence in nature. But the Hudson Valley's remaining rural areas bear little relation to the popular image of rolling hills and a crystal-clear river. Areas of outstanding natural beauty still exist, of course, and the river is less polluted than it once was, but Shore emphasizes neither the picturesque nor the defiled. He has, instead, chosen "peripheral landscapes"—those neglected or simply uneventful.

In every case, Shore has scrupulously shunned atmo-

spheric overtones to depict his subject in a relentlessly cold, hard light. Flattened spaces, repetitious textures, and static, sometimes dingy colors mark most of these photographs. It is hardly surprising that no composition is centered, symmetrical, or hierarchical in the manner of conventional calendar photographs, but Shore's tactics are lawless even by the standards of the new color photography that he helped pioneer. Only faint echoes remain of his contrapuntal technique, which involved orchestrating a motif or several motifs in inverted, augmented, and diminished manifestations. Missing are the luminous, vibrating zones created by the careful placement of trees, posts, cars, building edges, or other objects near the photograph's boundaries. Gone in some photographs is the top-to-bottom, side-to-side, tack-sharp focus that Shore and other new color photographers employed to weave near and far facts tautly on the picture plane.

Shore's stubborn refusal to lure the viewer contrasts with the blandishments of picturesque painting and photography. Practitioners of those genres record the face of God as seen in nature to provide viewers with uplifting visions of divine benevolence. Shore would consider such motives right for the nineteenth century but anachronistic and irrelevant today.

This reluctance to unveil nature's hidden glory might cause Shore to be labeled a postmodern cynic. But as Shore demonstrates, the legacy of Transcendentalism has long been tainted. In a region where religious iconography was once considered unnecessary (nature was by definition Christian and spiritual), God is represented by a religious statue (plate 137); once undefiled waters host recreational bathers (plate 135); mountains of unimpressive size and majesty are outflanked by graffiti-covered rocks (plate 136); wild and savage nature (as represented by lurid white branches) impotently gestures at an alien car and a sleek railway (plate 133); and a garden grows a nooselike form, hardly an auspicious sign for Paradise Regained (plate 134).

But Shore is not satirizing a set of values that he unavoidably shares to some extent. Although distrustful of the quasi-Transcendental beliefs on which Americans are nurtured, he lacks the detachment that irony demands. Shore's doubt has pushed him to create an intensely personal art that is honest in ways that most people are afraid to be.

In his most recent work, Shore has abandoned the disinterest that was integral to the photographs in his book *Uncommon Places* of the mid-1970s. Those photographs, taken while Shore was passing through small western towns, were based on momentary visual epiphanies. Because he lacked any real knowledge of or personal commitment to those places, Shore could be the consummate formalist, meticulously adjusting and readjusting his frame until everything that was visually uncouth and discordant was omitted in favor of balance, order, and serenity. His passionate concern for visual quality, however, was countered by his utter lack of interest in extrapictorial content. The meaning of intersections, buildings, automobiles, roads, and lampposts was subordinate to their value as line, shape, tone, color, and texture.

In ''The Montana Suite'' and now ''The Hudson Valley,'' Shore has harnessed his aesthetic will in the service of personal content. As an inhabitant rather than a spectator of each of these places, he can no longer impose an a

priori sense of composition, and he has tried to drain his work of calculation and contrivance. Instead, locale determines character. In the Far West, views are expansive, the cloud cover eventful. The Hudson Valley, on the other hand, is a tight crisscrossing of dirt roads, tracks, thickets, wires, houses, docks, and other structures. In Shore's hard-won new aesthetic, conscious striving after ideal forms is inimical to observation.

Shore has also pushed psychological concerns to the forefront for the first time in his career. The most salient characteristic of these photographs is their hermetic, secretive quality. The sparkling invitations of illusionistic space are forestalled by masses of eye-deadening texture and blackened shadow areas. Shore's critics would attribute the characteristically heavy ambience of these photographs to poor printing technique, but the image quality is intentional. The Hudson Valley series is, on the most personal, metaphorical level, about inner pressures, claustrophobia, and death. The open, breathing, luminous quality of Joel Meyerowitz's prints would be inappropriate.

Printing is but one device Shore uses to "block up" his photographs. At first glance, the Hudson Valley pictures offer the illusion of navigable space, but upon closer examination the landscapes seem pinned down by wires, trees, and brush. The fact that elements such as wires and shadows are not initially very noticeable (plates 131 and 134) or that a white wall reads, at first, as a long foaming wave on the river (plate 137) is essential to Shore's strategy.

Shore presents obstacles as ordinary matters of fact, the routine elements that might block or obscure one's view of nature during a daily walk. The lack of dramatic emphasis in these photographs facilitates viewers in projecting their own identifications and mythic associations. Bypassing the articulating tendency of the mind, Shore's pictures provoke a more free-flowing, instinctual response. To photograph recognizable landmarks rather than ordinary, undistinguished mountains, thickets, and sections of the river would be to confuse the issue. To fill the entire frame with dense forests as symbols of the dark, hidden, nearly impenetrable unconscious would be too obvious.

Shore's quest to discover the darker, chaotic forces within himself allies him spiritually with the Abstract Expressionists, and several of his formal maneuvers link him as well. A Cubist syntax was used during Abstract Expressionism's formative years to provide both a means of structure and an indeterminate atmosphere. Shore adapts this strategy to photography. Consciously compressing space, he builds vague and often inarticulate forms from overlaid objects and interpenetrating shapes. "The Hudson Valley" differs greatly from *Uncommon Places*, in which configurations remained clearly distinguished by local color and visible contours. Here closely valued tones blend together, contradicting their crisp depiction by his view camera and giving these photographs their characteristic heavy, fluctuant atmosphere.

The Abstract Expressionists emphasized the blurred conflations of peripheral vision and the fuzzy mergings that result from staring intently for too long. Shore arrived at a peculiarly photographic equivalent in occasional out-of-focus zones (plate 134) but more often by rendering abstract ovoid patches, amoebic shapes, and other seemingly unfocused spots that are analogous to the meanderings

of the preconscious or unconscious mind (plate 138). Notable are the anamorphic faces that emerge from the rocks in the top right of plate 136. Shore projects his interior state through the world's outward countenance.

Like the Abstract Expressionists, Shore makes images that may be invested with mythic meaning: whiplashing branches (plate 133), tenebrous shadows (plate 138), scabrous surfaces (plate 135), lineups of totemic objects (plate 131), and talismanic graffiti that seems to lock its secrets in stone (plate 136). In plate 135, swimmers have stripped off their clothing (blood-red, white, and blue) and entered the water in what might be a ritual of purification. In a Nietzschean acquiescence to the dark, unsurveyed unconscious, they have left the bleached white stones of Apollo's pure reason to risk Dionysus's shadowy rocks, water, and foliage.

Thus Stephen Shore, once color photography's consummate classicist, now explores the irrational. "The Hudson Valley" offers a startling departure from his previous work. Dark, haunting, and chthonic, poised on the threshold between the conscious and the unconscious mind, and filled with unresolved existential incidents, these images pose new possibilities for redeeming the banality and sterility of the contemporary landscape.

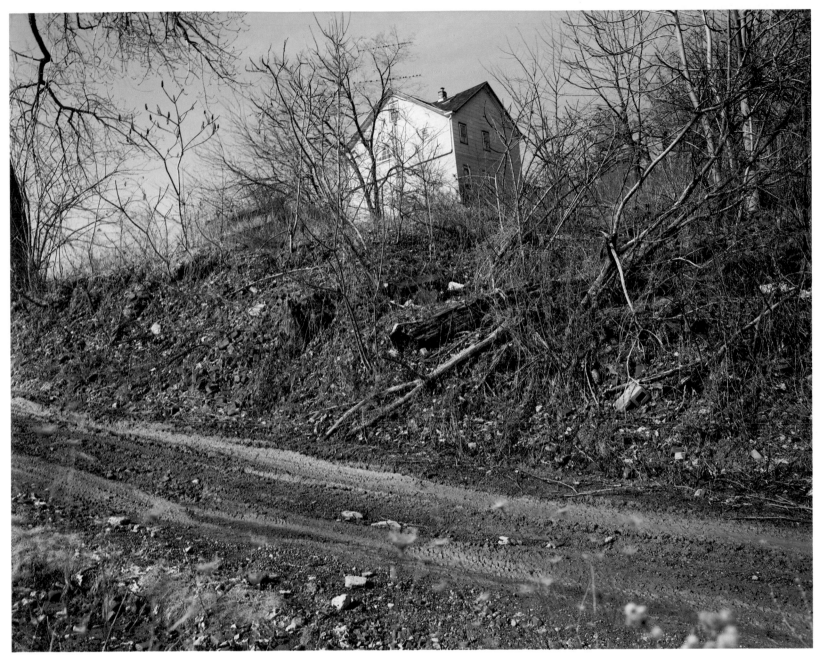

132 Ulster County, 1984

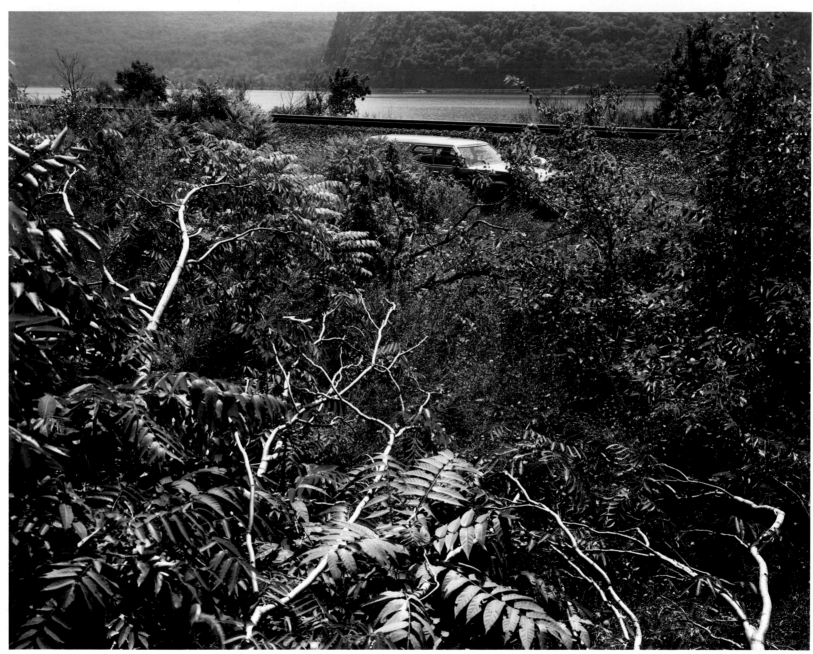

133 Putnam County, 1985

134 Ulster County, 1985

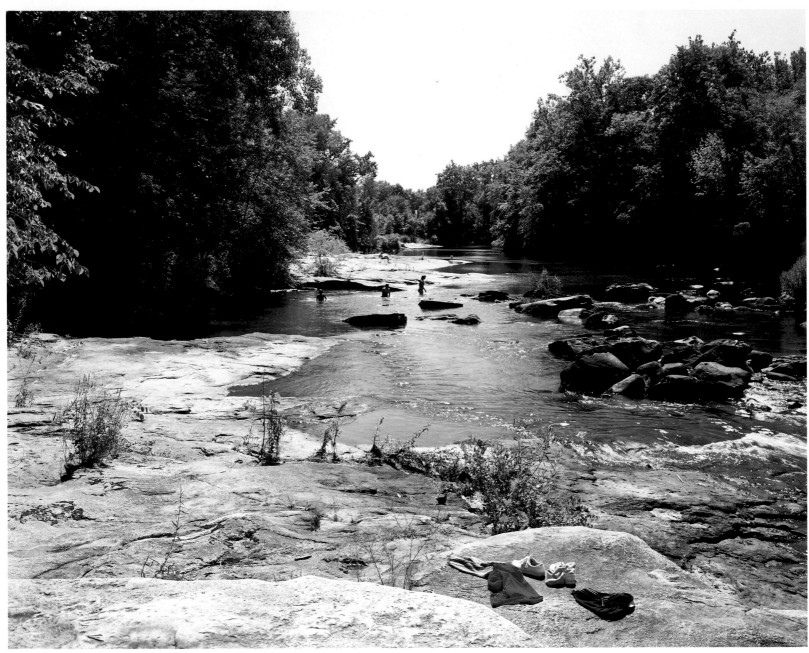

135 Ulster County, 1985

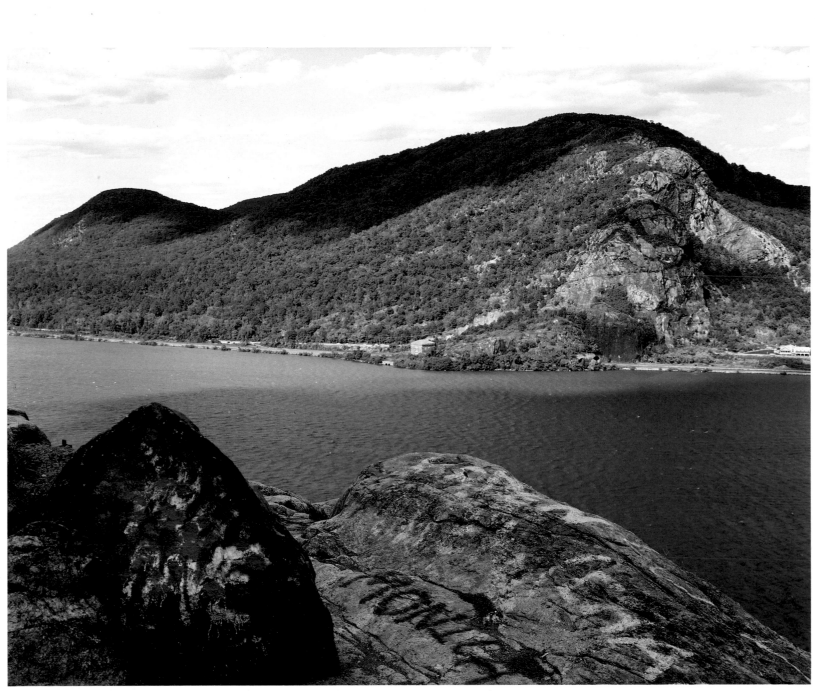

136 Orange County, 1985

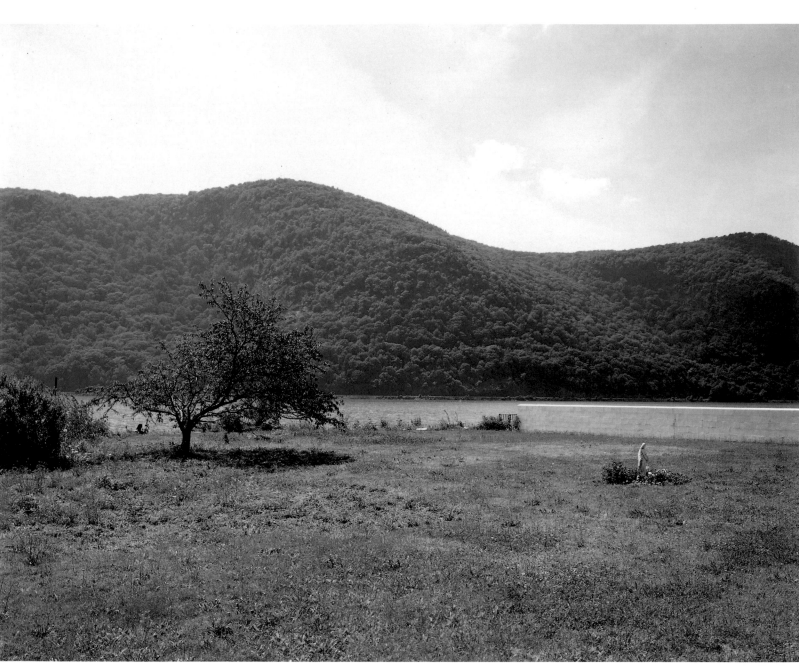

137 Putnam County, 1985

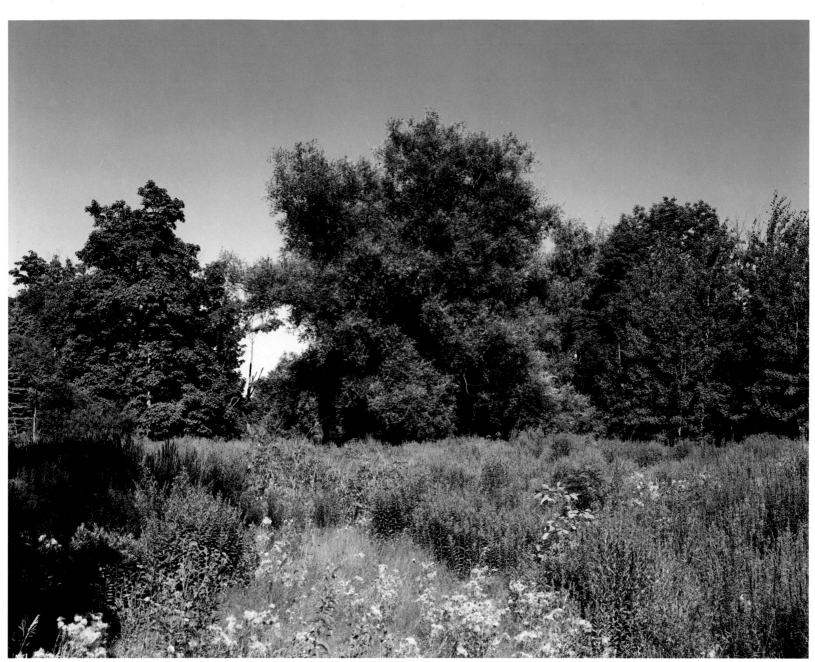

138 Ulster County, 1985

JOEL STERNFELD

Alaska at 25

It was inevitable that Joel Sternfeld would travel to Alaska. His ongoing essay "An American Prospect" had taken him to most of the Lower Forty-eight, where he had chronicled the American experience with hundreds of richly descriptive photographs whose meanings hinged on incongruity, paradox, and allusions to American history and literature.

Alaska alone, however, could offer Sternfeld the chance to fully explore the collision between the nineteenth-century frontier and twentieth-century progress. During his visit in 1984, the twenty-fifth year of Alaska's statehood, he encountered the issue of land use and the conflict between wilderness and technology that were long ago experienced in the American West.

In Alaska—as in the West a century ago—the central paradox is scale. Spaciousness has shaped the character of the country and its people, yet the state is as minuscule as it is immense. A population smaller than that of the city of San Jose resides in an area twice the size of Texas. Seen from an airplane with a high-powered telescope, the controversial Trans-Alaska pipeline seems no larger than a hair. But this nearly invisible mark is a prodigy of large-scale engineering that has altered or will alter the lives of every Alaskan resident.

Sternfeld noticed its consequences nearly everywhere in Alaska. Once-virgin landscapes are dotted with trailers, oil rigs, pumping stations, and pipeline workers' houses (government graded A, B, and C). Elk and bear roam amid the oil rigs and industry of Prudhoe Bay, a region otherwise much like the New Jersey Meadowlands in appearance. Snowmobiles ratchet the air, and Winnebagos cushion armchair tourists who have come all the way from Miami Beach to the Arctic Ocean. In Anchorage, the pipeline has meant more people, money, and enough smog, traffic jams, and fast-food stands to justify the nickname "Los Anchorage."

To deal with the discrepancy between the pipeline's relatively tiny size and its extensive impact, Sternfeld revived

an approach he had mastered in the late 1970s: the nearly subliminal presentation of information that dramatically alters a photograph's meaning. Two well-known examples of Sternfeld's method are a tranquil and lovely seascape that camouflages a contingent of dead whales, and an image of a raging fire destroying a farmhouse while a fireman picks out his Halloween pumpkin. In Alaska, where wilderness and civilization coexist in uneasy tension, Sternfeld photographed equally telling details: a white stretch limousine parked before the Portage Glacier, a smiling Eskimo holding a "ghetto-blaster" radio, and an old-fashioned log cabin hoisted up by a high-tech cherry picker. But the Alaskan photographs shown here cannot be read as one-liners; they intimate rather than dictate interpretation.

Sternfeld's photographs of the lower forty-eight states, taken at times of the day and in weather conditions when pale colors predominate, emphasize the anemia of pseudo-naturalistic environments—such as tract home developments named "Meadowlands" or "Timberline Estates"—that many Americans consider normal. For those who decry these buffered environments, Alaska beckons as a land of opportunity. Sternfeld found many men and women of pioneering spirit who have rejected mollycoddling, commercialism, and conformity and who thrive on Alaska's heady blend of risks and possibilities.

Sternfeld agrees with John McPhee and other chroniclers of contemporary Alaska that the bulk of the state's population divides into saints and sinners, people who have immigrated for either the purest or the impurest of reasons. But rather than vilify the state's outlaws, alcoholics, and nouveau-riche industrialists, or cynically mock the assorted do-gooders and Bible thumpers determined to save their souls, Sternfeld focused on the Alaskan prototypes he admired.

Hawk and Dove are among Alaska's young people who have opted for self-sufficiency, authentic experience, and a vigorous, direct relationship with nature. Their biodegradable cabin and roof garden (plate 140) would—if left untended—eventually collapse and disintegrate into the ground. Their names hark back not only to the counter-culture of the 1960s but also to frontier America, where people were often identified by their occupations, characteristics, or accomplishments. Hawk and Dove were recommended to Sternfeld by several people, some living as far as 300 miles away, the typical radius formed by many communities in Alaska. Paradoxically, vast distances make the huge country seem like a small town, with road-houses serving as centers of gossip and informal government.

The call of the wild brings many newcomers to Homer, Alaska, including a bearded fisherman, seen here admiring a shrimp (plate 146). Like the majority of Alaska's population, he is under the age of thirty and stands an even chance of returning to the mainland states within three or four years; the high turnaround is partly attributable to the impossibility of fulfilling wilderness fantasies inspired by calendar photographs. Sportsmen in particular are often bitterly disappointed when they learn that hunting, fishing, and wilderness exploration can only be done by renting float planes (plate 143) at well over a hundred dollars an hour. The era of elk behind every bush and salmon in every stream is history.

Few Alaskans have been in residence long enough to

possess historic consciousness. An exception is the nearly blind gardener whose delphiniums have been spurred to great heights by the midnight sun (plate 141). He is a true pioneer, an Alaskan founding father whose wisdom, generosity, and jack-of-all-trades practicality have been of inestimable help to many new settlers. He has lived in Homer since the 1940s, conducting biological research, and has lived to rue the town's metamorphosis into a weekend hideaway for Anchorage residents.

In Alaska's spaciousness, Sternfeld was drawn to distant views. Most of his scenes are unabashedly beautiful, unsettling only if the viewer is, ipso facto, disturbed by telephone and electrical wires, roads, and other signs that indicate habitation. The sign for "Majestic View Estates" suggests that the once pristine Matanuska Glacier is, or soon will be, ringed with tract homes with picture windows (plate 139). A log cabin under construction may be intended for year-round residency or vacation retreats. Whatever the case, the owner's temporary home is a recreational vehicle (plate 145). Log cabins in Alaska are fully functional—warm in winter, cool in summer—not simulated throwbacks to yesteryear. To Sternfeld, they epitomize Alaska's new–old dialectic at its best.

One might expect that the battle lines between development and preservation, free enterprise and regulation, would be clearly drawn. Instead, the very people who live simply and directly, treasuring the land and their isolation from society, are often those who adamantly declare their right to do with the land what they will, when they will. Conservationists are routinely denounced as "ecophiles" or "posy sniffers," and the Sierra Club is loathed as an intruder and adversary. The frontier mentality inadvertently aids the industrialization of the state.

Disturbed as he may be by the seemingly unstoppable invasion of technology and commercialism, Sternfeld nonetheless declines to adopt an incendiary, propagandistic style. His personal odyssey has led him to accept Americans as they are rather than crusade for what they ought to be. His pictures have grown increasingly resonant as he has gained the maturity to recognize the validity of opposing viewpoints. Their titles brief and factual and their message cumulative, Sternfeld's photographs represent his ongoing exploration of the material.

Sternfeld is highly assertive, however, in his deep commitment to compositional order and harmony. He finds strong concordances, between patches of snow and the dangling white of clothes on a line (plate 142), or in the repetitions and variations of line, tone, color, shape, and texture of a straightforward view containing log foundations, a recreational vehicle, water, and snowcapped peaks (plate 145). Sternfeld often invigorates the picture surface with patches of coruscating color. In these photographs, the facts described by his 8 x 10 inch view camera compete for supremacy according to optical laws rather than subjective importance. In one image, large neutral areas of sky, water, and buildings corral an orgy of color in striped seaplanes and vivid lawn (plate 143). But Sternfeld is not always so restrained; the dizzying stature and exuberance of bright-hued delphiniums camouflage the gardener, overwhelm our senses, and threaten to overrun the photograph's borders (plate 141).

Color absence also makes a point. Alaska—said to be so

beautiful that if it is not God's country, God ought to acquire it—is ironically muted in a view of the Basin Bible Church (plate 144). An abandoned freighter, in an image of subtle color duality, suggests the landscape's defeat of an inappropriate technology (plate 147). Yet a faint sign of life remains—like many of the photographs in Sternfeld's Alaskan essay, this picture is residential. The ladder on the freighter provides entry for a squatter.

Sternfeld perceives himself as a new journalist working, though photographically, in the manner of Edward Hoagland, Peter Matthieson, and John McPhee, writers whose prose rings true with clarity, accuracy, memorable detail, and marked absence of personal ego. He credits McPhee's book *Coming into the Country* for inspiring him to visit Alaska and found that his own experiences often verified McPhee's perceptions.

Having spent the past decade finding the ordinary incredible, Sternfeld went to Alaska in search of the incredible, which he feared might prove ordinary. Instead, Alaska suggested that the American frontier continues to be developed by people who are inspired by large-scale fantasies and uninhibited tall talk and who possess the flexibility to accept the unusual. Sternfeld found Alaska to be by turns unfamiliar, comfortable, incongruous, frustrating, and marvelous—the last bastion of America's frontier spirit.

139 Majestic View Estates, near the Matanuska Glacier, Alaska, August 1984

140 Dove Watering Her Roof Garden in the Matanuska Valley, near Sheep Mountain, Alaska, August 1984

141 James Calkins with His Delphiniums, Homer, Alaska, July 1984

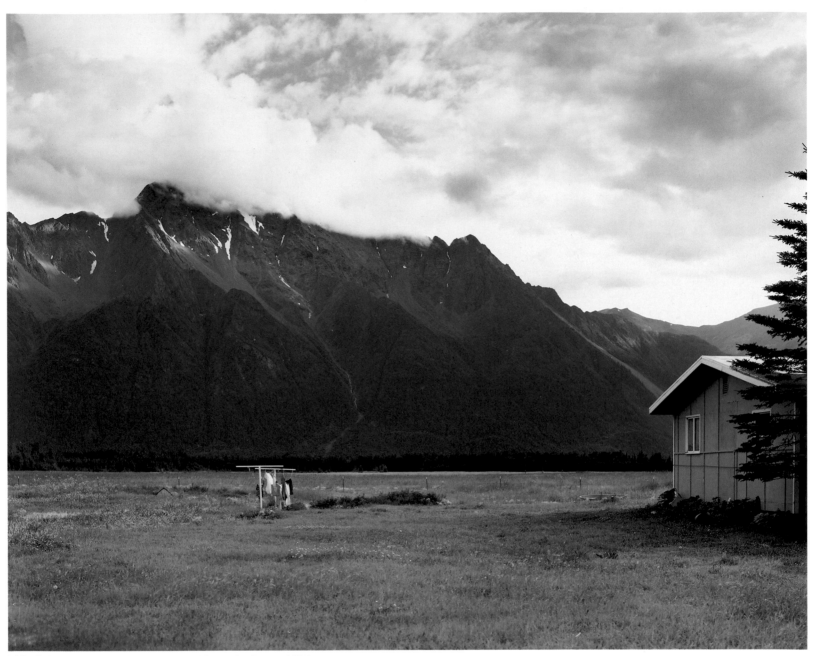

142 Palmer, Alaska, in View of Pioneer Mountain, August 1984

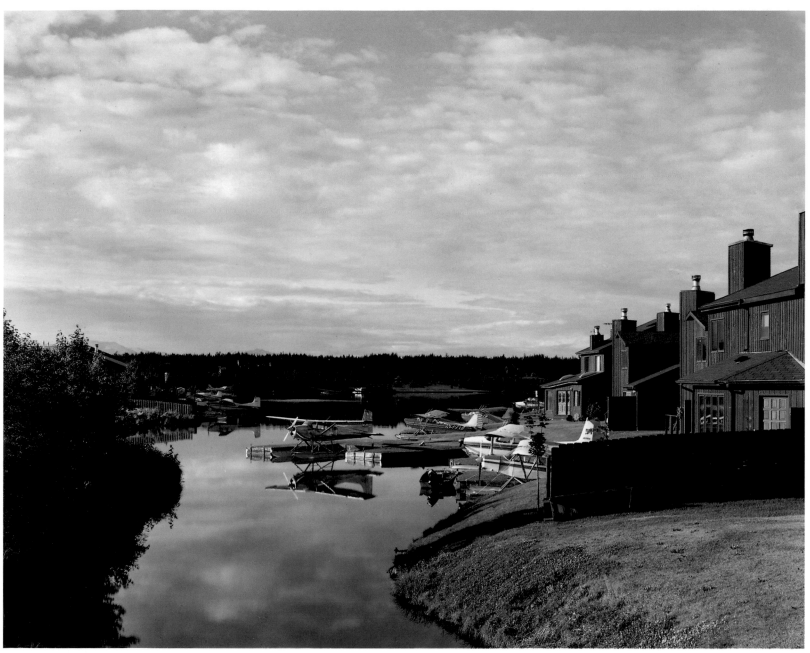

143 Condominiums, Suburban Anchorage, Alaska, July 1984

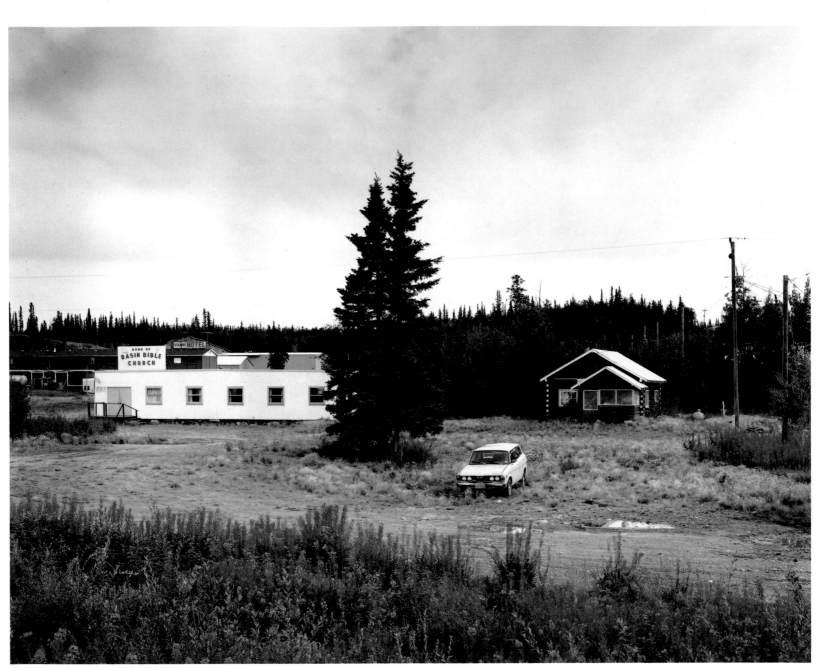

144 Glennallen, Alaska, August 1984

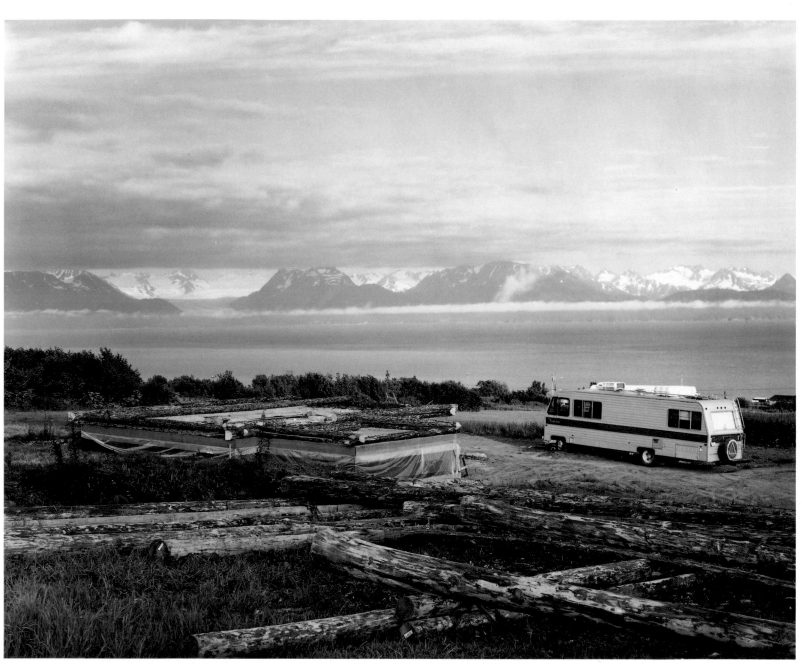

145 Log Cabin under Construction, Homer, Alaska, July 1984

146 Scott Burbank, Homer Spit, Alaska, July 1984

147 Abandoned Freighter, Homer Spit, Alaska, July 1984

JACK D. TEEMER, JR.

Personal Spaces

In the ethnic working-class backyards photographed by Jack D. Teemer, Jr., the people he portrays are rarely present. Instead, quirky decoration, religious statuary, pets, evidence of patching and fixing, landscaping or the lack thereof, and contrasts of clutter and tidiness reveal characteristics of ego, taste, achievement, class, and identity.

Teemer looks closely at the ordinary lives that might easily be overlooked, at spaces where the small, various, and personal hold sway. Though his subdued pastel colors and taut, packed compositions may not mime festivity, the photographs are meant to be celebratory. Teemer wishes to honor the individuals who have shaped these environments to be useful and meaningful.

With the exception of a photograph overlooking the city and another showing the yards off an alley (plates 149 and 154), each view concentrates on one family's space, usually a backyard hidden from the street. These are variously inviting, mysterious, frightening, whimsical, perplexing, or lackadaisical. Signs of life—the presence of children, toys, dogs, and clutter—offer clues but never clear descriptions of the people within.

Few of the houses and yards display the neatness that suburbanites equate with pride of ownership. Many are scavenger heaps of tables, chairs, planks, tires, cans, and other objects saved for some potential future use. Some owners iconicize one object, such as a hooded barbecue grill (plate 152) or a statue (plate 155), to serve as a yard's focal point or crossroads. The barbecue, nobly adorned with heraldic symbols, is featured in an especially inventive and exuberant use of space, with American flags, a sunflower whirligig, brightly colored towels, and patterned terrace. Business needs determine the arrangement of a backyard worm farm (plate 153), a checkerboard of wood partitions, concrete, bags of mulch, and dirt.

These are older neighborhoods, often adjacent to industry and considered disposable by urban planners who would

bulldoze them to build expressways, malls, or parking lots. The individuality of these spaces stands in marked contrast to the die-stamped designs of many housing projects and condominiums, whose uniformity precludes both the problems and pleasures of a multifaceted neighborhood life. Older communities are charming for their idiosyncrasies—varied topography and botany, channeled and multilayered views, individual forms of expression, and differences of use—all of them pictured in Teemer's photographs.

Fences, walls, and other enclosures indicate that these Americans regard their homes as their castles, and signs reinforce the barriers (plates 150 and 151). Predatory strangers enter these yards at their peril; the photographs suggest that dogs might outnumber human residents. One canine surveys the neighborhood from the roof of a house (plate 154), and three fluffy dogs of dubious ferocity peer through a fence understatedly posted "Beware of *the* Dog" (plate 151).

Actually, the fences are less a product of fear than of a fervent desire to mark one's own space and possessions. Most were installed when these communities were ethnically cohesive, so they do not guard against heterogeneity so much as they proclaim pride of ownership. Indeed, the fences are like picture frames around each yard.

In his title, "Personal Spaces," Teemer refers not only to each backyard's personality but also to his own formal photographic solutions. His fascination with these neighborhoods is matched by the pleasure he takes in rendering observed spaces into two-dimensional, peculiarly photographic images.

Forms float in and out of focus in staccato dances of light and shadow, but as part of compositional structures in which recurring motifs, hues, textures, and tonalities are interwoven. Except when viewed at extreme close range, individual components optically blend together. The tangled debris of foreground, middle ground, and background join on the planar surface; flora becomes the warp and shadows or reflections the weft of a lush, deep carpet. Motifs recur with sufficient frequency to coordinate otherwise unruly chromatic, textural, and spatial elements. In virtually all of the photographs, the grids of chain fences activate the colors beyond them. In plate 148, the floral design of a hanging coverlet joins the patterns of genuine flowers and leaves, trellises, bricks, clapboard, and other objects to form a striking patchwork quilt.

Analyzing why cities do and do not work, in *The Death and Life of Great American Cities*, Jane Jacobs noted that "almost nobody travels willingly from sameness to sameness and repetition to repetition, even if the physical effort required is trivial. . . . Differences," she says, "not duplications, make for cross use and hence for a person's identification with an area greater than his immediate street network." Similarly, Teemer's gravitation toward exotic groupings of colors, textures, and forms suggests that it is not the number of small elements, but their unique congregations that provide the visual interest that keeps both cities and photographs lively.

Teemer's personal spaces are stage sets awaiting the arrival of human players. The classical 4 x 5 proportion of his frame, combined with his intense compression of interweaving visual motifs, invests these pictures with a quality of suspension that contributes to such a reading. The scenes

are structured for viewers to vicariously peep through the many fences that veil, disguise, and contain the lives within.

Teemer says, "My photographs are beautiful because I need beauty, and organized because I need organization. It is also a way to entrust a sense of integrity for these people. I am not making fun of their tacky taste or their ignorant sense of design, form, and relationship. I feel alive when touching these people's lives, in the streets and in their personal spaces, particularly the people of a different culture or social class. I am reminded of what is truly important in life—love, empathy, and human relationships."

148 Dayton, 1983

149 Pittsburgh, 1984

150 Dayton, 1983

151 Dayton, 1984

152 Pittsburgh, 1984

153 Dayton, 1983

154 Baltimore, 1980

155 Dayton, 1983

DANIEL S. WILLIAMS

Emancipation Day

Many white Americans—and many blacks—have never heard of Emancipation Day celebrations. These events, commemorating the abolition of slavery, differ from most national holidays in several respects: they are held only sporadically, depend on local initiative, and are staged on different days in various parts of the country.

January 1, the anniversary of Lincoln's Emancipation Proclamation of 1863, is usually considered Emancipation Day, though September 22, the anniversary of Lincoln's Preliminary Emancipation Proclamation, also has supporters, as does August 1, for the day in 1833 when Great Britain abolished slavery in its colonies. Alternatively, states may celebrate Emancipation Day on National Freedom Day (February 1, when the Thirteenth Amendment was signed in 1865), on the date the state adopted this constitutional amendment, on the date the state abolished slavery, or on whatever date the state's black population first received word that they were free.

Daniel S. Williams discovered Emancipation Day celebrations by accident, when he was already thirty-nine. As a black American, he vowed to record this part of his heritage and to revive interest in this custom, which has been dying out since World War II. Many middle-class blacks decline to celebrate Emancipation Day because it reminds them that their ancestors were slaves, but for Williams, the drive to achieve equal justice and opportunity that is commemorated by the event is the heart of the American dream.

In these photographs, Williams stresses the tragic and the heroic, the resignation and the affirmation to be found in the commonplace rather than in dramatic personalities and events. People party with family and friends, convivial men drink beer and clasp arms in the rain (plate 156); a trio of impish boys pose with motorcycles (plate 161); a pair of small boys peep out of a decorated pickup truck that is equipped with a Michael Jackson poster and a "boom

box" (plate 159); and a group of women relax outdoors (plate 160).

Traditionally, Emancipation Day is family oriented; homecoming is often a theme. Indeed, its decline has followed the breakup of extended families that accompanied the flow of black labor to the North during World War I and World War II. Families living in different cities no longer celebrate on the same day; friends brought together in northern locales rarely share the same Emancipation Day tradition.

In Thomaston, Georgia, typical family-oriented events are held on May 26, the day in 1865 that news traveled to the local residents. Despite its small size, Thomaston stages a major Emancipation Day celebration that attracts scores of out-of-state visitors, including many former residents who return South to visit their relatives and join in the festivities (plates 156, 157, 159, 160, and 161).

One of the grandest of Emancipation Days was held in Houston, Texas, from June 13 to 19, 1984 (plates 158, 162, and 163). "Juneteenth" is a state holiday in Texas, commemorating June 19, 1865, the date Gen. Gordon Granger, commander of the military district of Texas, notified the slaves that they were free. The festival included media-hyped events, parades, dinners, parties, "name" entertainers, and corporate sponsors. In contrast to his more subdued approach at rural celebrations, Williams used his film to exaggerate the garish polyester colors and the brassy celebratory ambience.

While admiring Garry Winogrand's eye for the comic, characteristic, and convergent, Williams rejects Winogrand's confrontational style for one that is participatory.

Like many photographers of the 1980s, he fears that the sharp scalpel with which Winogrand brilliantly excised the bombast, pretentions, and simple-minded slogans of the 1960s can be easily misused to intrude the photographer's opinions and personality. Williams's joining of reportage, candid empathy, and humanistic reverence for individual dignity and value is more old-fashioned. But Williams is no idealizing sentimentalist. His photographs make the ordinary vividly apparent.

Surrounded by so much staged drama, Williams generally ignored the featured events and chose incidents that became significant when framed and frozen by the flash of his camera. Fortuitous coincidences abound. An interracial teenage couple stands under a tree while rope from the nearby awning dangles above them like a noose, perhaps a dire prophecy but surely a reminder of the past (plate 158). A poster bearing the word "bull" mocks the empty, macho posturing of a man's karate kick, and his head seems severed from his body (plate 157).

The religious fervor often present at these gatherings is captured by flash-lit, burned-out foregrounds and naturally illuminated backgrounds. Subjects often seem lurid and startled, ringed by murky shadows and dramatic twilight skies. Messianic zeal is seen in a woman whose hands are raised in ecstasy (plate 162). The portentous mood of a lineup of people, many of whom guardedly look to the right, is exacerbated by a balloon in the air, which at first appears to be a stain on the print (plate 163).

Williams reveals a spirit in these celebrations that originated over a century ago. In his book *There Is a River: The Black Struggle for Freedom in America* (Harcourt Brace

Jovanovich, 1981), historian Vincent Harding writes of the first major celebration in 1865:

The signs were everywhere, even on the calendar. For a people caught up in messianic expectations, looking for the kingdoms of this world to become the liberated kingdoms of their God, it was surely no mere coincidence that the first day of 1865 was also Sunday, the Lord's Day. So after resting briefly from their Watch Night services, they went back again to the Sunday church gatherings, putting off their formal celebration of the Emancipation Proclamation until the next day. Then on the third day of excitement and hope they rose again, this time pouring out of the buildings and the fields, marching, singing, often following the drums and cadences of their black soldiers, carrying their children, helping the old folk, listening to speeches, sermons, and songs, then breaking bread—and much more—together.

Signs, intimations, ecstasies, urgent challenge—such words still befit the Emancipation Day celebrations that Williams has recorded. These jamborees call for a new beginning—not one that forgets the past but one that seeks to overcome it and transform its meaning. As a photographer, Williams must believe that black visibility is a step toward black power.

156 Thomaston, Georgia, May 23, 1984

157 Thomaston, Georgia, May 1984

158 Juneteenth Celebration, Houston, Texas, June 19, 1982

159 Thomaston, Georgia, 1984

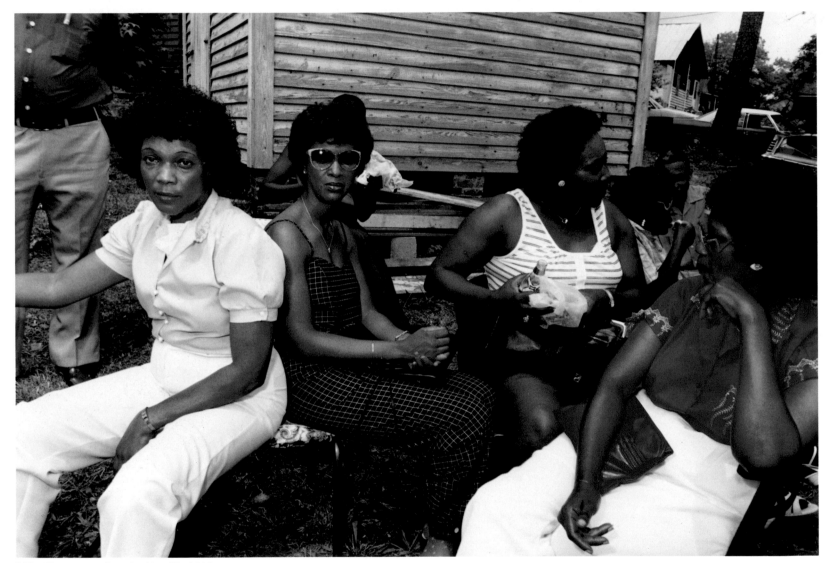

160 Thomaston, Georgia, May 23, 1983

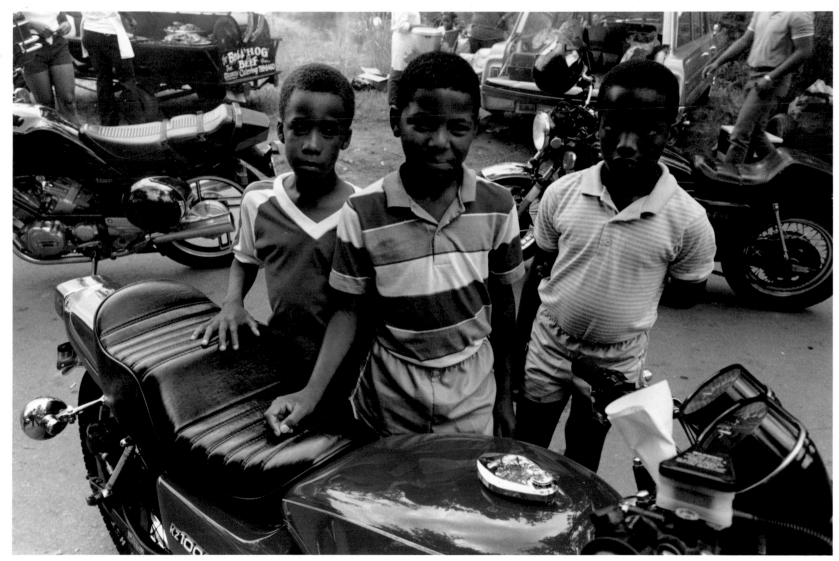

161 Thomaston, Georgia, May 23, 1984

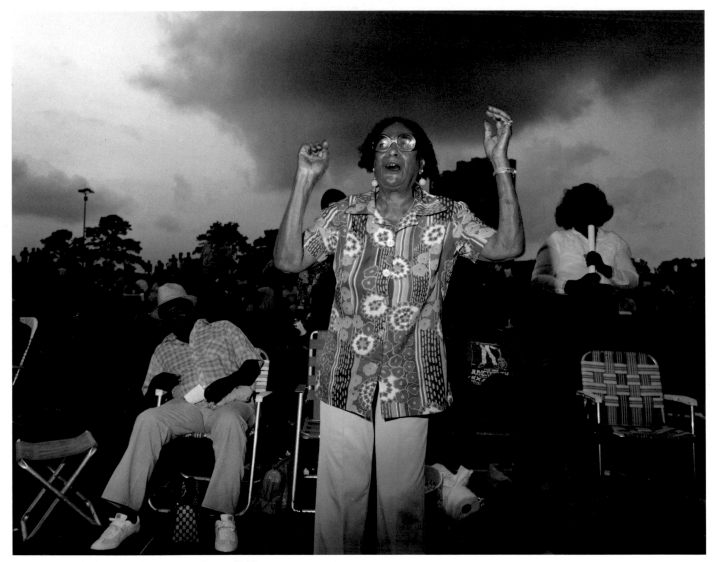

162 Juneteenth Celebration, Houston, Texas, 1983

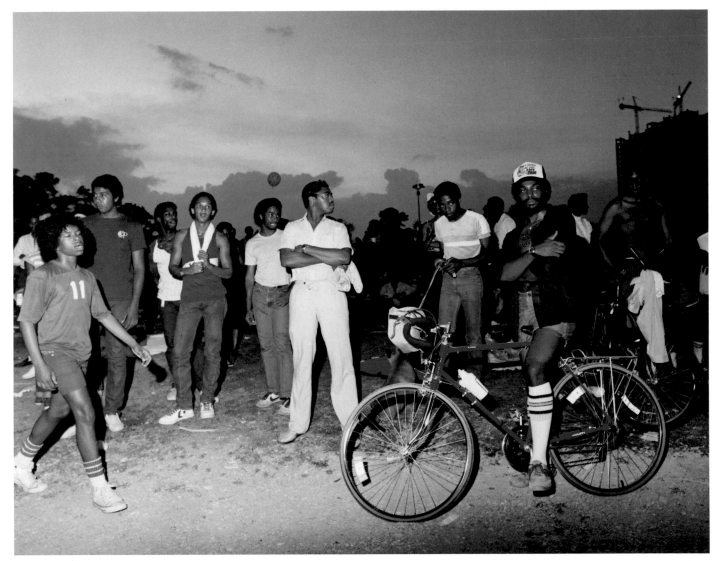

163 Juneteenth Celebration, Houston, Texas, 1982

Photography Copyrights and Credits

Larry Babis: © 1973 plates 5, 9; © 1974 plates 3, 7; © 1975 plates 6, 8; © 1976 plates 1, 2; © 1977 plate 4. All photographs courtesy of the photographer.

Jim Dow: © 1978 plate 11; © 1979 plate 16; © 1980 plates 10, 15, 18, 19; © 1981 plates 12, 13, 14, 17. All photographs courtesy of the photographer.

William Eggleston: © 1984 plates 20, 21, 22, 23, 24, 25, 26, 27, 28, 29, 30, 31. All photographs courtesy of the photographer and Middendorf Gallery, Washington, D.C.

Mitch Epstein: © 1981 plates 39, 41; © 1983 plates 32, 33, 34, 35, 36, 37, 38, 40. All photographs courtesy of the photographer.

David T. Hanson: © 1982 plates 45, 46; © 1984 plates 42, 43, 44, 47, 48, 49, 50. All photographs courtesy of the photographer.

John Harding: © 1983 plates 51, 52, 53, 54, 55, 56, 57, 58. All photographs courtesy of the photographer.

Len Jenshel: © 1978 plate 68; © 1979 plate 59; © 1980 plates 60, 63; © 1981 plate 64; © 1984 plate 65; © 1985 plates 61, 62, 66, 67, 69. All photographs courtesy of the photographer.

Nancy Lloyd: © 1983 plates 70, 71, 76; © 1984 plate 72; © 1985 plates 73, 74, 75, 77. All photographs courtesy of the photographer.

Kenneth McGowan: © 1977 plate 79; © 1978 plate 81; © 1979 plate 80; © 1981 plate 78; © 1983 plate 83; © 1984 plates 84, 85; © 1985 plate 82. All photographs courtesy of the photographer and Marvin Heiferman, Photographs, New York.

Roger Mertin: © 1985 plates 86, 87, 88, 89, 90, 91, 92, 93, 94, 95. All photographs courtesy of the photographer.

Joel Meyerowitz: © 1968 plate 96; © 1973 plate 103; © 1974 plate 98; © 1975 plates 97, 100; © 1976 plates 99, 101, 102, 104. All photographs courtesy of the photographer.

Richard Misrach: © 1983 plates 106, 109, 110; © 1984 plates 105, 108, 111, 112; © 1985 plate 107. All photographs courtesy of the photographer and Fraenkel Gallery, San Francisco.

Joanne Mulberg: © 1982 plate 113; © 1983 plates 114, 117; © 1984 plates 116, 118, 119, 120; © 1985 plate 115. All photographs courtesy of the photographer.

Stephen Scheer: © 1984 plates 121, 122, 123, 125, 128, 129, 130; © 1985 plates 124, 126, 127. All photographs courtesy of the photographer.

Stephen Shore: © 1984 plates 131, 132; © 1985 plates 133, 134, 135, 136, 137, 138. All photographs courtesy of the photographer and Pace/MacGill Gallery, New York.

Joel Sternfeld: © 1984 plates 139, 140, 141, 142, 143, 144, 145, 146, 147. All photographs courtesy of the photographer and Pace/MacGill Gallery, New York.

Jack D. Teemer, Jr.: © 1980 plate 154; © 1983 plates 148, 150, 153, 155; © 1984 plates 149, 151, 152. All photographs courtesy of the photographer.

Daniel S. Williams: © 1982 plates 158, 163; © 1983 plates 160, 162; © 1984 plates 156, 157, 159, 161. All photographs courtesy of the photographer.

Photographers' Biographies

Larry Babis

Larry Babis was born in New York City in 1949. He received his B.F.A. in 1975 from Cooper Union in New York City, where he studied with Joel Meyerowitz and Tod Papageorge, and briefly with Garry Winogrand. During the same period he studied drawing, silkscreen printing, Spanish guitar, and animated filmmaking.

In the mid-1970s Babis spent two years photographing the double houses and postage stamp–size gardens of Brooklyn and Queens. He then increased his range of subjects and locations, riding buses to the New Jersey coast and trains to Philadelphia and Chicago. By 1976 he was journeying all over America, hitchhiking or traveling by small plane and Land-Rover. Since then Babis has photographed in Canada, Mexico, Egypt, Italy, and Australia. A portfolio of his Australian landscapes was published in *New Color/New Work* (Abbeville, 1984). He has lived in Missoula, Montana, since 1985.

The photographs in "Got What It Takes till It Breaks" were made on 35mm Kodachrome II film with an M2 Leica using 35mm or 28mm lenses. The strobe unit used on some of the exposures was a Braun RL515.

Awards

1977 National Endowment for the Arts Individual Photographer's Fellowship.

Selected Group Exhibitions

1975 *Color Photographs*, Houghton Gallery, Cooper Union, New York.
1976 *Spectrum*, Rochester Institute of Technology, Rochester, New York.
1977 *Contemporary Color Photography*, Bard College, Annandale-on-Hudson, New York.
1981 *Photography: Cooper Union's Products of the Seventies*, Houghton Gallery.
 The New Color: A Decade of Color Photography, Everson Museum of Art, Syracuse, New York (traveling exhibition).
1983 *Response to Nature*, Tisch School of the Arts, New York University.
1984 *Exposed and Developed*, National Museum of American Art, Smithsonian Institution, Washington, D.C. (traveling exhibition).
 New Color/New Work: Eighteen Photographic Essays, Addison/Ripley Gallery (joint exhibition with Kathleen Ewing Gallery, Middendorf Gallery, and Jones Troyer Gallery), Washington, D.C.
1985 *Photography from the Permanent Collection*, National Museum of American Art.
 New Color/New Work: Eighteen Photographic Essays, Museum of Contemporary Photography, Columbia College, Chicago.
1986 *Twenty-Five Years of Modern Color Photography*, Photokina, Cologne, West Germany.

Selected Public Collections

Museum of Contemporary Photography, Columbia College, Chicago.
National Museum of American Art, Smithsonian Institution, Washington, D.C.

Jim Dow

Jim Dow was born in 1942 in Boston and currently lives in Belmont, Massachusetts. He studied with Harry Callahan at the Rhode Island School of Design, Providence, where he received his B.F.A. in graphic design and photography in 1965 and his M.F.A. in 1968.

Since 1972 Dow has documented the American vernacular, first in black and white and, since 1980, in color. His direction was set in the late 1960s after reading Walker Evans's *American Photographs*, which affected him deeply. After graduating from RISD, Dow printed for Evans for two years in preparation for the Walker Evans retrospective held at the Museum of Modern Art in 1972.

In 1976 Dow was one of twenty-four American photographers chosen to photograph the interiors and exteriors of American courthouses for the Joseph E. Seagram and Sons Bicentennial book and exhibition *Court House* (Horizon, 1977). Fascinated with courthouses not only for their myriad architectural styles but also because they are so often at the center of American life, Dow photographed more than two hundred of them. Since 1980 Dow has made multiple-image panoramas of soccer fields, rugby stadiums, and ballparks in America, Argentina, and Great Britain. These have been reproduced in *Camera Arts* magazine (October 1982), *New Color/New Work* (Abbeville, 1984), and *Spirit of Sport* (New York Graphic Society, 1985).

Dow has been on the faculty of the School of the Museum of Fine Arts, Boston, since 1973, and has been photographing the photography collection of the Canadian Centre for Architecture since 1976.

Dow works with an 8 x 10 inch Deardorff view camera with normal- to wide-angle lenses. He uses Vericolor S or L film with ambient light, sometimes supplemented with flashbulbs. Dow makes his own 8 x 10 inch contact prints.

Awards and Commissions

1972 National Endowment for the Arts Individual Photographer's Fellowship.
1975 John Simon Guggenheim Memorial Foundation Photographer's Fellowship.
1976 Commission from Joseph E. Seagram and Sons to photograph for the Bicentennial book and exhibition *Court House*.
1979 National Endowment for the Arts Individual Photographer's Fellowship.

1984 Commission from the Olympic Arts Festival and the Los Angeles Center for Photographic Studies to photograph at the 1984 Summer Olympics.
Commission from Polaroid Corporation and *Close-Up* magazine to photograph soccer stadiums in Great Britain and Argentina.
1985 Commission from the Cambridge 7 Architects and the Basketball Hall of Fame to photograph the Boston Garden.
1986 Commission to photograph for *Portfolio*, yearbook of the Rhode Island School of Design, Providence.

Selected Solo Exhibitions

1980 Nexus Galleries, Atlanta, Georgia.
1982 Light Works/Community Darkroom, Syracuse, New York.
Crescent Art Centre, Scarborough, England.
1983 Fay Gold Gallery, Atlanta, Georgia.
Brent Sikkema/Vision Gallery, Boston.
Robert Freidus Gallery, New York.

Selected Group Exhibitions

1977 *Court House*, Museum of Modern Art, New York (American Institute of Architects and Joseph E. Seagram and Sons traveling exhibition).
1982 *Photography in Color*, Stockton State College, Pomona, New Jersey.
Harry Callahan and His Students, Georgia State University, Atlanta (Southern Arts Foundation traveling exhibition).
1984 *New Color/New Work: Eighteen Photographic Essays*, Jones Troyer Gallery (joint exhibition with Addison/Ripley Gallery, Kathleen Ewing Gallery, and Middendorf Gallery), Washington, D.C.
1985 *New Color/New Work: Eighteen Photographic Essays*, Museum of Contemporary Photography, Columbia College, Chicago.

Selected Public Collections

Art Institute of Chicago.
Museum of Fine Arts, Boston.
Museum of Modern Art, New York.
National Museum of American Art, Smithsonian Institution, Washington, D.C.

William Eggleston

William Eggleston was born in Memphis in 1939, attended three colleges in Tennessee and Mississippi, and graduated from none. He took up photography in 1962 after seeing the work of Henri Cartier-Bresson and has worked in color since 1966.

Eggleston's solo exhibition at the Museum of Modern Art in New York City in 1976 prompted widespread museum recognition for color photography as an art form and aroused considerable controversy. Eggleston's proponents were hard-pressed to articulate why they found certain works potent, suggestive, and complex, and detractors felt that the museum curators were conning the public. Photographs that seemed "perfect" to one critic seemed "perfectly banal" to the next. The flak, however, was minor compared to what might have ensued had John Szarkowski's catalog, *William Eggleston's Guide*, been published under its original title, *William Eggleston's Guide to Perfect Color Photography*.

Eggleston was a lecturer in visual and environmental studies at the Carpenter Center for the Visual Arts, Harvard University, Cambridge, Massachusetts, in 1974, and a researcher in color video at the Massachusetts Institute of Technology, Cambridge, in 1978–79. Although best known for his photographs of the American South—particularly of Tennessee, Mississippi, and New Orleans—Eggleston has also photographed in Africa, Great Britain, Germany, and Austria.

Portfolios of Eggleston's photographs have been reproduced in *American Images: New Work by Twenty Contemporary Photographers* (McGraw-Hill, 1979), *The New Color Photography* (Abbeville, 1981), *Annie on Camera* (Abbe-

ville, 1982), and *New Color/New Work* (Abbeville, 1984). He lives in Memphis.

The over twelve thousand photographs in "The Democratic Forest" series were all shot with 35mm cameras, most of which were Leicas or Canons. Eggleston uses either Vericolor or Kodacolor film. Ektacolor prints, 16 x 20 inches, were made by Bob Liles of Memphis.

Awards and Commissions

1974 John Simon Guggenheim Memorial Foundation Photographer's Fellowship.
1975 National Endowment for the Arts Individual Photographer's Fellowship.
1978 Commission from AT&T to photograph for the book and exhibition *American Images: New Work by Twenty Contemporary Photographers*.
National Endowment for the Arts Survey Grant for a photographic and color video survey of Mississippi cotton farms.
1981 Commission from Columbia Pictures to photograph the making of the film *Annie*.
1983 Commission from the Elvis Presley Estate to photograph Graceland mansion for the commemorative book *Elvis at Graceland* (Cypress, 1983).
1985 Commission from David Byrne to photograph Texas for the book *True Stories* (Viking, 1986).

Selected Solo and Two-Person Exhibitions

1974 Jefferson Place Gallery, Washington, D.C.
1975 Carpenter Center for the Visual Arts, Harvard University, Cambridge, Massachusetts.
1976 Museum of Modern Art, New York (traveling exhibition).
1977 Corcoran Gallery of Art, Washington, D.C.
Lunn Gallery, Washington, D.C.
Frumkin Gallery, Chicago.
Castelli Graphics, New York.
Brooks Memorial Art Gallery, Memphis, Tennessee.

1978 Laguna Gloria Art Museum, Austin, Texas.
1980 Charles Cowles Gallery, New York.
1983 Fotogalerie um Forum Stadtpark, Graz, Austria (traveling exhibition).
Werkstatt für Fotografie, West Berlin.
Victoria and Albert Museum, London.
1984 Art Institute of Chicago.
Robert Miller Gallery, New York.
Middendorf Gallery, Washington, D.C.
1985 *William Eggleston and William Christenberry*, Burden Gallery, New York.

Selected Group Exhibitions

1972 *Photography Workshop Invitational*, Corcoran Gallery of Art, Washington, D.C.
1974 *Art Now '74*, Kennedy Center for the Performing Arts, Washington, D.C.
1975 *14 American Photographers*, Baltimore Museum of Art (traveling exhibition).
1977 *Contemporary American Photographic Work*, Museum of Fine Arts, Houston, Texas.
The Contemporary South, New Orleans Museum of Art, New Orleans, Louisiana (United States Information Agency traveling exhibition).
1978 *Amerikanische Landschaftsphotographie, 1860–1978*, Neue Sammlung, Munich, West Germany.
Photographs from the Wagstaff Collection, Corcoran Gallery of Art (traveling exhibition).
Mirrors and Windows: American Photography since 1960, Museum of Modern Art, New York (traveling exhibition).
1979 *Photographie im Alltags Amerikas*, Kunstgewerbemuseum, Zurich, Switzerland.
American Images: New Work by Twenty Contemporary Photographers, Corcoran Gallery of Art (traveling exhibition).
American Photography in the 1970s, Art Institute of Chicago.
1981 *Color in Contemporary Photography*, University Museum, Southern Illinois University, Carbondale.

The New Color: A Decade of Color Photography, Everson Museum of Art, Syracuse, New York (traveling exhibition).
1982 *Slices of Time: California Landscape Photography: 1860–1880, 1960–1980*, Oakland Museum, Oakland, California.
Photography in Color, Stockton State College, Pomona, New Jersey.
Twentieth-Century Photographs from the Collection of the Museum of Modern Art, Seibu Department Store Gallery, Tokyo.
Color as Form: The History of Color Photography, International Museum of Photography at George Eastman House, Rochester, New York, and Corcoran Gallery of Art.
Floods of Light: Flash Photography, 1851–1981, Photographer's Gallery, London.
1983 *Subjective Vision: Photographs from the Lucinda W. Bunnen Collection*, High Museum of Art, Atlanta, Georgia.
1984 *New Color/New Work: Eighteen Photographic Essays*, Middendorf Gallery (joint exhibition with Addison/Ripley Gallery, Kathleen Ewing Gallery, and Jones Troyer Gallery), Washington, D.C.
1985 *New Color/New Work: Eighteen Photographic Essays*, Museum of Contemporary Photography, Columbia College, Chicago.
1986 *Twenty-Five Years of Modern Color Photography*, Photokina, Cologne, West Germany.

Selected Public Collections

Art Institute of Chicago.
Corcoran Gallery of Art, Washington, D.C.
High Museum of Art, Atlanta, Georgia.
Museum of Modern Art, New York.

Mitch Epstein

Mitch Epstein was born in 1952 in Holyoke, Massachusetts. In 1974 he attended Cooper Union in New York City, where he was most

influenced by teacher Garry Winogrand. In 1977 Epstein taught at the Carpenter Center for the Visual Arts, Harvard University, Cambridge, Massachusetts.

Portfolios of Epstein's work have appeared in *The New Color Photography* (Abbeville, 1981), *Annie on Camera* (Abbeville, 1982), and *New Color/New Work* (Abbeville, 1984). As a free-lance editorial photographer, he has published in the *New York Times Sunday Magazine, Cuisine,* and other publications. Although best known for his still photographs, taken in India, Italy, Egypt, and America, Epstein is also a gifted cinematographer. His films include *So Far from India* (1982) and *India Cabaret* (1985), both produced and directed by Mira Nair. Epstein lives in New York City.

Epstein uses either a 6 x 9 cm Palm Press camera with a 65mm Schneider Super-Angulon lens or a Fujica GW 690 with a 90mm Fujica lens. Film was Kodacolor 400, ASA 120. If a strobe was used, it was a Norman 200 B or a Rollei Beta 5. Otherwise, the photographs were made with existing light. All prints are Ektacolor, 22 x 14¾ inches.

Awards and Commissions

1978 National Endowment for the Arts Individual Photographer's Fellowship.
1980 New York State Council on the Arts Creative Artists Public Service Program (CAPS) Photographer's Fellowship.
1981 Commission from Columbia Pictures to photograph the making of the film *Annie*.
1983 One of ten photographers selected for the project and book *A Day in the Life of London* (Jonathan Cape, 1983).

Selected Solo and Two-Person Exhibitions

1980 Vision Gallery, Boston.
1981 Light Gallery, New York.
1982 Light Gallery.
Mitch Epstein and Rosalind Solomon, Dubose Gallery, Houston, Texas.

1983 Hampshire College, Amherst, Massachusetts.
1984 H. F. Manès Gallery, New York.

Selected Group Exhibitions

1981 *New American Colour Photography*, Institute of Contemporary Arts (ICA), London.
Love Is Blind, Castelli Graphics, New York.
Light/Color, Handwerker Gallery, Ithaca College, Ithaca.
Color Photography: New Images, Mandeville Art Gallery, San Diego, California.
Photography: Cooper Union's Products of the Seventies, Houghton Gallery, Cooper Union, New York.
The New Color: A Decade of Color Photography, Everson Museum of Art, Syracuse, New York (traveling exhibition).

1982 *Photography in Color*, Stockton State College, Pomona, New Jersey.
Color as Form: The History of Color Photography, International Museum of Photography at George Eastman House, Rochester, New York, and Corcoran Gallery of Art, Washington, D.C.
Window, Room, Furniture, Houghton Gallery (traveling exhibition).

1983 *High Light: The Mountain in Photography from 1840 to the Present*, International Center of Photography, New York.

1984 *New Color/New Work: Eighteen Photographic Essays*, Addison/Ripley Gallery *(joint exhibition with Kathleen Ewing Gallery, Middendorf Gallery, and Jones Troyer Gallery), Washington, D.C.*
Color Photographs: Recent Acquisitions, Museum of Modern Art, New York.

1985 *Traveling*, Addison Gallery of American Art, Phillips Academy, Andover, Massachusetts.
New Color/New Work: Eighteen Photographic Essays, Museum of Contemporary Photography, Columbia College, Chicago.

1986 *Twenty-Five Years of Modern Color Pho-*

tography, Photokina, Cologne, West Germany.

Selected Public Collections

Australian National Gallery, Canberra.
Bibliothèque Nationale, Paris.
Corcoran Gallery of Art, Washington, D.C.
Museum of Contemporary Photography, Columbia College, Chicago.
Museum of Fine Arts, Boston.
Museum of Modern Art, New York.
Vassar College Art Museum, Poughkeepsie, New York.

David T. Hanson

David Taverner Hanson was born in 1948 in Billings, Montana. He received his B.A. in English literature from Stanford University, Palo Alto, California, in 1970 and his M.F.A. in photography from the Rhode Island School of Design, Providence, in 1983. He taught at the Phillips Academy, Andover, Massachusetts, from 1975 to 1978 and has taught at the Rhode Island School of Design since 1983. Hanson was a technical assistant and apprentice to Minor White in 1973–74 and an assistant to photographer Frederick Sommer in 1980–81. He was director in charge of gallery and traveling exhibitions at the Center for Photographic Studies, Louisville, Kentucky, in 1974–75.

Prior to beginning the Colstrip series, Hanson photographed the wilderness in western national parks. Gradually, he began to include man-made elements in his landscapes. At Colstrip he discovered for the first time a way to address larger social and environmental issues.

In 1982 *Aperture* magazine (no. 89) published a transcription of a conversation between Hanson and critic Max Kozloff entitled "Photography: Straight or on the Rocks." Hanson currently divides his time between Billings, Montana, and Providence, Rhode Island.

Hanson uses a Plaubel Makina 6 x 7cm camera with a Nikkor 80mm f2.8 lens and Vericolor

120 film (VPS, VPL, and VCS). He exhibits 9 x 11 inch Ektacolor Type 78 prints.

Awards

1978 Camargo Foundation Fellowship in Photography.
1984 Rhode Island State Arts Council Photography Fellowship.
1985 John Simon Guggenheim Memorial Foundation Photographer's Fellowship.
1986 National Endowment for the Arts Individual Photographer's Fellowship.

Selected Solo Exhibitions

1979 Camargo Foundation, Cassis, France.
1981 Castle Gallery, Billings, Montana.
1986 Sheldon Memorial Art Gallery, University of Nebraska, Lincoln.

Selected Group Exhibitions

1976 University Museum, Southern Illinois University, Carbondale.
1978 Addison Gallery of American Art, Phillips Academy, Andover, Massachusetts.
1981 Summer show, Fifth Avenue Gallery of Photography, Scottsdale, Arizona.
1984 Faculty show, Museum of Art, Rhode Island School of Design, Providence.
 Color Photographs: Recent Acquisitions, Museum of Modern Art, New York.
1985 *Western Spaces*, Burden Gallery, New York, and Tyler Art Gallery, State University of New York, Oswego.
 American Images, Barbican Art Gallery, London (traveling exhibition).
 Four Landscape Photographers, Atrium Gallery, University of Connecticut, Storrs.
1986 *Three Photographers* (with Vance Gellart and Jack Stuler), Northlight Gallery, Arizona State University, Tempe.
 Ten Years of Photography, Museum of Art, Rhode Island School of Design, Providence.
 Twenty-Five Years of Modern Color Photography, Photokina, Cologne, West Germany.

New Photography (with Mary Frey and Philip Lorca diCorcia), Museum of Modern Art, New York.

Selected Public Collections

Addison Gallery of American Art, Phillips Academy, Andover, Massachusetts.
International Museum of Photography at George Eastman House, Rochester, New York.
Museum of Modern Art, New York.
Sheldon Memorial Art Gallery, University of Nebraska, Lincoln.

John Harding

John Harding was born in Washington, D.C., in 1940, was raised in Granite City, Illinois, and currently lives in San Francisco. He "cut his teeth" making black-and-white portraits of sisters and brothers; these photographs, dating from 1975 to 1976, were published in a book entitled *Siblings* (Verlag Dieter Fricke, 1982). He began to photograph in the street, and in 1977 he took up color for its "pure descriptiveness"—to reveal the vibrant colors that had disappeared in the gray tones of his black-and-white photography. These color street photographs led to the style he is known for today.

Harding studied with Jack Fulton and Henry Wessel, Jr. at the San Francisco Art Institute, where he received his M.F.A. in 1976. Although he obtained his degree in order to teach, Harding left the profession after five years. He feels that "if you're a good teacher you give that part of yourself that should go into your work—your life's blood." Today Harding regularly contributes editorial photographs to *Fortune* and other magazines.

Harding uses Leica cameras equipped with 28mm lenses and Kodacolor 400 film. His Ektacolor prints are 16 x 20 inches.

Awards

1977 National Endowment for the Arts Individual Photographer's Fellowship.
1983 John Simon Guggenheim Memorial Foundation Photographer's Fellowship.

Selected Solo and Two-Person Exhibitions

1976 *Siblings* (with Laura Gilpin), Focus Gallery, San Francisco.
1977 *Fifty-two Sittings*, Canessa Gallery, San Francisco.
1982 *Greece/Photographs*, IVC Gallery, Novato, California.
1983 *Pictures Seen/Fortunes Found*; *Color Photographs from San Francisco's Chinatown*, Canessa Gallery.
1985 *Two Views of Mallorca* (with Elena Sheehan), Focus Gallery.

Selected Group Exhibitions

1981 *Street Shooters*, San Francisco Camerawork.
1982 *Urban Spaces*, San Francisco Airport Exhibition.
1983 *Color in the Street*, California Museum of Photography, University of California, Riverside.
 Trends in Color, Focus Gallery, San Francisco.
 Cities and Urban Reality, South of Market Cultural Center, San Francisco.
1984 *10th Anniversary Exhibition*, San Francisco Camerawork.
 Exposed and Developed, National Museum of American Art, Smithsonian Institution, Washington, D.C. (traveling exhibition).
 Color Photographs: Recent Acquisitions, Museum of Modern Art, New York.
1985 *Photography from the Permanent Collection*, National Museum of American Art.
 The Civic Center Project, A. P. Giannini Gallery, San Francisco.
 50th Anniversary Acquisitions, San Francisco Museum of Modern Art.

Selected Public Collections

Bibliothèque Nationale, Paris.
Museum of Modern Art, New York.
National Museum of American Art, Smithsonian Institution, Washington, D.C.

New Orleans Museum of Art, New Orleans, Louisiana.
Oakland Museum, Oakland, California.
Princeton University Art Museum, Princeton, New Jersey.
San Francisco Museum of Modern Art.

Len Jenshel

Len Jenshel was born in Brooklyn in 1949 and now lives in Manhattan. He received his B.F.A. from Cooper Union in New York City in 1975, where he studied with Joel Meyerowitz, Tod Papageorge, and Garry Winogrand.

The photographs in "Industrial Tourism" are from the same period as the seven landscape photographs of the late 1970s reproduced in *The New Color Photography* (Abbeville, 1981). Other work includes Jenshel's 1980–82 photographs of the Gilded Age mansions of Old Westbury, New York, and Newport, Rhode Island: some of these appeared in *Camera Arts* magazine (March/April 1982). Jenshel's "Pictures at an Arboretum" of 1982 and 1983 are landscape photographs that flow with energy and crackle with visual surprise. Ten are reproduced in *New Color/New Work* (Abbeville, 1984).

In addition to giving numerous workshops around the country, Jenshel has taught at the International Center of Photography (1979–81), Cooper Union (1979–83), the School of Visual Arts (1980–83), and New York University (1983–84), all in New York City, and at the Massachusetts Institute of the Arts, Boston (1982). He has photographed in Thailand as well as in most parts of America. Although he lives in New York City, he rarely photographs there.

Len Jenshel uses a 6 x 9 cm Palm Press camera and Kodacolor film. His Ektacolor prints are 16 x 20 inches.

Awards and Commissions

1978 National Endowment for the Arts Individual Photographer's Fellowship.
New York State Council on the Arts Creative Artists Public Service Program (CAPS) Photographer's Fellowship.
1980 John Simon Guggenheim Memorial Foundation Photographer's Fellowship.
1985 Commission from the Greene County (New York) Council on the Arts to photograph the nineteenth-century houses and landscaped properties of the Hudson River School painters.
Commission from David Byrne to photograph Texas for the book *True Stories* (Viking, 1986).

Selected Solo Exhibitions

1980 *Coastline Photographs*, Castelli Graphics, New York.
Galerie Rudolf Kicken, Cologne, West Germany.
1982 *Mansions in Public Places*, ARCO Center for the Visual Arts, Los Angeles.
A Show of Wealth, Thomas Segal Gallery, Boston.
1983 *One Decade*, Joan Whitney Payson Gallery of Art, Westbrook College, Portland, Maine.
Era of Extravagance, International Center of Photography, New York.
Beyond the Sea, Blue Sky, Oregon Center for the Photographic Arts, Portland.
1984 *Pictures at an Arboretum*, H. F. Manès Gallery, New York.
Museum of Art, Carnegie Institute, Pittsburgh, Pennsylvania.
Mansions, Art Institute of Chicago.
1985 Ledel Gallery, New York.
1986 *The Outer from the Inner*, Gibbes Art Gallery, Charleston, South Carolina.

Selected Group Exhibitions

1977 *Some Color Photographs*, Castelli Graphics, New York (traveling exhibition).
After the Fact, Carpenter Center for the Visual Arts, Harvard University, Cambridge, Massachusetts.
1979 *Pictures: Photographs*, Castelli Graphics.
1980 *U.S. Eye*, Myers Fine Arts Gallery, State University of New York, Plattsburgh. (Winter Olympics debut and traveling exhibition).
Aspekte Amerikanischer Farbfotographie, Spectrum Photogalerie, Hanover, West Germany.
1981 *New American Colour Photography*, Institute of Contemporary Arts (ICA), London.
The New Color: A Decade of Color Photography, Everson Museum of Art, Syracuse, New York (traveling exhibition).
1982 *Place: New England Perambulations*, Addison Gallery of American Art, Phillips Academy, Andover, Massachusetts.
Color as Form: The History of Color Photography, International Museum of Photography at George Eastman House, Rochester, New York, and Corcoran Gallery of Art, Washington, D.C.
1983 *High Light: The Mountain in Photography from 1840 to the Present*, International Center of Photography, New York.
1984 *New Color/New Work: Eighteen Photographic Essays*, Jones Troyer Gallery (joint exhibition with Addison/Ripley Gallery, Kathleen Ewing Gallery, and Middendorf Gallery), Washington, D.C.
1985 *Portraits and Architecture*, Museum of Fine Arts, Boston.
New Color/New Work: Eighteen Photographic Essays, Museum of Contemporary Photography, Columbia College, Chicago.
1986 *Twenty-Five Years of Modern Color Photography*, Photokina, Cologne, West Germany.

Selected Public Collections

Art Institute of Chicago.
Museum of Art, Carnegie Institute, Pittsburgh, Pennsylvania.
Israel Museum, Jerusalem.
Minneapolis Institute of Art, Minneapolis, Minnesota.

Museum of Fine Arts, Boston.
Museum of Modern Art, New York.
Stedelijk Museum, Amsterdam, The Netherlands.

Nancy Lloyd

Nancy Lloyd was born in Harvard, Illinois, in 1949. From early childhood she loved drawing, especially the copying of cartoons, but did not take up photography until she attended the University of Wisconsin in Madison, where she received her B.A. in fine arts in 1976. In 1977 Lloyd traveled to France and visited the Arles Festival, where the exhibition *The Second Generation of Color Photographers*, organized by Allen Porter, inspired her to take up color photography. On returning to the States, she became an assistant to commercial photographer Shig Ikeda, who taught her technical skills and a sense of professionalism. Soon afterward, she moved to upstate New York to live on a farm with the painters Jack Beal, Sondra Freckelton, and Dan Van Horn, and pursued color photography seriously for the first time.

Lloyd has attended photographic workshops at the International Center of Photography, New York (1981), the Rochester Institute of Technology, Rochester, New York (1981), and the Visual Studies Workshop, Rochester, New York (1982), and has taught at the Friends of Photography, Carmel, California (1981 and 1983), the Ansel Adams Workshop, Pebble Beach, California (1982), and the Parsons School of Design, Paris (1984). A portfolio of her photographs of Niagara Falls and other sites was published in the spring 1985 issue of *Zoom* magazine. She lives in Easton, Pennsylvania.

The photographs in "Keeping Place" were made with either a Calumet 4 x 5 inch studio view camera with a 135mm Nikon lens or a Fujica 6 x 9 cm camera with a 65mm lens. With the Calumet camera Lloyd used either Type L or Type S Vericolor film; with the Fujica she used Type S Vericolor. She halves the ASA of the film, uses existing light, exposes for the shadows, and chooses slow exposures. She exhibits 16 x 20 inch Ektacolor prints.

Awards

1980 New York State Council on the Arts Creative Artists Public Service Program (CAPS) Photographer's Fellowship.
1981 Photographer's Fund Grant, Catskill Center for Photography.
1985 City of Easton (Pennsylvania) Arts Grant.

Selected Solo Exhibitions

1982 International Museum of Photography at George Eastman House, Rochester, New York.
1983 Frog Prince Gallery, San Francisco.

Selected Group Exhibitions

1981 *22 Photographers: Work by Recipients of the 1980–1981 Creative Artists Public Service Program (CAPS) Fellowship Awards*, New York State Council on the Arts (traveling exhibition).
1982 *View from Upstate*, A.I.R. Gallery, New York.
Ansel Adams Workshop Assistants Exhibition, Pebble Beach, California.
The Taking of Niagara: A History of the Falls in Photography, Buscaglia-Castellani Art Gallery, Niagara University, Niagara Falls, New York.
1981 Photographer's Fund Recipients, Catskill Center for Photography, Woodstock, New York.
1983 *Response to Nature*, Tisch School of the Arts, New York University.
1985 *New Color Landscapes*, Cleveland Center for Contemporary Art, Cleveland, Ohio.
Viewing the Landscape, Catskill Center for Photography.
Easton: Top to Bottom, Four Photographers View the City, Williams Center for the Arts, Lafayette College, Easton, Pennsylvania.

Selected Public Collections

Catskill Center for Photography, Woodstock, New York.
City Hall, Easton, Pennsylvania.
International Center of Photography, New York.
International Museum of Photography at George Eastman House, Rochester, New York.

Kenneth McGowan

Kenneth McGowan was born in 1940 in Ogden, Utah, and earned a B.A. (1964) and an M.A. (1966) from the University of California, Los Angeles. McGowan's earliest visual memories were of Technicolor movies; as a high school student, he was impressed by Abstract Expressionist painting. He began photographing in black and white in 1959 and switched to color in 1967.

A self-taught photographer, McGowan gained technical facility from fifteen years as a commercial studio photographer, specializing in portraits, slide shows, album covers, pinups, and special effects for movies.

McGowan lived most of his adult life in the Los Angeles area; the photographs that appeared in *The New Color Photography* (Abbeville, 1981) and *New Color/New Work* (Abbeville, 1984) were produced there, as were most of "The God Pictures." He died in New York City in 1986.

McGowan used a 2¼ x 2¼ inch Hasselblad camera. He preferred the normal 80mm lens, for its "bluntness," and used existing light whether indoors or out. Cibachrome prints are 19 x 19 inches on 20 x 24 inch paper.

Commissions

1979 Private commission to photograph the sets and studios of Universal Pictures.

Selected Solo Exhibitions

1977 Castelli Graphics, New York.
1979 Castelli Graphics.
1980 Los Angeles Institute of Contemporary Art.

1982 Impressions Gallery, Boston.
 Museum of Fine Arts, Houston, Texas.

Selected Group Exhibitions

1977 *Some Color Photographs*, Castelli Graphics, New York (traveling exhibition).
1978 *The Male Nude*, Marcuse Pfeifer Gallery, New York.
 The American West, Galerie Zabriskie, Paris.
 Color Photographs, Thomas Segal Gallery, Boston.
1979 *Color: A Spectrum of Recent Photography*, Milwaukee Art Center, Milwaukee, Wisconsin.
 One of a Kind, Polaroid Corporation traveling exhibition.
1980 *Contemporary Photographs*, Fogg Art Museum, Harvard University, Cambridge, Massachusetts.
 Photography: Recent Directions, DeCordova Museum, Lincoln, Nebraska.
 Urban/Suburban, Addison Gallery of American Art, Phillips Academy, Andover, Massachusetts.
1981 *Photoflexion*, Los Angeles Municipal Art Gallery (traveling exhibition).
 Couches, Diamonds and Pie, Project Studios One (PS 1), New York.
 The New Color: A Decade of Color Photography, Everson Museum of Art, Syracuse, New York (traveling exhibition).
1982 *Still Life Today*, Hudson River Museum, Yonkers, New York.
 Faces Photographed, Grey Art Gallery, New York University.
1983 *3-D Photographs*, Castelli Graphics.
1984 *Love*, White Columns, New York.
 Exposed and Developed, National Museum of American Art, Smithsonian Institution, Washington, D.C. (traveling exhibition).
 The Family of Man, Project Studios One.
 The Auto and Culture, Museum of Contemporary Art, Los Angeles.
 Photography in California: 1945–1980,

San Francisco Museum of Modern Art (traveling exhibition).
 New Color/New Work: Eighteen Photographic Essays, Addison/Ripley Gallery (joint exhibition with Kathleen Ewing Gallery, Middendorf Gallery, and Jones Troyer Gallery), Washington, D.C.
1985 *Seduction*, White Columns.
 Weird Beauty, Palladium, New York.
 New Color/New Work: Eighteen Photographic Essays, Museum of Contemporary Photography, Columbia College, Chicago.
1986 *Twenty-Five Years of Modern Color Photography*, Photokina, Cologne, West Germany.

Selected Public Collections

Museum of Contemporary Photography, Columbia College, Chicago.
Museum of Modern Art, New York.
San Francisco Museum of Modern Art.

Roger Mertin

Roger Mertin was born in 1942 in Bridgeport, Connecticut. He became seriously interested in photography after attending workshops by Nathan Lyons and Minor White at the Rochester Institute of Technology, Rochester, New York, where he received his B.F.A. in 1965. In 1972 he received his M.F.A. from the State University of New York, Buffalo, through the photography program of the Nathan Lyons Visual Studies Workshop.

Mertin's black-and-white photographs include the series "Plastic Love Dream" of 1968, featuring nudes enshrouded in plastic. His "Trees" of 1971–76 showed the startling transformations effected by flash. Since 1976 Mertin has worked with an 8 x 10 inch view camera making quiet, formal records of such all-American subjects as apple trees and basketball hoops.

A little-known color project dates from 1973, when Mertin and photographer Michael Becotte

traveled across America making color photographs. These were exhibited in *Road Shots* at the International Museum of Photography at George Eastman House, Rochester, New York, in 1974. The show mixed formal photographs with works resembling the off-balance, out-of-focus, flash-lit efforts of amateurs. In 1978 Mertin began to use Polacolor sheets in his view camera, and a year later he switched to color negative film. Photographs from his essay "The Blues" were published in *New Color/New Work* (Abbeville, 1984). One of Mertin's ongoing projects is the photographing of Christmas trees and other holiday decor.

Mertin has been on the fine arts faculty of the University of Rochester since 1975. He has also taught at the Rochester Institute of Technology (1969–72 and 1983–85) and at the University of New Mexico, Albuquerque (1972). Mertin was cofounder and partner of Walrus Company, a technical firm specializing in slide reproduction of photographs (1969–74); assistant curator for extension activities (1968–69) and head of the reproduction center (1966–67) at George Eastman House; and photographic technician for the Eastman Kodak Company (1965–66)—all of Rochester, New York. He continues to live in Rochester, where the majority of his photographs are taken.

Mertin's "Rochester Sesquicentennial" photographs were made with an 8 x 10 inch view camera, Vericolor film, existing light, and normal processing. They are Ektacolor 8 x 10 inch contact prints.

Awards and Commissions

1974 New York State Council on the Arts Creative Artists Public Service Program (CAPS) Photographer's Fellowship.
 John Simon Guggenheim Memorial Foundation Photographer's Fellowship.
1976 National Endowment for the Arts Individual Photographer's Fellowship.
1978 National Endowment for the Arts Photographic Survey Grant for the project and exhibition *From This Land*.

1984 Sesquicentennial Arts Grant, Rochester, New York.

1985 Commission from Light Work (Syracuse, New York) and the New York State Council on the Arts to photograph for the "I Love New York" advertising campaign.

Selected Solo Exhibitions

1965 Rochester Institute of Technology, Rochester, New York.

1966 International Museum of Photography at George Eastman House, Rochester, New York.

1969 Memorial Union Art Gallery, University of California, Davis.

1971 Haystack School of Crafts, Deer Isle, Maine.
Plastic Love Dream, Do Not Bend Gallery, London.
Center-of-the-Eye Gallery, Aspen, Colorado.

1972 Toronto Gallery of Photography.
23 Couples, San Francisco Art Institute.

1974 Galerie Stampa, Basel, Switzerland.
Road Shots (with Michael Becotte), International Museum of Photography at George Eastman House.

1976 Afterimage Photograph Gallery, Dallas, Texas.

1978 *Records*, Center for Contemporary Photography, Columbia College, Chicago.
Visual Studies Workshop, Rochester, New York.

1979 Gallery, Sun Valley Center for Art and Humanities, Sun Valley, Idaho.
Light Works/Community Darkroom, Syracuse, New York.

1980 Light Gallery, New York.
Film in the Cities Gallery, Saint Paul, Minnesota.

1981 Friends of Photography, Carmel, California.

1982 Photographers' Gallery, Toronto.
Brent Sikkema/Vision Gallery, Boston.
Robert Freidus Gallery, New York.

1983 Freidus-Ordover Gallery, New York.

1984 *Decorated Trees*, Northlight Gallery, Arizona State University, Tempe.

1985 *1984: Rochester*, Hartnett Gallery, University of Rochester, Rochester, New York.

Selected Group Exhibitions

1965 *Photography '65*, New York State Exposition, Syracuse, New York.

1966 *Seeing Photographically*, International Museum of Photography at George Eastman House, Rochester, New York.

1967 *Contemporary Photographers IV*, International Museum of Photography at George Eastman House.

1969 *The Photograph as Object: 1943–1969*, National Gallery of Canada, Ottawa.
Vision and Expression, International Museum of Photography at George Eastman House.

1970 *Be-ing Without Clothes*, Massachusetts Institute of Technology, Cambridge.
The Found Photograph, Visual Studies Workshop, Rochester, New York.

1976 *Contemporary Photography*, Fogg Art Museum, Harvard University, Cambridge, Massachusetts.
Photographie: Rochester, New York, Centre Culturel Américain, Paris.
Peculiar to Photography, University Art Museum, University of New Mexico, Albuquerque.

1977 *The Great West: Real/Ideal*, University of Colorado, Boulder.
New Aspects of Self in American Photography, Herbert F. Johnson Museum of Art, Cornell University, Ithaca, New York.
From This Land, Metropolitan State College, Denver, Colorado.

1978 *Mirrors and Windows: American Photography since 1960*, Museum of Modern Art, New York (traveling exhibition).
The Nude in Photography, Photopia Gallery, Philadelphia.

1979 *Attitudes: Photography in the 1970s*,

Santa Barbara Museum of Art, Santa Barbara, California.
The Residual Landscape, Addison Gallery of American Art, Phillips Academy, Andover, Massachusetts.
American Photography in the 1970s, Art Institute of Chicago.
One of a Kind, Polaroid Corporation traveling exhibition.

1980 *Photography: Recent Directions*, De-Cordova Museum, Lincoln, Nebraska.

1981 *American Photography: 1970–1980*, Whatcom Museum of History and Art, Bellingham, Washington.
American Landscapes, Museum of Modern Art, New York.
The New Color: A Decade of Color Photography, Everson Museum of Art, Syracuse, New York (traveling exhibition).

1982 *Twentieth-Century Photographs from the Collection of the Museum of Modern Art*, Seibu Department Store Gallery, Tokyo.
Floods of Light: Flash Photography, 1851–1981, Photographer's Gallery, London.

1983 *Arboretum*, University of Denver, Denver, Colorado.

1984 *Rochester: An American Center of Photography*, International Museum of Photography at George Eastman House.
American Photography Today: 1984, University of Denver.
New Color/New Work: Eighteen Photographic Essays, Middendorf Gallery (joint exhibition with Addison/Ripley Gallery, Kathleen Ewing Gallery, and Jones Troyer Gallery), Washington, D.C.

1985 *American Images*, Barbican Art Gallery, London (traveling exhibition).
New Color/New Work: Eighteen Photographic Essays, Museum of Contemporary Photography, Columbia College, Chicago.

Selected Public Collections

Art Institute of Chicago.
Bibliothèque Nationale, Paris.

International Museum of Photography at George Eastman House, Rochester, New York.

Museum of Contemporary Photography, Columbia College, Chicago.

Museum of Modern Art, New York.

National Museum of American Art, Smithsonian Institution, Washington, D.C.

Joel Meyerowitz

Joel Meyerowitz was born in 1938 in New York City. He attended Ohio State University, Columbus, on a swimming scholarship and studied painting and medical drawing. He painted loosely, drew tightly, and enjoyed the difference between the two. After receiving his B.A. in 1959, Meyerowitz returned to New York City and worked as an art director and graphic designer until 1962. That career ended abruptly; he was so moved by the sight of photographer Robert Frank at work that he decided to devote full time to exploring the gestural potential of 35mm photography. Although Meyerowitz took up color slide film from the outset, making color prints proved so difficult and expensive that the work remained "invisible" for most of the next two decades. In addition to the portfolio in *American Independents*, examples of this early work can be seen in *Aperture* magazine (no. 78) and Meyerowitz's book *Wild Flowers* (New York Graphic Society, 1983). In contrast, Meyerowitz's black-and-white photography was highly visible and appeared in exhibitions at the Museum of Modern Art, New York, and other museums.

When Meyerowitz began his own color printing in 1973, color became the most important side of his work. In 1976 he bought an 8 x 10 inch Deardorff view camera that was built during the month and year of his birth. In addition to the landscapes in his books *Cape Light* (New York Graphic Society, 1978), *St. Louis and the Arch* (New York Graphic Society, 1981), and *A Summer's Day* (Times Books, 1985), Meyerowitz has used his view camera for portraiture. Portfolios of his work are included in *The New Color Photography* (Abbeville, 1981), *Annie on Camera* (Abbeville, 1982), and *New Color/New Work* (Abbeville, 1984). Meyerowitz continues to use both 35mm Leica and 8 x 10 inch Deardorff and argues that the two poles of his work make him no more schizophrenic than a painter who also draws.

Meyerowitz taught at Cooper Union in New York City in 1971 and has free-lanced as a commercial photographer since the 1960s. He spends six to eight weeks per year producing advertisements for a variety of clients. Staying on the margins of the business, he employs no representative and has never owned a business card. Although the work gives him the freedom to spend the remainder of each year making pictures for himself, he warns young photographers of the dangers of going "too far in" commercial photography and being "caught in the trap." He lives in New York City and spends his summers in Provincetown, Massachusetts.

All photographs in "Out to Lunch" were made with Kodachrome II or Kodachrome 25 film. The camera was a Leica M2 with a 35mm Summicron lens.

Awards and Commissions

1970 John Simon Guggenheim Memorial Foundation Photographer's Fellowship.

1976 New York State Council on the Arts Creative Arts Public Service Program (CAPS) Photographer's Fellowship.

1977 Commission from the Saint Louis Art Museum to photograph the city of Saint Louis and the Erro Saarinen Arch.

1978 Commission from AT&T to photograph for the book and exhibition *American Images: New Work by Twenty Contemporary Photographers* (McGraw-Hill, 1979).

National Endowment for the Humanities Grant to research and write a book with Colin L. Westerbeck, Jr., on the history of street photography (to be published by New York Graphic Society, 1988).

National Endowment for the Arts Individual Photographer's Fellowship.

John Simon Guggenheim Memorial Foundation Photographer's Fellowship.

1981 Commission from Columbia Pictures to photograph the making of the film *Annie*.

Photographer of the Year Award, Friends of Photography, Carmel, California.

1985 Ansel Adams Book Award for *A Summer's Day*.

Selected Solo and Two-Person Exhibitions

1968 *My European Trip: Photographs from a Moving Car*, Museum of Modern Art, New York.

1977 Witkin Gallery, New York.

1978 *Cape Light*, Museum of Fine Arts, Boston (traveling exhibition).

1979 *St. Louis and the Arch*, Saint Louis Art Museum, Saint Louis, Missouri.
Akron Art Museum, Akron, Ohio.

1980 San Francisco Museum of Modern Art.
Stedelijk Museum, Amsterdam, The Netherlands.

1981 Greenberg Gallery, Saint Louis, Missouri.
San Francisco Museum of Modern Art.

1982 Provincetown Art Association and Museum, Provincetown, Massachusetts.
Greenberg Gallery.

1983 Grapestake Gallery, San Francisco.

1985 *Works of the Same Nature: Joel Meyerowitz and Vivian Bower*, Witkin Gallery.
Joel Meyerowitz/Stephen Shore, Chapter Arts Centre, Cardiff, Wales.
A Summer's Day, Hong Kong Arts Center, Hong Kong.
Twentieth-Century Photographs from the Collection of the Museum of Modern Art, Seibu Department Store Gallery, Tokyo.

1986 *Light and Time*, Daniel Wolf Gallery, New York.
A Summer's Day, Brooklyn Museum, Brooklyn, New York.

Selected Group Exhibitions

1963 *The Photographer's Eye*, Museum of Modern Art, New York.

1966 *Seeing Photographically*, International

Muscum of Photography at George Eastman House, Rochester, New York.

1970 *10 Americans*, U.S. Pavilion, Expo 70, Osaka, Japan.

1971 *New American Photography*, Museum of Modern Art (traveling exhibition).

1977 *Warm Truths/Cool Deceits*, California State University, Chico (traveling exhibition).
The Second Generation of Color Photographers, Arles Festival, Arles, France.
Wedding, Carpenter Center for the Visual Arts, Harvard University, Cambridge, Massachusetts.
Inner Light, Museum of Fine Arts, Boston.

1978 *Mirrors and Windows: American Photography since 1960*, Museum of Modern Art, New York (traveling exhibition).

1979 *American Images: New Work by Twenty Contemporary Photographers* Corcoran Gallery of Art, Washington, D.C. (traveling exhibition).

1981 *American Photographers and the National Parks*, National Parks Service traveling exhibition.
A Sense of Order, Institute of Contemporary Art, University of Pennsylvania, Philadelphia.
The New Color: A Decade of Color Photography, Everson Museum of Art, Syracuse, New York (traveling exhibition).

1982 *Twentieth-Century Photographs from the Collection of the Museum of Modern Art*, Seibu Department Store Gallery, Tokyo.
Color as Form: The History of Color Photography, International Museum of Photography at George Eastman House, and Corcoran Gallery of Art.

1983 *Response to Nature*, Tisch School of the Arts, New York University.
Color in the Street, California Museum of Photography, University of California, Riverside.
200 Photographs from the Museum Collection, Seattle Art Museum, Seattle, Washington.

1984 *Autoscape: The Automobile in the American Landscape*, Whitney Museum of American Art, Stamford, Connecticut.
Color and Straight Photography, Paris Art Center, France.
New Color/New Work: Eighteen Photographic Essays, Kathleen Ewing Gallery (joint exhibition with Addison/Ripley Gallery, Middendorf Gallery, and Jones Troyer Gallery), Washington, D.C.

1985 *Light—From Illumination to Pure Radiance*, San Francisco Museum of Modern Art.
The Nude in Photography, Münchner Stadtmuseum, Munich, West Germany.
American Images, Barbican Art Gallery, London (traveling exhibition).
Contemporary Photographers, Museum of Art, Carnegie Institute, Pittsburgh, Pennsylvania.
New York: The City and Its People, Peking Workers Culture Palace, Peking, China (and tour to Japan).
New Color/New Work: Eighteen Photographic Essays, Museum of Contemporary Photography, Columbia College, Chicago.
City Light, International Center of Photography (Midtown Branch), New York.

1986 *Winter*, Hood Museum of Art, Dartmouth College, Hanover, New Hampshire.
The Image of France, Art Institute of Chicago.
Twenty-Five Years of Modern Color Photography, Photokina, Cologne, West Germany.

Selected Public Collections

Art Institute of Chicago.
Brooklyn Museum, Brooklyn, New York.
Corcoran Gallery of Art, Washington, D.C.
International Museum of Photography at George Eastman House, Rochester, New York.
Museum of Fine Arts, Boston.
Museum of Modern Art, New York.
Saint Louis Art Museum, Saint Louis, Missouri.
San Francisco Museum of Modern Art.

Richard Misrach

Richard Misrach was born in Los Angeles in 1949 and now lives in Emeryville, California. He received a B.A. in psychology from the University of California, Berkeley, in 1971 and is largely self-taught as a photographer.

In order to portray an important aspect of Berkeley's youth culture, Misrach photographed at night for the book *Telegraph 3 A.M.* (Cornucopia, 1974). He then became interested in night photography in and of itself and produced the black-and-white photographs for which he is best known—dramatic, flash-lit, iconic portraits of cactus in the desert, of ruins in Greece, and of Stonehenge. A widely distributed catalog, (*a photographic book*), was published by San Francisco's Grapestake Gallery in 1979.

Misrach began working in color in 1976, but in a group show of 1979 he exhibited color work for the first time. A portfolio of these photographs—flash-lit images of the Hawaiian jungle at night—are reproduced in *American Images: New Work by Twenty Contemporary Photographers* (McGraw-Hill, 1979).

Misrach has given workshops at the San Francisco Art Institute; the Photographer's Gallery, London; the Ansel Adams Workshop, Yosemite, California; the Center for Creative Photography, Tucson, Arizona; and many other institutions. He was on the staff of the ASUC Studio at the University of California, Berkeley, from 1971–78, a visiting lecturer in the Department of Landscape Architecture at the University of California, Berkeley, in 1982, and a member of the Department of Art at the University of California, Santa Barbara, in 1984.

Misrach uses an 8 x 10 inch Deardorff view camera. Instead of using Vericolor L film, he departs from standard practice and combines Vericolor S film with long exposures. His Ektacolor prints are 20 x 24 inches or 30 x 40 inches.

Awards and Commissions

1973 National Endowment for the Arts Individual Photographer's Fellowship.

1975 Western Book Award for *Telegraph 3 A.M.*
1976 Ferguson Grant, Friends of Photography, Carmel, California.
1977 National Endowment for the Arts Individual Photographer's Fellowship.
1978 Commission from AT&T to photograph for the book and exhibition *American Images: New Work by Twenty Contemporary Photographers*.
1979 John Simon Guggenheim Memorial Foundation Photographer's Fellowship.
1984 National Endowment for the Arts Individual Photographer's Fellowship.

Selected Solo and Two-Person Exhibitions

1975 International Center of Photography, New York.
1976 Madison Art Center, Madison, Wisconsin.
1977 Oakland Museum, Oakland, California. ARCO Center for the Visual Arts, Los Angeles.
1978 Silver Image Gallery, Seattle, Washington.
Museum of Art, University of Oregon, Eugene.
1979 G. Ray Hawkins Gallery, Los Angeles. Grapestake Gallery, San Francisco. Camera Obscura, Stockholm, Sweden. Musée National d'Art Moderne, Centre Beaubourg, Paris.
1980 Young Hoffman Gallery, Chicago. Paul Cava Gallery, Philadelphia. G. Ray Hawkins Gallery.
1981 Grapestake Gallery.
1982 *Guadalajara '82*, Guadalajara, Spain.
1983 Grapestake Gallery.
Los Angeles County Museum of Art.
1984 Honolulu Academy of Arts, Honolulu, Hawaii.
Richard Misrach: A Decade of Photography, Friends of Photography, Carmel, California.
1985 Martin Gallery, Washington, D.C. Fraenkel Gallery, San Francisco.

Richard Misrach and Joanne Verburg, Light Gallery, New York.
Houston Center for Photography, Houston, Texas.

Selected Group Exhibitions

1973 *Places*, San Francisco Art Institute.
1976 *Contemporary Photography*, Fogg Art Museum, Harvard University, Cambridge, Massachusetts.
1977 *Young American Photographers*, Kalamazoo Institute of Arts, Kalamazoo, Michigan (traveling exhibition).
Night Landscape, Oakland Museum, Oakland, California.
1978 *Mirrors and Windows: American Photography since 1960*, Museum of Modern Art, New York (traveling exhibition).
1979 *Beyond Color*, San Francisco Museum of Modern Art.
Color: A Spectrum of Recent Photography, Milwaukee Art Center, Milwaukee, Wisconsin.
American Images: New Work by Twenty Contemporary Photographers, Corcoran Gallery of Art, Washington, D.C. (traveling exhibition).
Attitudes: Photography in the 1970s, Santa Barbara Museum of Art, Santa Barbara, California.
1981 *American Photographers and the National Parks*, National Parks Service traveling exhibition.
Whitney Biennial, Whitney Museum of American Art, New York.
1982 *Flash*, Rochester Institute of Technology, Rochester, New York.
California Photography, Rhode Island School of Design, Providence.
1984 *Photography in California: 1945–1980*, San Francisco Museum of Modern Art (traveling exhibition).
Color Photographs: Recent Acquisitions, Museum of Modern Art, New York.
1985 *American Images*, Barbican Art Gallery, London (traveling exhibition).

Selected Public Collections

Musée National d'Art Moderne, Centre Georges Pompidou, Paris.
Museum of Contemporary Photography, Columbia College, Chicago.
Museum of Fine Arts, Houston, Texas.
Museum of Modern Art, New York.
National Museum of American Art, Smithsonian Institution, Washington, D.C.
Oakland Museum, Oakland, California.
San Francisco Museum of Modern Art.
Victoria and Albert Museum, London.

Joanne Mulberg

Joanne Mulberg was born in New York City in 1954, grew up in Syosset on Long Island, New York, and now lives in Huntington, Long Island. She received her B.F.A. from Cooper Union in New York in 1976 and was a printer for Joel Meyerowitz from 1976 to 1983. Since 1985 she has taught photography at the New York Institute of Technology, Old Westbury, New York.

Mulberg's 1975–76 photographs of Long Island shop windows feature complex plays of space, surface, and reflection. Since then she has made landscape photographs such as those in the series "Threaded Light," reproduced in *New Color/New Work* (Abbeville, 1984). The majority of Mulberg's photographs have been taken on Long Island, but she has also photographed in Ireland, Italy, and France.

Mulberg's photographs are taken with a 2¼ x 2¼ inch twin-lens Rolleiflex and Vericolor II or III film. Her Ektacolor prints are 8¼ x 8¼ inches.

Awards

1981 New York State Council on the Arts Creative Artists Public Service Program (CAPS) Photographer's Fellowship.

Solo and Two-Person Exhibitions

1983 *Running Threads*, Sea Cliff Photographic Company, Sea Cliff, New York.

1985 *Seeing Through and Beyond*, Marin College, Kentfield, California.
1986 *Joanne Mulberg and Jeanne Moutoussamy*, Port Washington Public Library, Port Washington, New York.

Selected Group Exhibitions

1976 *Contemporary Color Photographs*, Bard College, Annandale-on-Hudson, New York.
1977 *Warm Truths/Cool Deceits*, California State University, Chico (traveling exhibition).
1980 Sprengel-Museum, Hanover, West Germany.
Galerie Rudolf Kicken, Cologne, West Germany.
A Century of Photography, C. W. Post College, New York.
1981 *22 Photographers: Work by Recipients of the 1980–1981 Creative Artists Public Service Program (CAPS) Fellowship Awards*, New York State Council on the Arts (traveling exhibition).
Nassau County Museum of Fine Art, Roslyn Harbor, New York.
American House, U.S. Information Service, West Berlin.
Photography: Cooper Union's Products of the Seventies, Houghton Gallery, Cooper Union, New York.
The New Color: A Decade of Color Photography, Everson Museum of Art, Syracuse, New York (traveling exhibition).
1983 *Response to Nature*, Tisch School of the Arts, New York University.
1984 *New Color/New Work: Eighteen Photographic Essays*, Middendorf Gallery (joint exhibition with Addison/Ripley Gallery, Kathleen Ewing Gallery, and Jones Troyer Gallery), Washington, D.C.
1985 *New Color/New Work: Eighteen Photographic Essays*, Museum of Contemporary Photography, Columbia College, Chicago.
1986 *Twenty-Five Years of Modern Color Photography*, Photokina, Cologne, West Germany.

Selected Public Collections

Joseph E. Seagram and Sons, New York.

Stephen Scheer

Stephen Scheer was born in Boston in 1954 and now lives in New York City. During high school he was a black-and-white landscape photographer in awe of Edward Weston; at the age of seventeen, he attended a lecture by Garry Winogrand and was introduced to the work of Robert Frank. By the age of nineteen he had taken up the small camera and was influenced as well by Henri Cartier-Bresson, Diane Arbus, and Josef Koudelka. Scheer began working in color in 1975, when he took a year off from college and took a course at the San Francisco Art Institute.

Scheer received his B.A. in art history from Bowdoin College, Brunswick, Maine, in 1976 and his M.F.A. from the Yale University School of Art, New Haven, Connecticut, in 1980, where he studied with Tod Papageorge. He has taught at the Pratt Institute, Brooklyn, New York (1980–82), Yale University (1982–84), and Rice University, Houston, Texas (1984). In fall 1986 he returned to teaching at Yale and also held classes at the School of Visual Arts in New York City. For the past several years Scheer has worked as a free-lance editorial photographer for *Fortune* and other magazines, illustrating lifestyle stories on multiplex cinemas, long-term personal financing, yuppies, executives who are ballroom dancers, the Texas oil glut depression, and other subjects.

Reproductions of Scheer's earlier series "The Maples" can be found in *Aperture* magazine (no. 91). "Summer States" is included in *New Color/New Work* (Abbeville, 1984).

The photographs in "Texas Tourney" were made with a Canon F1 35mm camera and Kodacolor VR films. Scheer used three lenses: a 24mm Aspherical, a 28mm Standard, and a 35mm Aspherical. Exhibition prints are Ektacolor or dye transfer, 16 x 20 inches.

Awards

1980 National Endowment for the Arts Individual Photographer's Fellowship.

Selected Solo Exhibitions

1984 Rice University Media Center, Houston, Texas.
1985 *The Maples*, Blue Sky, Oregon Center for the Photographic Arts, Portland.

Selected Group Exhibitions

1976 Walker Art Museum, Bowdoin College, Brunswick, Maine.
1977 Panopticon Gallery, Boston.
Boston Visual Artists Union, Boston.
1978 Kiva Gallery, Boston.
1980 Gallery of the Yale School of Art, New Haven, Connecticut.
1981 Summer show, Daniel Wolf Gallery, New York.
1983 *Color in the Street*, California Museum of Photography, University of California, Riverside.
1984 *New Color/New Work: Eighteen Photographic Essays*, Addison/Ripley Gallery (joint exhibition with Kathleen Ewing Gallery, Middendorf Gallery, and Jones Troyer Gallery), Washington, D.C.
1985 *New Color/New Work: Eighteen Photographic Essays*, Museum of Contemporary Photography, Columbia College, Chicago.

Selected Public Collections

National Museum of American Art, Smithsonian Institution, Washington, D.C.

Stephen Shore

Stephen Shore was born in New York City in 1947 and now lives in Stone Ridge, New York. At the age of fifteen Shore worked with Andy Warhol at the Factory and later published black-

and-white photographs in the book *Andy Warhol* (Moderna Museet, Stockholm, 1968). His sole photographic training was a ten-day workshop with Minor White at the Hotchkiss School, Lakeville, Connecticut, in 1970. Shore's first major exhibition was of black-and-white photographs at the Metropolitan Museum of Art in New York, when he was twenty-four.

Soon afterward, he began working in color and in 1976, at the age of twenty-nine, he was given a major color exhibition at the Museum of Modern Art, New York. That same year, the Metropolitan Museum of Art published a limited edition portfolio of twelve of his photographs. His work has appeared in *The New Color Photography* (Abbeville, 1981) and *New Color/New Work* (Abbeville, 1984), and in two monographs, *Uncommon Places* (Aperture, 1982) and *The Gardens of Giverny* (Aperture, 1983).

As a free-lance editorial photographer he has worked on assignments for *Fortune, Architectural Digest*, and other publications. Since 1982 Shore has been chairman of the Department of Photography at Bard College, Annandale-on-Hudson, New York.

Shore's photographs were made with an 8 x 10 inch Deardorff view camera. His Hudson Valley photographs are 8 x 10 inch or 16 x 20 inch Ektacolor prints produced by Dimension Color Labs, New York City.

Awards and Commissions

1974 National Endowment for the Arts Individual Photographer's Fellowship.
1975 John Simon Guggenheim Memorial Foundation Photographer's Fellowship.
1976 National Endowment for the Arts Individual Photographer's Fellowship.
Commission from Joseph E. Seagram and Sons to photograph for the Bicentennial book and exhibition *Court House* (Horizon, 1977).
1977 Commission from the Metropolitan Museum of Art to photograph Monet's gardens at Giverny, France.
1978 Commission from AT&T to photograph

for the book and exhibition *American Images: New Work by Twenty Contemporary Photographers* (McGraw-Hill, 1979).
1980 American Academy (Rome) Special Fellowship.
1981 Commission from Columbia Pictures to photograph the making of the film *Annie* for the book *Annie on Camera* (Abbeville, 1982).
1984 Commission from the Lila Acheson Wallace Foundation to photograph the Hudson Valley.

Selected Solo and Two-Person Exhibitions

1971 Metropolitan Museum of Art, New York.
1972 Thomas Gibson Fine Arts, London.
Light Gallery, New York.
1973 Light Gallery.
1975 Light Gallery.
1976 Museum of Modern Art, New York.
Renwick Gallery, National Collection of Fine Arts, Smithsonian Institution, Washington, D.C.
1977 Galerie Lichttropfen, Aachen, West Germany.
Städtische Kunsthalle, Düsseldorf, West Germany.
Light Gallery.
1978 Light Gallery.
1980 Light Gallery.
1981 John and Mable Ringling Museum of Art, Sarasota, Florida.
Fraenkel Gallery, San Francisco.
1982 ARCO Center for the Visual Arts, Los Angeles.
1983 Pace/MacGill Gallery, New York.
1984 Art Institute of Chicago.
Eisenhower Hall, United States Military Academy, West Point, New York.
Philadelphia College of Art.
Mattingly Baker Gallery, Dallas, Texas.
1985 *Joel Meyerowitz/Stephen Shore*, Chapter Arts Centre, Cardiff, Wales.
Center for Creative Photography, Tucson, Arizona.

Film in the Cities Gallery, St. Paul, Minnesota.

Selected Group Exhibitions

1970 *Fotoportret*, Haags Gemeentemuseum, The Hague, The Netherlands.
1972 *Sequences*, Photokina, Cologne, West Germany.
1973 *Landscape/Cityscape*, Metropolitan Museum of Art, New York.
1974 *New Images in Photography*, Lowe Art Museum, University of Miami, Coral Gables, Florida.
1975 *Color Photography: Inventors and Innovators: 1850–1975*, Yale University Art Gallery, New Haven, Connecticut.
New Topographics, International Museum of Photography at George Eastman House, Rochester, New York.
1976 *American Photography: Past into Present*, Seattle Art Museum, Seattle, Washington.
100 Master Photographs, Museum of Modern Art, New York.
1977 *The Great West: Real/Ideal*, University of Colorado, Boulder.
The Second Generation of Color Photographers, Arles Festival, Arles, France.
Documenta VI, Kassel, West Germany.
Court House, Museum of Modern Art, New York (American Institute of Architects and Joseph E. Seagram and Sons traveling exhibition).
1978 *Amerikanische Landschaftsphotographie, 1860–1978*, Neue Sammlung, Munich, West Germany.
Mirrors and Windows: American Photography since 1960, Museum of Modern Art, New York (traveling exhibition).
1979 *American Images: New Work by Twenty Contemporary Photographers*, Corcoran Gallery of Art, Washington, D.C. (traveling exhibition).
American Photography in the 1970s, Art Institute of Chicago.
1981 *The New Color: A Decade of Color Pho-*

tography, Everson Museum of Art, Syracuse, New York (traveling exhibition).

1982 *Counterparts*, Metropolitan Museum of Art.
Slices of Time: California Landscape Photography: 1860–1880, 1960–1980, Oakland Museum, Oakland, California.
Photography in Color, Stockton State College, Pomona, New Jersey.
Color as Form: The History of Color Photography, International Museum of Photography at George Eastman House, and Corcoran Gallery of Art, Washington, D.C.

1983 *200 Photographs from the Museum Collection*, Seattle Art Museum, Seattle, Washington.

1984 *Photographs from the Museum's Collections*, Metropolitan Museum of Art.
New Color/New Work: Eighteen Photographic Essays, Addison-Ripley Gallery (joint exhibition with Kathleen Ewing Gallery, Middendorf Gallery, and Jones Troyer Gallery), Washington, D.C.

1985 *Images of Excellence: Photographs from the George Eastman House Collection*, IBM Gallery of Art and Science, New York (traveling exhibition).
American Images, Barbican Art Gallery, London (traveling exhibition).
New Color/New Work: Eighteen Photographic Essays, Museum of Contemporary Photography, Columbia College, Chicago.

Selected Public Collections

Art Institute of Chicago.
Art Museum, Princeton University, Princeton, New Jersey.
International Museum of Photography at George Eastman House, Rochester, New York.
Metropolitan Museum of Art, New York.
Museum of Fine Arts, Houston, Texas.
Museum of Modern Art, New York.
Yale University Art Gallery, New Haven, Connecticut.

Joel Sternfeld

Joel Sternfeld was born in New York City in 1944. He received his B.A. from Dartmouth College, Hanover, New Hampshire, in 1965 and has taught at Stockton State College, Pomona, New Jersey (1971–84), and Yale University, New Haven, Connecticut (1984–85). Since 1985 he has been on the faculty of Sarah Lawrence College, Bronxville, New York.

Sternfeld has worked in color since 1970. From 1976 to 1978 Sternfeld made candid street photographs with a 35mm camera and a 4 x 5 inch press view camera. This work, emphasizing the anxiety-ridden faces of commuters and careerists, was reproduced in a portfolio in *Camera* magazine (November 1977). Earlier work includes photographs taken in the Deep South and at Nags Head, North Carolina. Some of these photographs explore Josef Albers's color theories and some are synesthetic attempts to stimulate nonvisual senses.

Since 1978 Sternfeld has engaged in an American odyssey, traveling alone in a Volkswagen camper-bus and photographing the natural and social landscape with an 8 x 10 inch view camera. This widely hailed work has been published in *Camera Arts* magazine (November/December 1980), *Modern Photography* magazine (March 1980), *The New Color Photography* (Abbeville, 1981), and *New Color/New Work* (Abbeville, 1984). "Alaska at 25" is a continuation of this project. In 1984 he was honored by inclusion in the exhibition *Three Americans*, which was the first photography exhibition held at the Museum of Modern Art in New York City after its reopening in 1984. Sternfeld lives in Manhattan.

Sternfeld's camera is a wooden Wista 8 x 10 inch view camera. His lenses include 240mm and 360mm Schneider Symmars and a 300mm Kodak Anastigmat, and he uses Kodak Vericolor films. His negatives are enlarged on Ektacolor paper to 13½ x 17 inches.

Awards and Commissions

1978 John Simon Guggenheim Memorial Foundation Photographer's Fellowship.

1980 National Endowment for the Arts Individual Photographer's Fellowship.
New York State Council on the Arts Creative Artists Public Service Program (CAPS) Photographer's Fellowship.

1982 John Simon Guggenheim Memorial Foundation Photographer's Fellowship.

1983 American Council for the Arts Emerging Artist Award.

1985 Grand Prize, Higashikawa International Festival, Higashikawa, Japan.
Artist in residence, Dartmouth College, Hanover, New Hampshire.

Selected Solo and Two-Person Exhibitions

1976 Pennsylvania Academy of the Fine Arts, Philadelphia.

1981 Photography Gallery, La Jolla, California.
Daniel Wolf Gallery, New York.
Larry Fink and Joel Sternfeld, San Francisco Museum of Modern Art.

1982 Blue Sky, Oregon Center for the Photographic Arts, Portland.
Looking Glass Gallery, Royal Oak, Michigan.
California Museum of Photography, University of California, Riverside.
Grapestake Gallery, San Francisco.
Brent Sikkema/Vision Gallery, Boston.

1983 Grapestake Gallery.

1984 Visual Studies Workshop, Rochester, New York.
Daniel Wolf Gallery.
Friends of Photography, Carmel, California.

1985 Halsted Gallery, Birmingham, Michigan.
Michael Carey Gallery, Austin, Texas.
Afterimage Photograph Gallery, Dallas, Texas.
Higashikawa International Festival, Higashikawa, Japan.

Selected Group Exhibitions

1976 *Photographs of the American Landscape*, Print Club, Philadelphia.

1977 *The Second Generation of Color Photographers*, Arles Festival, Arles, France.

1978 *New Color Visions*, Photokina, Kunsthalle, Cologne, West Germany.

1979 *Photographie im Alltags Amerikas*, Kunstgewerbemuseum, Zurich, Switzerland.

1981 *Color Landscape Photography*, Creative Photography Gallery, Massachusetts Institute of Technology, Cambridge.
The New Color: A Decade of Color Photography, Everson Museum of Art, Syracuse, New York (traveling exhibition).

1982 *Place: New England Perambulations*, Addison Gallery of American Art, Phillips Academy, Andover, Massachusetts.
Twentieth-Century Photographs from the Collection of the Museum of Modern Art, Seibu Department Store Gallery, Tokyo.
Color as Form: The History of Color Photography, International Museum of Photography at George Eastman House, Rochester, New York, and Corcoran Gallery of Art, Washington, D.C.

1983 *High Light: The Mountain in Photography from 1840 to the Present*, International Center of Photography, New York.
Color in the Street, California Museum of Photography, University of California, Riverside.
Subjective Vision: Photographs from the Lucinda W. Bunnen Collection, High Museum of Art, Atlanta, Georgia.

1984 *Three Americans: Robert Adams, Jim Goldberg, and Joel Sternfeld*, Museum of Modern Art, New York.
New Color/New Work: Eighteen Photographic Essays, Middendorf Gallery (joint exhibition with Addison/Ripley Gallery, Kathleen Ewing Gallery, and Jones Troyer Gallery), Washington, D.C.

1985 *American Nature and Culture*, Lamont Gallery, Phillips Exeter Academy, Exeter, New Hampshire.
American Images, Barbican Art Gallery, London (traveling exhibition).
Whitney Biennial, Whitney Museum of American Art, New York.
New Color/New Work: Eighteen Photographic Essays, Museum of Contemporary Photography, Columbia College, Chicago.
City Light, International Center of Photography (Midtown Branch), New York.

1986 *Twenty-Five Years of Modern Color Photography*, Photokina, Cologne, West Germany.

Selected Public Collections

Akron Art Museum, Akron, Ohio.
California Museum of Photography, University of California, Riverside.
Dallas Museum of Art, Dallas, Texas.
High Museum of Art, Atlanta, Georgia.
Herbert F. Johnson Museum of Art, Cornell University, Ithaca, New York.
Middlebury College, Middlebury, Vermont.
Museum of Fine Arts, Houston, Texas.
Museum of Modern Art, New York.
San Francisco Museum of Modern Art.
Seattle Art Museum, Seattle, Washington.
Worcester Art Museum, Worcester, Massachusetts.

Jack D. Teemer, Jr.

Jack Drew Teemer, Jr., was born in Baltimore in 1948. He received his B.A. (1977) and M.F.A. (1979) from the University of Maryland in Baltimore and studied there with John Gossage. Teemer now lives in Dayton, Ohio, and has taught at the University of Dayton since 1980. In addition to his regular college teaching, Teemer has, since 1981, directed photographic workshops with project support grants from the Ohio Arts Council and the National Endowment for the Arts.

Prior to his ongoing series of color photographs featuring working-class backyards and city neighborhoods, Teemer made infrared photographs of nudes. He is currently involved in a joint project with his wife, Jone Teemer. Using mixed media and collage, they have produced a photographic album exploring the dynamics of family relationships.

For the photographs in "Personal Spaces," Teemer used a 4 x 5 inch view camera equipped with either a 210mm or a 135mm lens. His film is Vericolor Type S. Ektacolor prints are 8 x 10 inches.

Awards

1980 National Endowment for the Arts Individual Photographer's Fellowship.

1982 Ohio Arts Council Individual Artist's Fellowship.
Ohio Arts Council Photographic Survey Fellowship to document the Lake Shore region of Cleveland.

1984 University of Dayton Summer Research Fellowship.

Selected Solo and Two-Person Exhibitions

1979 Hartman Gallery, Baltimore.

1980 Northern Virginia Community College, Sterling, Virginia.

1981 *RTA #12*, Creative Photography Gallery, University of Dayton, Dayton, Ohio.

1983 *Jack D. Teemer, Jr., and Diane Belfiglio*, Gund Gallery, Ohio Arts Council, Columbus, Ohio.
Akron Art Museum, Akron, Ohio.
Blue Sky, Oregon Center for the Photographic Arts, Portland.

Selected Group Exhibitions

1979 *Some Photographs*, Fine Arts Gallery, University of Maryland, College Park.

1981 *The Ohio Selection*, Dayton Art Institute, Dayton, Ohio.
Recent Acquisitions, Corcoran Gallery of Art, Washington, D.C.
The New Ohio Photography, Art Gallery, Cleveland State University, Cleveland, Ohio (Ohio Foundation of the Arts traveling exhibition).